FASCINATION
THE CELLULOID DREAMS OF JEAN ROLLIN

by
David Hinds

WWW.WORLDHEADPRESS.COM

CONTENTS

Introduction... 1

PART ONE: ESSAYS

Orchestrator of Storms ... 10
Personal Visions.. 22
Visual Obsessions.. 30
The Art of Creation ... 38
Black Widows, Femme Fatales and Male Fools.................. 46
The Literary Fantastique... 52

PART TWO: FILMS

The Films of Jean Rollin... 57
Also Known As: The Pseudonymous Films.......................193
Sexual Vibrations: The Hardcore Years213
Short Films and Unfinished Projects...............................228

APPENDIX

Interview with Jean Rollin...234
Interview with Lionel Wallmann252
Jean Rollin Bibliography..255
Jean Rollin Filmography ...257

Index of Film Titles..257
Sources..259
Acknowledgements..260

For Jean Rollin

'The presbytery has lost none of its charm,
nor the garden its colours.'

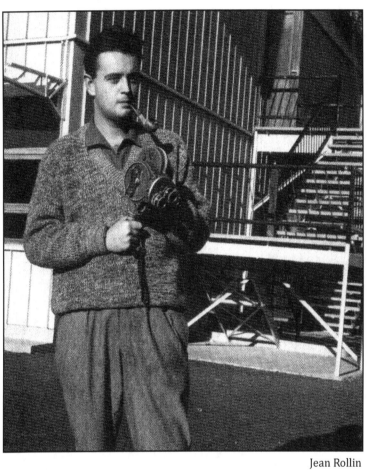

Jean Rollin

Introduction

THROUGHOUT MY TEENAGE years, I warmly recall devoting a vast majority of my time and what little money I had to watching and seeking out horror films, becoming more and more intrigued by obscure cult movies. Seeing John Carpenter's *Halloween* (1978) on late-night TV at a friend's house when I was twelve changed my life. It was exhilarating and terrifying, and from that moment on I was besotted with the horror genre. Shortly afterwards, I managed to obtain a copy of Tobe Hooper's *The Texas Chain Saw Massacre* (1974), and I knew I wanted to spend my life making, discussing, and writing about horror films. It was, and still is, an obsession.

I was a late child of the 'video nasty' generation. Upon hearing about the movies deemed too disturbing and offensive to view on videocassette in Britain, I was driven like so many others to collect and see them all. It didn't matter if the movie had a shit reputation. I lapped them up, one and all. I quickly became immersed in the bootleg circuit via mail order traders and was constantly mesmerized by the hundreds of titles that I knew nothing about. When I'd devoured the most notorious titles, I began looking to the more obscure films and filmmakers. I noticed one name appearing time and again: Jean Rollin. Many of my friends were keen fans of European horror and fantasy cinema, yet, they knew nothing of the mysterious Frenchman or his alluring titles — titles such as *The Living Dead Girl*, *The Grapes of Death* and *Rape of the Vampire*.

It wasn't until Channel 4 screened their 'Eurotika' season in 1999 that I finally saw my first Rollin film, *Le Frisson des Vampires* (*The Shiver of the Vampires*). The film left me spellbound and begging for more. It was utterly different to anything I had seen — its striking visuals, deliberate pacing and morbid romanticism were a million miles away from contemporary horror and Hollywood films. It was oddly calm and resplendent with atmosphere. Each frame was as composed as a painting and alive with vivid colour. Being interested in low-budget filmmaking and scriptwriting, I found the film to be a great inspiration.

I quickly sought out more Jean Rollin titles.

Next was the purchase of an uncut VHS release of *La Morte Vivante* (*The Living Dead Girl*), imported from Holland. Again, I was mesmerized, not only by its visual elegance, but also by the pow-

erful emotional tone and the sense of nostalgia that supported its simple narrative. The final scene depicting Françoise Blanchard devouring her childhood companion in a welter of gore remains, I believe, one of the most moving and shocking moments in horror cinema — a simultaneous crescendo of violence and melancholy beauty. Rollin's best work is like this, imbued with distinct and symbolic trademarks, revelling in sex, nudity, blood, vampires, gothic atmosphere, and seductive, dangerous women. Beneath the surface lies an intricate web of interconnected narratives.

Alas, not everyone feels the same way. To say that Rollin's movies are an acquired taste and divide audiences is an understatement.

Rollin's films were never the easiest to track down, especially uncensored and in their original language. Until recently, it took much time and effort. And only recently have they gained any sort of critical acceptance. UK-based Redemption made great inroads in this respect when they picked up distribution rights to Rollin's films in the mid-nineties. Even so, coverage of the films was relegated to fanzines and cult cinema books. A small number of writers and publications spring to mind as English-language champions of Rollin, including the excellent *Immoral Tales* by Cathal Tohill and Pete Tombs, *Necronomicon* fanzine, some excellent essays by Tim Lucas and favourable comments in Nathanial Thompson's *DVD Delirium*.

It's different in Rollin's native France. But only inasmuch as his work, if not ignored altogether, is frowned upon. Ever since the scandal caused by the theatrical release of his deliberately bizarre 1968 feature debut, *Le Viol du Vampire*, Rollin has been regarded as an outsider in French cinema. His films were critically despised upon their initial theatrical releases and often flopped commercially. His association with hardcore pornography helped to cement his outlaw status in the French film business.

In telling his tales, Rollin drew on specific themes. Childhood, obsolescence, the living dead, blood, and man's destruction in the face of technology are some of the recurrent motifs throughout his entire body of work. These are films populated with deserted beaches and crumbling castles, sex, doomed romance, pulp horror imagery and, of course, seductive female vampires drinking eagerly from sweet throats. Indeed, the latter play a heavy role in Rollin. It is impossible

FASCINATION

Jeunes Filles Impudiques is one film that Rollin made under a pseudonym. He also appears uncredited as an actor. Here he is in a scene on the floor.

to think of a Rollin movie without conjuring images of beautifully photogenic female vampires in revealing attire, and a sense of the *fantastique*.

Rollin's films are gentle in pace. They are obsessive and deeply self-referential — making them all the more personal. Rollin relished the creative process and his films enabled him to explore his personal obsessions and push his imagination to the limit. He revisited his key themes and images over and over, giving them greater resonance and new meaning as they matured with each film. As an artist, he lived through his work and constantly breathed new life into it, rather than simply recycling and pillaging.

In the past, some critics have confused Rollin's work with that of infamous Spanish filmmaker Jess Franco. Both were rebels and auteurs in their own right, working in the 'Eurotrash' market at the same time. They both made deeply personal, obsessive films, and also worked as directors for hire in order to fund their own projects. They both had a propensity towards erotic horror and vampires in particular. Their films were always low-budget, frequently re-cut, dubbed and universally despised by film critics. They both also worked in hardcore porn. Their paths even crossed on two occasions. *Le Lac des Morts Vivants* (*Zombie Lake*) is a film that Franco was supposed to direct, but, failing to turn up for the shoot, Rollin took over. On the second instance, Rollin shot some random footage that would later find its way into Franco's re-edited version of *A Virgin Among the Living Dead*.

The Celluloid Dreams of Jean Rollin 3

Despite these crossovers, the work of the two filmmakers couldn't be more different. Franco is more honestly exploitative and his films have a very different edge to them. (I do not mean this in a negative way; I am a fan of Franco's work.) Often set in jungle jails or tropical environments, Franco's movies have a less elegant, sweaty, dangerous appeal. He has a distinct propensity for naked female flesh and zoom lenses, with a camera that so persistently seeks out mounds of pubic hair that it borders on the psychopathic. By comparison, Rollin's films are gentle, romantic and playful. They often embody an innocent fairytale ambience. They do not aim to directly shock the viewer, but immerse them in another world — a world of the *fantastique*.

Rollin's low-budget films were created with a free form jazz sensibility, which is to say they are largely improvised. With very little he created a great deal, using whatever was available to its fullest, whether locations, actors or equipment. The improvisational approach to shooting is rarely seen in today's commercially saturated film business were nothing is left to chance.

There are a number of reasons why Rollin's cinematic output reached only a small audience in its day. His films were originally shot in French. To the English-speaking world, the market for foreign language films was relegated to serious film buffs and cult movie fanatics. The unavailability of alternate dubs made it harder to distribute the films overseas in the early days of video. English speaking versions that did find video release were often re-cut, censored, and so poorly dubbed they appeared cheap and silly.

Another reason for their limited audience stems from the fact that Rollin's films are bizarre and shy away from genre traps. They cannot be simply categorized as erotic films or horror films, although that is what they sometimes appear to be. When compared with the Hammer vampire films of the seventies, for example, they stand a world apart. Rollin doesn't go for shocks and jumps, but instead explores melancholy and poetic tragedy, with phantasmagorical imagery and dreamlike overtones. Rollin never compromised his personal visions to fit genre demands; he told the stories he wanted to tell and made the movies he wanted to make.

Ironically, Rollin's most prolific output came at a time when French cinema was in turmoil with the legalization of hardcore

CineMuerte Horror Film Festival, Vancouver (2000).
L-R: Simone Rollin, Lionel Wallmann, Jean Rollin.

pornography. Rollin was a key contributor to the hardcore sex film industry in this era. Mainstream critics were quick to dismiss him, as they did anyone who dared to dabble in XXX material.

Ignoring his adult work, critics referred to Rollin's output as *Rollinades*: 'cheap films, full of clichés of horror cinema and sprinkled with amateur eroticism... elegantly made popular cinema, art for the masses'[*]. In some ways, the comment is accurate but the derogatory stance is unfair. Ultimately, such criticism condemns Rollin for creating unique films. Despite the implication of the quotation above, the majority of Rollin's films were never popular or well received by the masses; his films were rarely seen at all.

When I first started researching this book, I was surprised at how hard Jean Rollin's films were to obtain, even in Paris. The most common response from VHS and DVD vendors was 'Jean who?' It was only in small independent and cult cinema stores that I actually

[*] Jean Marie Sabatier, cited in Cathal Tohill and Pete Tombs, *Immoral Tales*, 151.

found any of his films.

But it is not only the films that have been overlooked; Rollin dabbled in a variety of artistic mediums, including comic books and novels. His recent novels have probably received far wider distribution and greater appreciation in France than his film work of four decades. (At the time of writing, only one of his books has been translated into English.)

Consciously or otherwise, contemporary culture, pulp literature and political issues all worked their way into the fabric of Rollin's films. Although Rollin's films explore horror scenarios and themes, he treats the subject matter in an abstract manner, and his films do not sit comfortably with the label 'horror' (*Les Raisins de la Mort* and *La Morte Vivante* aside). Beauty lies at the core of all his personal work and is emphasized through the sumptuous photography, striking performers, picturesque locations and warm music. Even the nightmarish imagery of *La Morte Vivante*, which depicts a walking corpse, cannibalism, torture and graphic murder, is dreamlike and ethereal.

Unfortunately, Rollin's films were marketed as horror or sex films. Given that they don't wholeheartedly fit either category, it is easy to see why they failed commercially. The films may have emanated from the 'Eurotrash' era of the late sixties and seventies but that doesn't mean they are trash. Although they certainly adhere to certain key elements of exploitation cinema, they do not belong in the same school as, say, Sergio Garrone's *S.S. Experiment Camp* (1976), Umberto Lenzi's *Nightmare City* (1980) or Jean Brismée's *La Plus Longue Nuit du Diable* (*The Devil's Nightmare*) (1971).

After years in a commercial and critical wilderness, Rollin's films are making a return to our screens via DVD and the luxurious Blu-ray format, receiving the acclaim and attention they so rightfully deserve. Indeed, after decades of filmmaking and writing, and swathes of negative criticism, Jean Rollin received the Life Time Achievement Award at the Montreal Fantasia Film Festival on July 15, 2007. Cult Collectibles even released an official Jean Rollin 'Weird Wobbler' bobblehead figure (limited to 250 units) that included a filmstrip from *Les Raisins de la Mort*. A feature length documentary about his life and work entitled, *Jean Rollin: The Stray*

Dreamer, was completed in 2011 and is now available on DVD courtesy of French distributors The Ecstasy Of Films.

His work has also been emulated on the big screen. *Kiss of the Damned* (2012), directed by Xan Cassavetes (John Cassavetes' daughter), depicts a secret society of vampires, with explicit lesbian sex and a heavy dose of doomed romanticism. It's a warm homage to Rollin's vampire films.

Fascination: The Celluloid Dreams of Jean Rollin serves as a primer and celebrative exploration of Rollin's work, predominantly in film but also literature. Rollin's films may be difficult to categorize into distinct genres, but they can be split into two categories. Firstly, his personal, poetic films for which he is now celebrated in cult film circles. Secondly, his work as a director for hire, making movies under a pseudonym for other people and shooting solely for a pay check. Rollin had little control over his pseudonymous productions, and so it is unfair to group films the like of *Le Lac des Morts Vivants* and *Ne Prends Pas les Poulets pour des Pigeons*, his work for hire, with personal films like *Requiem pour un Vampire* or *Lèvres de Sang*. It is often his impersonal, pseudonymous films that critics reference when attempting to discredit Rollin and his abilities as a filmmaker. This book makes a clear distinction between the two, examining

Jean Rollin, en route to the château.

Rollin's personal and impersonal productions separately and in appropriate context.

Having been commissioned to write this book, I found myself in possession of Jean Rollin's home telephone number sometime in 2005. It was a time when I was trying to get my own no-budget film productions off the ground, and so I was delighted at the opportunity to speak with a man whose films I not only admired, but who was also a director who specialized in independent, low-budget filmmaking. Rollin answered the phone in English, a blessing for me due to my shortcomings in the French language. I explained the idea of the book, to which he was supportive and agreed for an interview to take place at his home in Paris.

Several weeks later, I was lost within the concrete atrocity that is Charles De Gaulle airport, trying to find my way to my hotel in the city centre. The subsequent meeting and discussion with Rollin more than made up for it, however. He was a kind, gracious host. His

FASCINATION

apartment was decorated with huge posters from *Lèvres de Sang* and *Le Viol du Vampire*. Books and films adorned almost every wall and were stacked in piles on the floor. Jean Rollin was one of the kindest and most generous artists I'd had the pleasure of meeting. Despite his serious health issues, he was extremely accommodating and possessed a genuine sense of humour, as he recollected his adventures in film and literature. It was a wonderful experience to be able to discuss the films I love with their creator and his recollections were vital in completing this book. Rollin's producer Lionel Wallmann was also a great help and resourceful when it came to tracking down some of Rollin's more obscure films.

Fascination was completed in two separate periods. The initial draft was finished in 2006 but I was unable to finalize the book until 2014. During that time, Rollin released two more feature films which are now included in the review section. On December 15, 2010, three months after the completion of his final film, *Le Masque de la Méduse*, Jean Rollin passed away. His body rests in his beloved Paris at the Père Lachaise Cemetery — where Rollin had recently shot scenes for his last picture.

Rollin is a true auteur. His films inhabit their own unique genre, one in which the filmmaker explores his personal obsessions, dreams and ideas. Each film takes us on a journey into this *Rollin*-world where nothing is quite as it seems, and all roads lead us back from whence we came ... 'back to the *château*'. The only guarantee in a Rollin film is that the open-minded viewer will be taken on an evocative journey. He will continue to live on through his films and stories as new generations of cult film fans rediscover his work. After decades in the shadows Rollin has carved himself a unique identity in cinema.

Orchestrator of Storms

JEAN MICHEL ROLLIN LE GENTIL was born on November 3, 1938 in Paris, France. His parents were separated and Rollin lived with his mother. His father was a theatre actor and director, who worked on Baudelaire classics and avant-garde productions. Rollin would frequently attend his father's performances. Although the content of the plays had little or no direct influence on Rollin's work, the world of storytelling and artistic expression did have an impact.

From an early age, cinema made a great impression upon him. At the tender age of five, he was fascinated by the French film, *Capitaine Fracasse* (1942), directed by Abel Gance. The storm sequence in particular captivated Rollin, and it was from this point that he knew he wanted to be an 'orchestrator of storms ... [and] ... a creator of images'.[*]

Rollin would obsessively visit the Cineaque, a motion picture theatre within a railway station. It was primarily built for passengers to kill time waiting between train connections. Here Rollin watched American serials, returning week after week to catch the latest instalment. The spirit and style of these serials remained present throughout his career, most obviously in *Les Trottoirs de Bangkok* (*The Sidewalks of Bangkok*) and *Les Échappées* (*The Escapees*). He also emulated their fragmented structure in his two-part melodrama *Le Viol du Vampire* and in his five-part serial novel *Les Deux Orphelines Vampires*. The other films he saw at the cinema during this period — such as *The Mysterious Dr Satan* (1940), popular American serials and the work of Cecil B. DeMille — heavily influenced his early forays into scriptwriting.

The unique, chaotic atmosphere of the Cineaque is never likely to recur in Western civilization. Rather than the films changing on the screen, the audience continuously changed. People rarely sat through an entire screening. They would constantly be entering and leaving. The announcements of arriving and departing trains blared within the cinema itself, and when the trains passed, the building would shake and the deafening roar of the locomotives would fill the air. This particular time and location became one of Rollin's greatest personal souvenirs of cinema and its ambience has

[*] Tohill and Tombs, 136.

worked its way, subconsciously, into the fabric of his films.

So, too, the train station as a recurrent image. It appears in Rollin's *La Rose de Fer*, *Lèvres de Sang*, *Les Raisins de la Mort* and *Les Deux Orphelines Vampires*. While the Cineaque was a constant arena of movement and noise, in his films, the train yards are always deserted and quiet. The subdued and distant railway sounds and stationary steam engines featured at the beginning of *La Rose de Fer* are a perfect example. Rollin creates a dreamlike ambience here, the images of the train yard and its huge locomotives being without the noisy atmosphere one would normally find at such a location. The train station is clearly a nostalgic reference point for Rollin. It seems to represent a passing of time on a personal level for the director: the images are iconic and clear but certain memories within them fade in time, just like the soundtrack.

At sixteen, Rollin began working for Le Films de Saturne, a company that specialized in the creation of opening and closing titles for animated shorts. Rollin offered a helping hand, which included general admin, such as invoicing. Le Films de Saturne also dabbled in short films and documentaries and offered Rollin his first filming experience. He assisted the cameraman and other crewmembers who were shooting footage for an industrial documentary in a factory that constructed aeroplane motors.

Rollin later joined the French army. During his service, he furthered his film career, becoming an editor, and mostly working on commercials. He assisted on the military productions *Mechanographie* and *La Guerre de Silence* (*The War of Silence*).

In 1958, Jean Rollin made his first short film, *Les Amours Jaunes* (*The Yellow Lovers*), inspired by the French poet and writer Tristan Corbière. Rollin borrowed an old 35mm Maurigraphe film camera and shot the film over the course of a single weekend at the beach of Dieppe. This location would become one of the most important and iconic locales of his films. It's also referenced in his books, particularly in *Une Petite Fille Magique*.

Rollin had first visited the beach at Dieppe as a child when holidaying with his mother. Its lonely shoreline and white chalk cliffs possessed a beautiful, powerful ambience that deeply touched Rollin. (The beach has since been smothered in shingle and black rock because the gleaming white surface was regarded as a shipping hazard.) Every chance he got, Rollin filmed at Dieppe. There is

The beach at Dieppe as it appears in *Le Viol du Vampire* (top) and *La Rose de Fer*.

something magical about this location. When captured on film, the beach is simultaneously beautiful, endless and poignant, reflecting the most pervasive moods and emotions of Rollin's personal films.

Rollin created several more short films and began a feature, *L'Itinéraire Marin* (1960). Only one-hour of footage was shot and, unfortunately, because of financing issues, the film was never completed. The era of *La Nouvelle Vague*, the French New Wave, was at its peak, with young filmmakers bringing edgy realism to their

FASCINATION

work. But Rollin chose to remain on his own path and explore the *fantastique*. Despite appreciating the style and visions of his French counterparts, Rollin still maintained his passion for traditional French cinema and the American serials.

Rollin sought film-related work wherever he could, and worked as an assistant director for Jean-Marc Thibault on the 1962 film *Un Cheval pour Deux* (*A Horse for Two*), starring Roger Pierre.

In 1965, he founded his own production company, Les Films ABC, which operated until his death. In 1967, he finally completed his first feature film, the delirious *Le Viol du Vampire* (*The Rape of the Vampire*). Rollin was extremely lucky in regards to financing, as he found an open-minded producer who would later become a close friend and something of a father figure. This man was Sam Selsky, an 'American Parisian', formally a geologist and mining engineer, who ventured into film when he purchased a chain of art cinemas. Selsky's love for film grew and he began importing American productions to show in cinemas and on French television. After several years in the business, Selsky had attained a healthy span of contacts and was introduced to Rollin by a friend. Rollin had a script titled 'Le Dernier Vampire' (The Last Vampire) that had commercial potential and greatly impressed Selsky.

Little needs to be said about the potential nightmare a demanding producer might have on a filmmaker's vision. Commercial marketability and budgetary constraints often destroy the original intentions of the filmmaker, whose work becomes an uneven mix of different elements to please different people. Rollin was fortunate in that he benefited from a wonderful working relationship with Selsky that lasted several decades. Without him, Rollin may not have made a feature film.

Selsky was a very trusting producer. It was only at the script stage that Rollin ever locked horns with him, fighting line by line to preserve his vision. They would quickly compromise, often with the inclusion of additional naked flesh, for Selsky's target audience, which Rollin would then present in an unsettling, eerie manner. With Rollin, a naked woman in a cemetery at night became something other than titillation ... it was creepy and foreboding. But the freedom granted to Rollin by Selsky had both both positive and negative sides: Rollin had the chance to make the kind of films he wanted, and he could maintain his artistic integrity. He did not have to

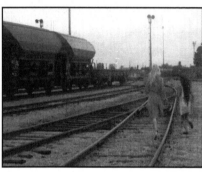

The train yard in *Les Deux Orphelines Vampires* (top left), *La Nuit Des Traquées* (top right) and *Les Trottoirs de Bangkok*.

fully adhere to popular trends. However, his films were often marketed as something they were not and many viewers felt cheated.

With *Le Viol du Vampire,* Rollin intended to create a film that was commercially appealing, and because of this, the film can be viewed on two levels. It can be seen as a commercial failure: surreal and bizarre, it was hated by mainstream audiences and did not achieve the commercial success its creators wanted. On the other hand, and more positively, Rollin created a unique, original work that defied contemporary cinematic convention on almost every level.

His second feature film, again produced by Sam Selsky, was *La Vampire Nue*. Rollin once more attempted to capture the commercial market with a more linear narrative. Although far from a 'commercial' vampire film, it was successful enough to receive overseas distribution. It played UK cinemas as *The Nude Vampire* in a dubbed, censored form.

In the early seventies, Rollin began working with another producer, Lionel Wallmann, whom he had met through Selsky. Wallmann was not familiar with Rollin's work but had a keen desire to enter the film business. Wallmann co-produced Rollin's classic *Req-*

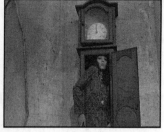

Surrealism. *Le Vampire Nue* (top left), *Le Frisson des Vampires* (top right) and *Les Pays Loins*.

uiem pour un Vampire, and thereafter worked with Rollin throughout the rest of his career.

Rollin always intended to make personal films, but also films that would be commercially successful despite their petite budgets. In most cases, his films were not successful. Sometimes a distribution deal fell through at the last minute (*Fascination*), compounded with the ubiquitous time and budget constraints, health issues and of course Rollin's scandalous reputation that stemmed from the critically despised *Le Viol du Vampire*.

On their initial release, the films that received theatrical distribution were only screened in three or four cinemas for a limited time, and then only in Paris. The French film industry was incredibly tough concerning financing, particularly during the seventies and eighties. Even filmmakers with good reputations found themselves facing the same obstacles with would-be investors. For his personal productions — i.e. the movies he wanted to make as opposed to those he didn't — Rollin always contributed a portion of his own money to help realize the project, investing whatever he

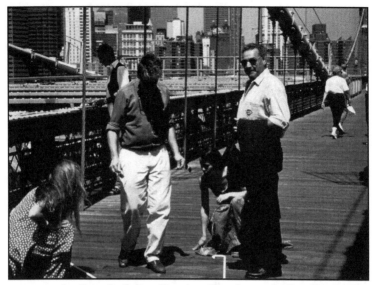

Les Deux Orphelines Vampires. Shooting on the Brooklyn Bridge.
L-R: Isabelle Teboul, Jean-Noel Dellamare, Alexandra Pic, Lionel Wallmann.

could afford at the time. More often than not, he failed to recoup what he had spent (*La Rose de Fer* was a particularly large loss), but by putting his own money into the film, he always had as much power as the producers and investors. By funding and owning a part of the film, Rollin had the right to say 'no' and keep control of the film throughout production and postproduction.

Rollin's films are a strange mixture of genre elements and comprise of three key influences. Firstly, art, such as the Dadaists and the surrealists, particularly the work of Luis Buñuel. Secondly, the nostalgic influences from Rollin's childhood such as places, events, and the aforementioned American serials. Thirdly, commercial and contemporary influences at the behest of financers. In many ways, Rollin was an outsider to French cinema, but at the same time his work was heavily influenced and referential to a variety of French culture. His passion for cinema and literature, such as the films of Abel Gance and Georges Franju, and the writings of Tristan Corbière and Gaston Leroux had an important effect. Spanish surrealists Luis Buñuel and Salvador Dalì were also important influences, being at the height of their controversy and notoriety. Echoes of these artists

FASCINATION

can be read in the mood and imagery of his work.

The mystery structures of *La Vampire Nue* and *Lèvres de Sang* are reminiscent of the works of Gaston Leroux, in particular the literary masterpiece *Phantom of the Opera*. Every sequence reveals a new piece of information that draws the viewer deeper into the mystery, answering old questions while also creating new ones. Leroux's focus on the opera house, beach and graveyard in *Phantom of the Opera* exerted a strong attraction for Rollin, and aesthetic similarities can be found in his films. Rollin was so impressed by the author's work he wrote a critically appraised essay of the author.[*] He referenced Leroux's book several times in *La Fiancée de Dracula*, while also incorporating dialogue from *Phantom of the Opera* in both *Le Viol du Vampire* and *La Fiancée de Dracula*. For years, it was a dream of Rollin's to bring Leroux's *La Reine du Sabbat* to life as a feature film, but due to the extremely high financial costs, the project remained untouched.

In terms of surrealism and Rollin's work, the director's artistic roots were with the surrealists. His mother, Rollin said, 'was very close to the surrealists at times ... to Breton, Prévert and a lot of people who where part of that world.'[†] As a young man, he looked up to artistic individuals, such as Buñuel, Dalì and Franju, as teachers of a sort. He almost had the opportunity of working with Franju as an assistant at one point, so too Buñuel, but neither dream materialized. Rollin was particularly enamoured of Buñuel, the man responsible for the deranged *Un Chien Andalou* and the groundbreaking *Belle de Jour*, films that provoked a similar scandal and public outrage to that of Rollin's own *Le Viol du Vampire*. 'I was a great admirer of [Buñuel]," he recalled. "I was almost his assistant in a film that unfortunately never got made ... he told me 'you'll be my second assistant on this project'...[‡]

Buñuel's influence can be seen in Rollin's more overtly surreal moments, in which he manipulates time and reality, and also in the use of bizarre imagery, for which he offers no rational explanation. In Rollin's early short film *Les Pays Loins,* the viewer is plunged into a world of crumbling stone and rain-drenched city streets as the lead protagonist attempts to locate 'the city centre', or more sym-

* See: 'The Literary *Fantastique.*'
† Jean Rollin, interview by Lucas Balbo, *Two Orphan Vampires* DVD.
‡ Ibid.

Requiem for a Vampire (top) and *Fascination.*

bolically, another world. The slick black and white photography flows to a combination of subdued jazz and piano. Characters appear and disappear without warning. Time and reality are manipulated, day and night confused. The film is driven by its composition and the rhythm of its editing.

Rollin's films are layered with symbolism and metaphors. Like the work of the surrealists, they can be interpreted on several levels, depending on the individual viewer. However, Rollin insisted his images were simply ideas that he found interesting or expressive of

FASCINATION

a certain emotion, such as the recurrent images of clowns or unusual inclusion of naked women in peculiar places. Nonetheless, these images are still potent and emotive, manifesting their own meanings if Rollin does not consciously do so himself.

Location was a vital influence on Rollin, no less because of his highly improvised approach to shooting. Landscapes and places dictated how scenes and shots would be constructed and choreographed. The beach at Dieppe, deserted railway stations, gothic castles, cemeteries and crypts all resonate with melancholy and eerie ambience. His films play like an evocative photo album, a collection of memories and emotions that gain further power with age.

Rollin's films evolved over time, and chronologically and aesthetically can be divided into two broad groups: vampires and expressionism. In his initial quartet of vampire films, *Le Viol du Vampire*, *La Vampire Nue*, *Le Frisson des Vampires* and *Requiem pour un Vampire*, we see Rollin honing his style and obsessive themes, attempting to fuse commercial and artistic elements in order to create financially successful films while maintaining his distinctive personality and sensibilities.

The influences of the contemporary commercial market on his filmography are easy to identify, despite his distinct, personal output. His early vampire films were produced and distributed at a time when Hammer Films were big business in French theatres, as indeed many other countries. These early Rollin films between 1967 and 1973 were marketed to crowds fed on Christopher Lee and Peter Cushing movies, and in particular gothic tales of the undead roaming the countryside and terrorising buxom heroines.

The popularity of Hammer's output created an obvious trend in the market for profit-seeking distributors to capitalize upon. However, Rollin's films are very different to the British gothic horror films of the time, and any other horror films since. To disguise this fact, distributors often re-titled Rollin's work and ensured cinema trailers reflected elements that were commercially marketable: breasts, blood and vampires, as opposed to poignant, dreamy atmosphere. Alternative marketing titles were misleading. Viewers expecting the standard exploitation fare suggested by such grindhouse titles were confused and disappointed by Rollin's *fantastique* sensibility and poetic delivery. This is none more evident than with

Le Viol du Vampire, whose initial audience attacked its creator and smashed up the cinema.

Rollin's next period of work was distinctly different, being more expressionist and deeply personal with signature films like *Les Démoniaques*, *La Rose de Fer* and *Lèvres de Sang*. This second wave almost financially ruined Rollin and his investors, but the work was pure, honest to the director's intentions and strikingly unique. *Les Démoniaques* was Rollin's love letter to the swashbuckling films he saw as a child, albeit with a decidedly perverse approach. *La Rose de Fer* and *Lèvres de Sang* were mournful, poetic ruminations on death, destiny and identity. All three films were too strange and sombre to compete with contemporary horror cinema at the time and were misunderstood.

By the late sixties, the graphic depiction of sex and nudity had become more significant in cinema, particularly in Europe with explicit Swedish productions such as *I Am Curious (A Yellow Film)* (1967). Hardcore sex films broke through to the mainstream in America in 1972 with Gerard Damiano's *Deep Throat*. During this time, filmmakers had the chance to explore and push boundaries even further. French film censorship was abolished in 1974 and the floodgates opened for the production, distribution and presentation of hardcore sex on cinema screens. After the commercial failure of *Lèvres de Sang* Rollin immersed himself in the production of hardcore pornography.

He was one of the first French filmmakers to experiment with the new genre. He attempted to do something interesting, with *Phantasmes* (1975), a hardcore sex film with a story and gothic design. The film was a commercial flop; it became clear that the audience for this new sexual liberal onscreen was only interested in sex — the story was not important.

Out and out sex films were relegated to the gutter, no small thanks to the fact they were screened in cinemas separate to those of regular movies. Thus a void that was literal as well as critical between respectable/acceptable filmmaking and pornography.

Throughout his hardcore sex period Rollin intermittently returned to his personal films, albeit with a slightly more commercial approach. Between 1978 and 1982, Rollin gave us the genuinely frightening *Les Raisins de la Mort*, the languid and iconic *Fascina-*

tion, the haunting *La Nuit des Traquées*, and the powerful melancholic gore film *La Morte Vivante*.

Zombie cinema was in vogue at the time. George A. Romero's *Dawn of the Dead* (1978) and Lucio Fulci's *Zombie* (1979) headed up a roster of films that were shocking audiences around the world. Rollin's contribution to zombie cinema, *Les Raisins de la Mort* and *La Morte Vivante*, remain his most commercially successful personal productions and are driven by narrative more coherent than his earlier offerings. These films are comparatively more conventional than his earlier works, but they retain Rollin's visual and thematic trademarks.

After the massive popularity of *The Howling* (1981), Rollin proposed an idea to direct a French werewolf movie starring Brigitte Lahaie, called *Beastiality*. The project was briefly announced in the mid-eighties but never came to fruition. Rollin later used the title for one of his novels.

His film productions slowed considerably with his increasing ill health in the eighties and titles like *Les Trottoirs de Bangkok*, *Perdues dans New York* and *Killing Car* were much cheaper, grittier affairs. The graveyards and crypts were replaced by rain-slicked streets and bleaker visual compositions. As the eighties wore on, Rollin's budgets decreased. *Killing Car* was shot in 1989 but postproduction wasn't completed until 1993, due to the director's health complications. The films from this period received minimal distribution, even by Rollin's measure. In order to obtain copies, fans of the director had to scour, not theatres or video stores, but the video underground.

Rollin's final cycle of films, *Les Deux Orphelines Vampires*, *La Fiancée de Dracula*, *La Nuit des Horloges* and *Le Masque de la Méduse*, were highly self-referential nostalgia pieces that beautifully encompass his achievements since his debut in 1967. These poignant latter films are overwhelmingly reminiscent and celebrative of the director's previous personal work, which is directly referenced throughout.

Each period for Rollin shows a progression in style and illustrates a slightly different approach. Even the more commercial efforts are still deeply personal and if anything, even more emotionally evoca-

tive and beautiful.

Rollin's films were intended to appeal to both horror and sex film audiences; they blended nudity and eroticism with gothic horror, vampires and other creatures of the night. More often than not, this combination didn't reap huge profits for his investors. Audiences who came to see naked flesh didn't care for the vampire and horror elements, and vice-versa. But the films have their own look and feel. They are undeniably *his*. They are distinctly European but stand apart and alone from other genre films of this golden age in Europe.

Personal Visions

FOLLOWING THE HORRORS of World War II, the 1950s witnessed a slew of monster and nuclear themed films, which proved popular throughout Europe, the United States and Asia. These films exploited man's fear of apocalypse, scientific experimentation and malefic alien invaders.

This focus shifted in the sixties and seventies, making way for gothic genre films preoccupied with the past, which often explored disturbed human psychology. Roger Corman's films for AIP, and Britain's Hammer and Amicus studios gave the world visions of crumbling castles with distressed buxom young women tormented by madmen or vampires.

Alien invaders were no longer the symbol of fear. Films such as *Psycho* (1960), *Peeping Tom* (1960) and *Blood Feast* (1963) explored the extremities of horror, pushing the boundaries of what was acceptable on the cinema screen. As the sixties drew to a close the love generation was dying and the Vietnam War raged. More cynical and nihilistic forms of horror cinema began to emerge, such as George A. Romero's seminal *Night of the Living Dead* (1968). 'Roughies' were a particularly popular subgenre of exploitation cinema at this time and dealt explicitly with themes of rape, murder and sadomasochism.

Sex and nudity opened up in cinema, be it grindhouse exploitation, mainstream, or avant-garde works. The period from the late sixties to 1980 was a veritable golden era of film production, a pe-

Requiem pour un Vampire, sold in the US as *Caged Virgins*.

riod where directors had the freedom to explore new and previously forbidden territory. It was a journey of groundbreaking, taboo-busting and experimental filmmaking. In America for a spell, film directors found they yielded considerable power within the studio system. Cinema was changing in Europe and the USA.

Rollin emerged during this era of new cinema. His first feature, *Le Viol du Vampire*, defied audience expectations and pushed the boundaries of what was visually acceptable on French cinema screens. Although originally hoping for a commercial release, Rollin daringly disregarded the traditional three-act structure — a clear beginning that establishes a dilemma, a middle that struggles with said dilemma, and an end in which the dilemma is overcome. His unconventional narrative remains challenging even now.

In France, Rollin's films were classified as Series-B movies. This category included fantasy films, police thrillers, westerns, softcore erotica, vampire films and terror films (they were not referred to as horror films in the sixties). There were several Series-B cinemas in Paris, the most famous being the Midi-Minuit. Rollin's *fantastique* films didn't fit a particular genre. Other than being distinctly European, his films bore little direct resemblance to other movies of the period. Series-B status ensured that Rollin's films were critically unappreciated and dismissed on their release. The multitude of al-

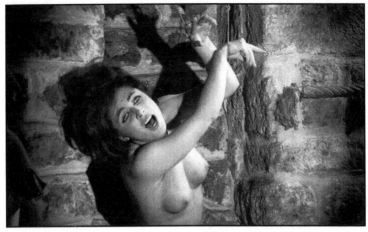

Part of the new era, *Le Viol du Vampire*.

ternate cuts and titles didn't help on a critical level, either. *Requiem pour un Vampire* was released as *Sex Vampires*, *Caged Virgins* and *The Crazed Vampire*.

Rollin may very well have used elements and imagery associated with the horror genre but his treatment of potentially horrific or frightening subject matter refused to conform to traditional or contemporary horror cinema. Aside from the genuinely frightening *Les Raisins de la Mort*, the viewer who approached Rollin's films as horror would likely be confused and disappointed. Rollin explained, 'I don't think I put horrible things [in my films], there are exceptions, such as *Grapes of Death*. I don't like horrible scenes. If I do some horrible scene it's with a background of poetry or something else.'[*]

Paradoxically, the films are more concerned with beauty than flesh and blood on a base level. To borrow a line from *Fascination*, 'death sometimes takes the form of seduction'. The eroticism and the horror are deeply entwined and balanced, even in the grainy, gritty *Killing Car* and *Les Trottoirs de Bangkok*.

At first his films appear simplistic. For instance, the plot for *La Rose de Fer* can be described in one sentence: A young couple spend a night in a deserted cemetery and become increasingly panicked. There are traditional elements of horror, most notably the eerie graveyard, the growing paranoia and anticipation of violence, which

* Jean Rollin, interview with the author. See appendix.

FASCINATION

On the surface, a night in the cemetery. *La Rose der Fer*.

is where genre similarities end. Beneath the surface, however, is a
journey that only exists through symbolism and visual design. But
even here, true 'meaning' for the film remains elusive.

The vampire film has always exploited the marriage of eroticism
and horror. In Britain, Hammer and Amicus films pushed the sexu-
al angle as far as they dared for their day. Spanish filmmakers Jess
Franco and José Larraz (*Vampyres,* 1974) pushed the erotic angle
in the vampire genre towards something altogether more sexually
explicit. Rollin, too.

Hereafter, from the seventies onwards, overt depictions of sex
and violence become inextricably bound to the horror film. Often a
taboo combination, sex and horror is used to unsettle, shock and/
or arouse the viewer. Films such as Tinto Brass' *Caligula* and Aris-
tide Massaccesi delirious productions, *Erotic Nights of the Living
Dead* (1980), *Emmanuelle and the Last Cannibals* (1977), *Porno
Holocaust* (1981), are good examples of this trend of filmmaking.
But whereas these films crowbar nudity, explicit sex and copious
amounts of gore into the mix, Rollin blended erotic and *fantastique*
elements to a complementary effect, not for simple shock value.

A wonderful example of Rollin's approach to horror can be seen
in *Fascination*. The film becomes progressively more unsettling as
the two seductive women at the heart of the film manipulate the
male protagonist. The events become more peculiar and the atmos-

phere more ominous through to the fifty-minute mark, at which point we are presented with a standout sequence. It takes place over the château's moat. The beautiful Brigitte Lahaie, wielding a huge scythe, traps an isolated female character. The soundtrack rumbles with low thunder and rising winds as Lahaie, cloaked in black, approaches her prey, climaxing in a sudden outburst of bloody violence. The sequence has considerable power and amply demonstrates Rollin's grasp of beauty and its relationship to horror.

In *Les Raisins de la Mort,* a mentally unstable Lahaie approaches a catatonic female victim. The camera presents her in close up as she moves towards her intended victim — her features lit by flickering flames; she slowly opens her mouth to reveal her teeth. This brief but highly sinister sequence is repeated in *Fascination*: the blade of Lahaie's scythe fills the top half of the screen and Lahaie's mouth the bottom, revealing white teeth through bloodstained lips. Images of beauty are suddenly penetrated by predatory fear and threat.

Rollin liked his violence theatrical and false-looking. For him it was poetry, expressive, a thing of beauty, not brutality. The final haunting sequence of *La Morte Vivante* is a perfect example, in which Catherine tears into the flesh of her childhood friend, with nothing but her bare hands and teeth, to feast upon her blood. Despite extreme gore and mutilation, the scene has a deep melancholia about it. It's effectiveness as a scene is in the emotion Rollin packs into it, not the ultraviolence.

To begin with, Rollin's use of sex and violence was dictated somewhat by his financiers. He recalled, of his first film, 'I was forced to add eroticism. The producers did not accept the genre of film I wanted to do, which was not a typical French genre. They would tell me the public would only watch English or American films. But if I could pass it off as a sexy film it could be distributed in theatres.'*

Rollin began incorporating sex and nudity into his films, but in his own stylistic way. "When I shot in a graveyard at night [and] I put a girl lying naked on a grave, the image became bizarre. There is something brought by the naked body which is not the same if she was dressed. Nudity had great importance for me ... a girl naked somewhere which is not in a bed, she is in a strange place. It's be-

* Ibid.

FASCINATION

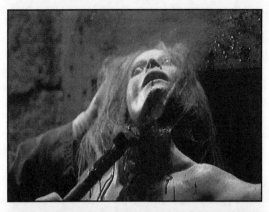

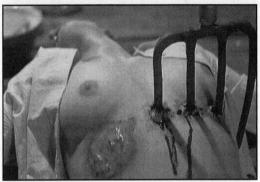

Theatrical violence, *Les Raisins de la Mort*.

come like a painting ... kind of collage."[*]

Rollin was partially influenced by the artist Paul Delvaux who specialized in surreal railway paintings that featured naked women in strange scenarios, sometimes featured in between two locomotives, or on the tracks themselves. Rollin incorporated the sexual theme but adding his own twist. In accomodating the demands of his backers, he turned what could have been a potential burden and distraction into something that, to him, was interesting. Rollin's surreal approach to nudity is one of the most recognized and celebrated elements of his work.

Location is a vital element to Rollin's films. His narratives unfold

* Jean Rollin, interview with the author. See appendix.

against beautiful, picturesque backdrops. Every frame is rich with detail and colour, presenting the viewer with images of lush countryside and elegant, archaic architecture. These scenic locales, coupled with an attractive cast make for a sublime concoction. Michael Reeves' *Witchfinder General* (1967) similarly explores the relationship between the beauty of landscapes and the horrific violence perpetrated within them.

All of Rollin's films end with tragedy. His characters are often naïve and ill-fated, driven by the past. They also journey often through obsolete buildings and train yards, places that in themselves carrying an aura of sadness and doom, having met their demise and existing now like tombstones. The representation of the gothic has been greatly exaggerated on a visual level in Hollywood cinema in last two decades. Tim Burton, for example, uses Gothicism purely as a form of cinematic stylization, most notably in *Edward Scissorhands* (1990), *Sleepy Hollow* (1999) and *Sweeney Todd: The Demon Barber Of Fleet Street* (2007). Nowadays any horror movie with a predominantly black and drained colour palette is considered gothic, regardless of content. In contrast, Rollin's films are colourful and vibrant. They utilize brightly lit locations and soft colour schemes, pale blues, greens and purples. But they are gothic in the tradional sense of classical gothic literature, which concerns the past creeping into the present.

Rollin also incorporates gothic elements on a visual level. For him, crumbling châteaux and castles, old graveyards, crypts and stone ruins, are emotionally charged images. Rollin's work echoes that of the classic gothic writers, like Mary Shelley, Bram Stoker and Edgar Allen Poe, whose sombre and ill-fated characters are surrounded by death and madness.

The old world and the new world are in constant contrast. At times, it feels the filmmaker has transported us into the past, as his protagonists become immersed in gothic surroundings. In *Requiem pour un Vampire,* the lead characters leave behind a world of automobiles and become lost in crumbling ruins and candlelight, a timeless dark fairytale ambience. *Le Frisson des Vampires* begins with a sepia-toned prologue in an isolated castle, set in an unidentified period in the past. Later on, the two female servants wander the castle with candelabras, only then to speed along a country road in a sports car, passing through a quaint village with overhead pow-

The gothic image.
Le Frisson des Vampires
(top left), *Two Orphan
Vampires* (top right) and
Fascination.

er cables — distinct and contemporary. *Lèvres de Sang* presents us with a central character in present-day Paris, but he is completely immersed in childhood memories. As he delves deeper into his past, images of cars, city streets and electricity are replaced by a coastal castle and crypts. The old world literally swallows the present. Similarly, *La Morte Vivante*, *Killing Car*, *Les Deux Orphelines Vampires*, *Les Démoniaques* and *La Nuit des Traquées* all feature stories in which memories and the past have a significant effect on the present.

In *Les Deux Orphelines Vampires,* the two bloodsuckers dwell obsessively on fantasies inspired by literature and of their past deeds. The image of a black, monolithic train at the beginning of *La Rose de Fer* is an interesting symbolic connotation; the monstrous form once represented power, yet it is now a dark shell, a metal skeleton, a marker of the past. *Les Trottoirs de Bangkok* makes for a notable exception in that it deals with memories but takes place in a distinctly modern environment.

Rollin also uses vampires to explore themes of time and memory. The vampire's fate, to be condemned by time, is beautifully symbolized in *Le Frisson des Vampires*. A huge grandfather clock, per-

The Celluloid Dreams of Jean Rollin 29

manently stuck at midnight, is the home of a vampire. *Le Frisson des Vampires* also features an entire cast of doomed characters. A vampire seduces a bride while her husband fights throughout the entire film to save her. In the end she is destroyed by sunlight, along with her vampire family, leaving her husband alone on an empty shoreline.

Rollin's films abide by their own rules and deliberately play with common horror tropes, undermining and ignoring familiar terror techniques. Likewise, the idea of good vs. evil is dismissed, while religion plays virtually no part in his films. Priests fending off hungry vampires with crucifixes are noticeably absent. The undead of Rollin's celluloid universe cannot be labelled as evil — they are far too tragic and sombre to be evil.

Visual Obsessions

ROLLIN USED SEVERAL directors of photography throughout the decades, but the visual composition and use of colour in his films bear his distinct signature. This is not to suggest that each director of photography did not have a strong influence on their respective films. A change in cinematographer can be seen to affect the visual style of Rollin's films in very subtle ways. The photography of Max Monteillet, for instance, is somewhat grittier, grainier and more tightly framed than Jean-Jacques Renon's vibrant colour palette and slow, roving camera. Norbert Marfaing-Sintes' Super 16mm photography is more contemporary. It's also more referential to Rollin's previous work, combining both of the above styles with a vibrant palette and grainy 16mm film.

Le Viol du Vampire features compositions photographed by Guy Leblond and Antoine Harispe that would recur in almost all of his subsequent films, such as the framing of wide landscapes in proportion to the sky, which creates a sense of depth. Rollin's characters often pass through the camera, so to speak: when they fill the screen in close up, we cut quickly to a reverse shot of the character walking away with their back to the lens. Rollin used this technique frequently.

Rollin's early films, *La Vampire Nue, Le Frisson des Vampires,*

Mood in *Le Frisson des Vampires*.

Les Démoniaques and *La Rose de Fer*, were photographed by Jean-Jacques Renon. They have a distinct presence with a slick style, vivid colour schemes, and a proliferation of wide shots full of space and depth, perfectly aligned with the contours of the landscape and characters.

Despite Renon's talent, he worked on very few other films, largely because of the alcoholism that eventually killed him. Initially, Renon wished to be a painter, as evident in his often static cinematography with prominent greens, reds, blues and purples. Everything is precisely composed. Rollin would go on to employ repeatedly these techniques, giving his films a distinct visual trademark, which he maintained throughout his career.

Rollin's visual eye is in some parts dictated by budgetary constraints and some parts a preference for classical filmmaking techniques: the camera is not used in an overly stylized manner. The photography in his films is rather static, yet this is used to wonderful effect and Rollin never allows the 'action' onscreen to become uninteresting. Every shot counts and he doesn't rely on snappy editing techniques to make up for pacing issues or dramatic effect. At

The Celluloid Dreams of Jean Rollin 31

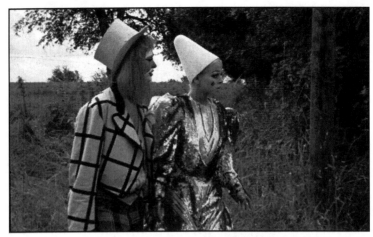

Clowns. Mireille d'Argent and Marie Pierre
Castel in *Requiem pour un Vampire.*

all times, something eye-catching and beautiful lurks within each
scene (perhaps discounting *Les Trottoirs de Bangkok*). This basic
approach to shooting creates a strange, surreal atmosphere, down-
playing the bizarre events that unfold. Static shots often linger for
several minutes without an edit, and yet, thanks to the choreogra-
phy and *mise en scène*, they are never flat or uninteresting. A fine
example is a scene depicting several vampire women descending
stone steps in *Lèvres de Sang*, which lasts almost two minutes.

Another notable two-minutes are to be had in the sepia-toned
opening of *Le Frisson des Vampires*, which consists of three separate
mood shots, for an eerie and sombre atmosphere. Following this
sequence, two servant girls walk silently across the castle grounds,
virtually in real-time. A scene like this is almost inconceiveable for
today's filmmaker. Many filmmakers would simply opt for an estab-
lishing shot of the characters and imply the journey this way, but
Rollin gives us the whole journey and it reads like a poem. The final
shot of *La Nuit des Traquées* bravely lasts for several minutes, de-
scribed by Pete Tombs and Cathal Tohill as 'one of the longest walks
in cinema history'*. The take is extremely haunting and reinforces
the amnesia-addled lead's sombre plight. Rollin reaches for a spe-
cific tone and content for each shot, without the use of weird angles

* Tohill and Tombs, 160.

Brigitte Lahaie wanders with amnesia. *La Nuit des Traquées.*

or rapid editing designed to 'speed up' the events.

Another example is the sequence in *Requiem pour un Vampire* where two clown-girls are pursued through the countryside by bestial slaves. The majority of the chase is a static shot: the characters begin hundreds of yards away, running towards the camera. By the time they have reached the foreground, several minutes have passed. This dramatic single-take sequence, lusciously photographed, enforces the notion that these girls are lost and have nowhere to hide.

In Rollin films, very rarely does the camera move from its tripod; motion shots are created with slow zooms and pans. Likewise, Rollin rarely uses a tracking shot. When he does it is to maximum effect, such as the final shot of the scythe sequence in *Fascination:* the camera slowly tracks away from Lahaie and her deceased victim, insinuating a sense of isolation and finality. The death is given more importance — as the victim dies the camera departs also.

The camera is effectively a substitute for the human eye. One function the camera can achieve which the human eye can not, however, is the zoom. The zoom technique is used for a variety of reasons. It can be used to draw attention to something important or to emphasize something 'unreal' or 'unnatural' onscreen. An example of this would be the visually striking opening shot of *Les Démoniaques*: the camera zooms back as pirates lunge forward over the sandy dunes, the impression created being one of the unreal

The Celluloid Dreams of Jean Rollin 33

within a real landscape. The second use of the zoom is essentially that of a cost-cutting exercise. It's cheaper than using tracks or steadicam. This is evident in Rollin's pseudonymous trash-fest *Le Lac des Morts Vivants*, a production on which corners were cut at every possible turn. The over-use of the zoom, in lieu of tracking shots, looks cheap.

A third use of the zoom is a means to fill up a film's running time. Thus visual non sequiturs are found crashing through many a 'Eurotrash' film, examples being Jean Brismée's *The Devil's Nightmare* (1971) and much of Jess Franco's output. (In his favour, Franco did frequently use the camera as a probing device, seeking out what interested him in the frame. Alas, this was usually tufts of pubic hair).

The visual style of Rollin's films bear a a strong similarity to classical cinema and silent-era cinema. The majority of his work has minimal dialogue, with everything taking place through the *mise en scène*. When Rollin does use dialogue, it is sharp and to the point, comparable to intertitle cards in early cinema.

Rollin's pseudonymous films and his hardcore sex offerings are much looser in terms of their composition. No surprise, as these are impersonal projects shot purely for the commercial market.

It is important to note that Rollin's films were shot in French (although *La Morte Vivante* and *Killing Car* do feature some English dialogue) and that the subsequent English dubbed releases contain some awful dialogue. The dubbing on *Le Frisson des Vampires* and *Requiem pour un Vampire* is particularly terrible, and simply degrades the films. To elaborate: The English language dubbing carries a French accent, while the translated dialogue is often completely different to that of the original, destroying atmosphere as well as meaning. Moreso, the dubbing seems to have been carried out by non-professional voice-actors, cheapening the films. The French language prints are far superior. The original French dialogue is intentionally expressionistic, so lyrical and bizarre at times that it verges on comic book.

The screen in Rollin's films is often tinted blue. During daylight sequences, the deep blue sky frequently commands the image, as happens in the opening graveyard scenes of *Requiem pour un Vampire*. Here, the frame is dominated by the skyline, its rich blue contasting with green vegetation and tombstones for a tremendous

sense of depth, of isolation and the infinite. The recurrent blue tones are visually striking but they also create a sobriety that signposts the fate of the doomed characters.

Jean-Jacques Renon's pristine photography in *Le Frisson des Vampires* utilizes purples, blues and reds. Red dominates the frame in the sequences of horror; such as the discovery of the two vampires with wooden stakes protruding from their chests, the subsequent journey to the graveyard to kill the remaining bloodsuckers, and the sequence where the vampire in the cemetery first bites the female lead.

The black and white photography and use of shadow in *Le Viol du Vampire* paints a canvas of doom and melancholy. Each image is full of sharp details, whether it is the cluttered château, the surrounding skeletal woodland or the shingle beach at Dieppe.

Rollin is playful with his use of colour. Many of his female cast members wear white gowns, as witnessed in *Les Démoniaques*, *Le Frisson des Vampires*, *La Morte Vivante*. This can be seen as a simple metaphor for innocence. Lahaie's character in *Fascination* evolves from wearing white to black (after committing murder). When Isle feeds on the blood of a dead white dove in *Le Frisson des Vampires* it is symbolic of her fading innocence. In *Les Démoniaques*, when one of the innocent girls is beaten and mauled by the wreckers, her costume changes from white to dirty brown as her body and innocence are destroyed. The main character in *Les Raisins de la Mort* wears a purple blouse, reminiscent of the deadly grapes and suggestive of the bloody finale in the wine vat. Colours for Rollin are symbolic: red is equated with danger, white is innocence, and black is death. A classical palette but no less effective for it.

Rollin's films possess a natural atmosphere, being often set in isolated, rural locations. These are landscapes largely unspoiled by man. The buildings that inhabit them are striking and mysterious. The interior of the castle or the château is luxuriant and traditional, sometimes lit by candlelight. One of Rollin's most memorable locations is the moat-protected château in *Fascination*. It is captivatingly beauty, but beyond its walls lurks something altogether sinister. We might liken it to the apparently deserted farmhouse in Romero's *Night of the Living Dead*, which promises sanctuary for the distraught Barbara, but contains horrors of its own and is essentially a

Memory and loss. *La Morte Vivante* (top), *La Fiancée de Dracula* (bottom left) and *La Nuit des Traquées.*

tomb from which there is no escape.

Obsolete stone structures are a recurring element. Almost all of Rollin's films feature archaic châteaux and castles, old tombstones, rocky beaches and bizarre stone formations (such as the Tower of the Damned in *La Fiancée de Dracula*). Virtually every shot in *La Rose de Fer* features a stone structure.

Clowns come a close second. They feature in *La Rose de Fer*, *Les Démoniaques*, and *Requiem pour un Vampire*. Clowns, of course, have great potential for filmmakers as symbols of horror, yet Rollin uses them in an abstract fashion. We witness a silent clown tending a grave in a darkening cemetery in *La Rose de Fer*, the juxtaposition of death, mourning, and the clown's happy facial makeup making for a bizarre and unsettling emotional contrast. (Rollin once humorously suggested that the clown is placing the flowers on the grave of

FASCINATION

another clown, given that he was only able to recruit one of the girls from *Requiem pour un Vampire* to appear in *La Rose de Fer*.) The clown in *Les Démoniaques* is presented as a benevolent, sensitive figure, who paves the way for the two murdered girls to exact their revenge. When the wreckers murder the female clown, we see the life disappearing from her eyes despite her huge red-painted smile.

No clowns in *Les Pays Loins* (1965), an early short of Rollin's, but a sense of déjà-vu pervades, as two lost protagonists desperately try to find a way out of a derelict city. Loss and memory. In *Le Viol du Vampire*, past and present constantly intercut each other. Four sisters have been conditioned to believe they are vampires by an old man, who has tampered with their recollection of past events (this is something Romero would later explore in *Martin*, 1976). Rollin developed this theme further in *La Vampire Nue*, where a woman is conditioned to believe she is a vampire, her memories distorted by her exploiters. Isle's character in *Le Frisson des Vampires* frequently recollects memories of her childhood spent with her cousins. Her husband becomes a symbol for the future, her cousins a metaphor for the past. In the end, Isle chooses her past.

La Rose de Fer, *Lèvres de Sang*, *Les Deux Orphelines Vampires*, *La Morte Vivante* and *La Nuit des Traquées* also dwell on themes of memory and the tremendous impact of the past on the present. In *La Morte Vivante*, Catherine Valmont wanders through her house and examines objects that were once a part of her life. The naïve orphans in *Les Deux Orphelines Vampires* constantly associate themselves with ancient history and goddesses, living in memories and daydreams. *Killing Car* omits Rollin's classical settings, but the outcome is much the same: the past is embodied in Tiki Tsang's character, a femme fatale and the angel of death for those who have wronged her. Even *Emmanuelle 6*, which an uncredited Rollin wrote and co-directed, features a woman suffering from amnesia who wanders like a stranger in her own home, attempting to recollect who she is.

Rollin's personal films make for rewarding repeated viewings. In their subtle nuances one can find something fresh and different every time. Rollin doesn't dwell on reason, or over-explain himself. As Buñuel and Dalì before him, his images and ideas stand on their own merits. Observe Tohill and Tombs, 'To [Rollin], the need to ex-

plain takes away the power of the images"*. Rollin's films, like the clowns, the colours, the exhausted stone structures within them, are open to multiple interpretations.

The Art of Creation

THE MEASURE OF a great filmmaker is the capacity to produce great work regardless of budget or expensive equipment. Minimal funding and tight production schedules can often lead to more impressive work. The director and his crew have to put in the extra effort to achieve the best possible result, and when money is in short supply, imagination and fresh ideas are vital.

Financial problems and time restrictions always plagued Rollin's films, but they do not suffer because of this. If anything, they are strengthened because Rollin made the very most of what was available. During shooting, Rollin worked in the moment and exercised his artistic freedom, often improvising and experimenting.

Most of Rollin's productions were made with a tight-knit bunch of friends and colleagues. They would have to endure extremely tight shooting schedules with long hours and be able to respond to Rollin's fast, improvised direction. Many of the people who have worked with Rollin speak fondly of him and their experiences. Performers and technical crewmembers returned film after film, despite little or no financial reward. Natalie Perrey contributed to the majority of Rollin's personal productions, working either as an actress, script girl or director's assistant. Jean-Pierre Bouyxou, Paul Bisciglia, Brigitte Lahaie, the Castel twins, Willy Braque and Jean-Loup Philippe also returned to work with Rollin on several projects, not to mention producers Lionel Wallmann and Sam Selsky. Wallmann regarded the working atmosphere as 'very friendly and convivial. The team [was] practically the same for years and it [was] like a family.' †

Rollin formed many lifelong friendships with his actors and crew. His makeup artist and assistant Eric Pierre had worked with him on and off since *Le Frisson des Vampires* in 1970. Musicians Pierre

* Tohill and Tombs, 143.

† Lionel Wallmann in a letter to the author.

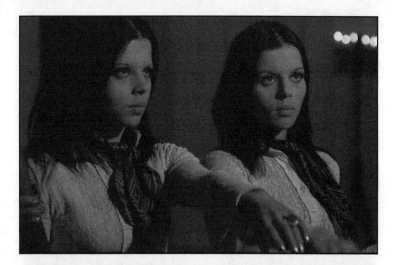

The Castel twins, *La Vampire Nue* (top), Nathalie Perrey, *La Nuit des Horloges* (above left) and Willy Braque, *Les Démoniaques* (with gun).

Raph and Philippe d'Aram have each scored several films for Rollin. Editors Michael Patient and Janette Kronegger, and directors of photography Max Monteillet, Claude Bécognée, Jean-Jacques Renon and Norbert Marfaing-Sintes, returned for several projects, the latter working with Rollin for over two decades.

For fans of Rollin's work, each film is like watching a family reunion. There are always familiar faces and recurrent names in the credits. Rollin's love of cinema and the warm friendships that helped create his personal films shine through in his work, embodied in the performances and the beautiful cinematography.

The Celluloid Dreams of Jean Rollin

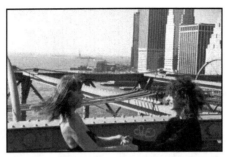

Perdues dans New York

Understandably, behind each film are anecdotal stories. There are several regarding the problematic shoot for *Les Démoniaques*. With only one week of shooting remaining, the money dried up. Rollin was deep in despair and close to leaving the film unfinished. The crew went to a local bar, frequented by his alcoholic cinematographer Jean-Jacques Renon, and Lionel Wallmann bought a lottery ticket. He won 100,000 Francs and they continued shooting. Alas, when the production was finished, Rollin and his crew were unable to leave the Chausey Island location. Every year there is a weeklong period in which no boats or planes can travel to or from the island. Having no money, food, or transport to go home, Rollin and his crew roughed it for this period. Wallmann cooked the spider crabs they had used as set decoration in onions and white wine for the crew.

Some stories are not so humorous. A persistent rumour that surrounded the director, particularly during the early to mid-seventies, was that he sold his female cast members to slave rings and brothels after the completion of his films. Ridiculous it sounds now, but Rollin found it difficult to find actresses who would trust him because of these stories, and casting was sometimes a problem. The rumours stemmed from negative criticism over the erotic content of Rollin's films, and the loathsome reaction to *Le Viol du Vampire*.

Rollin never prepared storyboards prior to filming. Virtually everything is improvised. Rollin reasoned that if he were to make a storyboard of the entire film, from beginning to end, anybody could direct it. It would be like following an instruction manual and the finished film would lack the magic that came from improvisation. Rollin took great pleasure in arriving on set with nothing prepared, other than a first draft script, and allow the ambience of the loca-

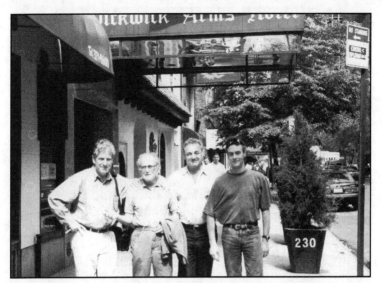

Perdues dans New York, New York crew. L-R: Jean-Noel Dellamare, Sam Selsky, Lionel Wallmann and (unidentified) crew member.

tion help form his vision. From the moment Rollin stepped onto a location, he instinctively knew where he wanted the camera, actors and crew. Rollin understood the importance of location, and went so far as to making the location a key character in the story, not just a backbone for narrative. The location, its natural energy, its atmosphere, influenced how he directed each scene.

In some cases, he had already selected his locations before the script had even been written. Locations were a source of inspiration, and Rollin allowed natural geography and the characteristics of buildings to influence the direction of a scene and its characters. 'Many times,' said the director, 'I chose the place to shoot before I wrote the script. I don't say that the locations are more important than the script or actors, but it's the location for me that conditions the rest. Even when I write a book I say we are in an old dungeon and so on, and after I begin the story. But during writing the story somewhere in my mind that old dungeon remains.' *

Rollin always wrote his first draft screenplay with budgetary constraints in mind, and his ideas often began in a very abstract

* Jean Rollin, interview with the author. See appendix.

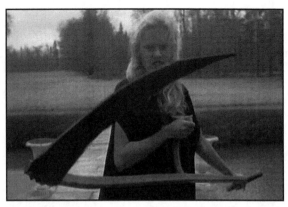

Brigitte Lahaie, *Fascination*.

fashion, with a single image or location rather than a character or story in mind. *Requiem pour un Vampire* was written as an improvisational script that began with a single image: Louise Dhour playing piano in a cemetery in the black of night. This spontaneous, free style manner was maintained during shooting, with Rollin making small alterations to the script but rarely did he redraft them. The films were written and filmed spontaneously; a sense of freedom prevailed throughout pre-production and production. This approach had a tremendous effect on the final film. Rollin and his actors were forced to think scenes through while at once capturing them. Had the films been minutely planned and systematically shot, it's safe to say the result would have been very different.

The pre-production stage of a film took Rollin approximately one month, during which time he completed the script and roughly planned the shoot. Average shooting time was three to four weeks. Within a couple of months, Rollin could create a feature film.

Le Viol du Vampire and *Les Trottoirs de Bangkok* were entirely improvised. But one of them shows it more than the other. It's easy to accept the surreal and deranged *Le Viol du Vampire* as an improvised project, because the whole thing is so wild. On the other hand, *Les Trottoirs de Bangkok* is a tight spy thriller with a complex narrative full of twists and turns, plus a large number of locales and characters. Far from perfect and incredibly low-budget (the film was completed with a technical crew of four, including the director!), the continuity is tight, which is amazing when one considers that it's an entirely improvised production drawn from only two rough

FASCINATION

Le Lac des Morts Vivants aka *Zombie Lake*, a Rollin work-for-hire job.

pages of script. Legend has it that Rollin stopped passers-by in the street and enlisted them as performers.

His most commercial film, *Les Raisins de la Mort*, progressed in much the same way. Although shooting started with a complete, pre-prepared script, Rollin decreed that, in the two months since he had written it, his view of the story had evolved. After the first week of production, Rollin stopped using his script and completely improvised the remainder of the film. Nor did the film have a technical script, so the whole visual and technical aspect was improvised as well. Fast paced and exciting, *Les Raisins de la Mort* remains one of Rollin's strongest creations

Although Rollin controlled the overall direction and artistic process of the film, he allowed room for his colleagues to express themselves. He gave his actors plenty of freedom within the frame, rather than smother them. Thus the films were not only personal to Rollin but also to the people who contributed to making them. This may be why many people have such fond memories of working with Rollin. It was teamwork. There was never a dull moment and everything kept moving until the film was complete.

Rollin was very lucky to have his producers, Sam Selsky and Lionel Wallmann, as they granted him artistic freedom despite the financial risks. Wallmann occasionally acted in Rollin's films in small

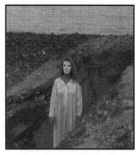

Perdues dans New York.
Opportune location shots
in New York (top left),
pieced together with a
story back in France (top
right, and left).

roles just for fun.[*]

Even as a director for hire, Rollin worked in a highly improvised
manner — if to less satisfying effect. *Le Lac des Morts Vivants* was
entirely improvised but the final result was neither good, nor a Roll-
in film in the true sense. Zombies dressed in SS uniforms rise from
a lake in France. Already it sounds like a passable 'Eurotrash' hor-
ror flick. But the actuality is that the film is terribly sloppy. Rollin
had virtually no idea of what the film was about before arriving on
set as a stand-in for Jess Franco. The shooting schedule was hectic.

[*] Outside of Rollin's movies, Wallmann worked on *Les Lettres de Stalingrad* (1969),
Les Maitresses de Vacances (1974), and a TV pilot, *La Femme Adultere*, which was
shot in Tunisia. Wallmann also produced a sex comedy called *Les Demoiselles a Peage*
(1975), directed by Richard Balducci, which the French censor classified as X-rated.
This destroyed any potential profits, and signalled the end of Wallmann's Nordia
Films production company. Wallmann relocated to Florida and kept himself busy
with many of his own projects, working with his friend Norbert Moutier (aka Nor-
bert Mount) on projects such as *Operation Las Vegas* (1988, starring Brigitte Borgh-
ese from *Tout le Monde il en a Deux* and *Les Trottoirs de Bangkok*) and *The Brooklyn
Cop*. Both cost around $100,000. The latter was a thriller featuring Jacqueline Stal-
lone (Sylvester's mother). Wallmann also worked for the Fort Lauderdale Film Festi-
val in 1990/91, where he met his wife Pamela. During the mid-2000s Wallmann was
developing a film called *Miami Vampire* based on his own screenplay, but the film
was never realized. Lionel Wallmann passed away on October 13, 2011, in France.

FASCINATION

The crew, made up of several Rollin regulars and a host of Franco technicians, had language problems and there was a general lack of organization. The project was neither personal to Rollin or the crew, and the friendly atmosphere and enthusiasm that propelled Rollin's other shoots is not evident here.

Wallmann regarded Rollin's style of filming as 'organized improvisational shooting'*. Given that his films were made with incredibly low budgets, there was no room for error. So, while there may not have been a detailed script, strict shooting schedules and time plans were always prepared in pre-production.

Rollin cast his own films more often than not. Some actors were brought back for different films if they embodied a certain ambience or personality that he found interesting.

When casting *Les Deux Orphelines Vampires*, Rollin put out a classified advertisement in a local magazine, *Pariscope*. The advertisement specified Rollin was looking for two women who could be the vampire girls in the image shown,† a drawing based on a still photograph of Marie-Pierre Castel and Mireille d'Argent from *Requiem pour un Vampire*. Rollin stated the advertisement was 'a pretty faithful representation of what I was looking for'.‡ Rollin received lots of photographs from wannabe vampires, but settled for theatre actresses Alexandra Pic and Isabelle Teboul after one meeting. (For Pic, who plays Louise, the opportunity was too good to miss — as child she was a huge fan of vampires.)

Everything happened very quickly on a Rollin shoot, the shoot itself rarely lasting more than four weeks. During this time, Rollin and his crew — comprising around twenty people in total — would work virtually non-stop. There was very little discussion or preparation between the director and his actors in the pre-production stage, chiefly due to time restrictions. Rollin only got the chance to meet with the actors once or twice to discuss their roles before shooting commenced.

Shooting tight, often on location, Rollin and his crew remained close, sharing lunch together. In these moments most discussions

* Lionel Wallmann, interview with the author. See appendix.
† This image was the cover of Rollin's novella, *Les Deux Orphelines Vampires*, first published by Fleuve Noir.
‡ Jean Rollin, interview by Lucas Balbo, *Two Orphan Vampires* DVD.

The Celluloid Dreams of Jean Rollin 45

regarding the acting performances took place. The only film Rollin rehearsed with his actors prior to shooting was *Les Deux Orphelines Vampires*, for which he had more time and money at his disposal.

Spontaneity also fuelled Rollin. Travelling to America on assignment to shoot stock footage for French TV producer Jacques Nahum, Rollin took time out to make another film. This was *Perdues dans New York*, a surreal, dreamlike fantasy shot on New York streets. He pieced the story together when he got home. Not dissimilar is *Les Trottoirs de Bangkok*, which Rollin was inspired to make after seeing grainy 16mm stock footage of Bangkok streets.

A large majority of Rollin's films were shot without sound, in order to reduce the number of technicians on set and to help cut down the shooting time. The synchronization of these dubbed features are near perfect and are works of postproduction excellence. Rollin's more recent features were shot with live sound because the actors, mostly beginners, delivered better live performances than they did dubbed studio audio.

Rollin's films were very tight and required little editing. Rollin would envision the entire film exactly how it would play out on the cinema screen as he was shooting, instinctively knowing where the edits would occur. Despite his early work on commercial projects as an editor in the French army, montage is not a technique Rollin incorporated. From conception to final cut, he would oversee the entire production of his personal films. He would often prepare the first rough cut himself just to ensure he had ninety minutes of film. The initial edit of *Requiem pour un Vampire*, for instance, a film that utilizes many long takes, was made by Rollin himself.

Rollin's method, and his films, should serve as a vital and encouraging reference for independent filmmakers, as an example of what can be achieved with very little money.

Black Widows, Femme Fatales & Male Fools

FROM THE DAYS of the 1922 expressionist classic, *Nosferatu*, through to Christopher Lee's iconic Dracula, the vampire in cinema prior to Rollin was usually male. The majority of Rollin's vampires

The men of Rollin's world. *Requiem pour un Vampire* (top) and *Le Frisson des Vampires*.

are women. They are predatory, seductive and dangerous. By extension, the aggressors in Rollin's films are almost always women. If not vampires per se, then bound to the predatory instinct of the undead. Take, for example, Lahaie's character in *Fascination*, or Tiki Tsang in *Killing Car*.

Rollin's vampires are sad and sympathetic individuals, not necessarily monsters. Like the archaic locations in which they often find themselves, they are a throwback to an old world. A dying breed. With the exception of *Lèvres de Sang*, whose protagonist is Frédéric, a male, the plot of each Rollin film concerns the dilemma or journey of a female character.

Rollin has a keen eye for beautiful women and showcases the female form as frequently as possible in his films. As a male spectator, he preferred to film women rather than men, but he was also more comfortable writing female characters. In his universe, wom-

Beautiful but deadly. Isabelle Teboul and Alexandra, *Les Deux Orphelines Vampires*. Tiki Tsang, *Killing Car*.

en are in charge and men are easily manipulated and controlled. In *Fascination*, a confident, cocky male is gradually belittled and subjugated to the point he becomes a comedic spectacle for his female onlookers. In *La Rose de Fer*, the roles are reversed for a young couple trapped in a cemetery. She at first is childishly taunted by her boyfriend for being afraid; later, however, it is the male who becomes frantic with terror as his girlfriend assumes a tranquil state of acceptance.

Rollin incorporates a large amount of nudity in his personal films, which, by his own admittance, was a commercial device for maximum ticket sales. He used nudity in a surreal and dreamlike fashion, bringing with it a sense of unease and danger. *Les Trottoirs de Bangkok* is somewhat different in that here it furnishes the sleazy backdrop of brothels and opium dens, the copious nude dancing scenes nothing more than sexual titillation.

In Rollin's world, females are often innocent and naïve, ignorant to or detached from the dangers that surround them. The vampire orphans in *Les Deux Orphelines Vampires* live outside reality in a life of dreams. The two lesbian lovers from *Requiem pour un Vampire* have no sense of danger as they enter the ominous castle and, within seconds, disrobe to sleep on a vacant bed. These characters have a playful quality about them, but often it is sullied by evil forces as the story unfolds. Beauty and innocence are tainted and destroyed; we witness the horror, destruction and perversion of the body (in *Les Démoniaques* or *La Morte Vivante*, for example).

Rollin's lead performers, some returning more than once, pos-

FASCINATION

Seductive and innocent. Mireille d'Argent and Marie
Pierre Castel in *Requiem pour un Vampire*.

sess genuine screen presence. As soon as we see them, we have an
immediate understanding of their personality. Joëlle Coeur is sex-
ually voracious in her roles in *Les Démoniaques* and *Jeunes Filles
Impudiques*. Tiki Tsang, who only ever appeared in one film, has
a stark, commanding presence in *Killing Car*. Her petite but stat-
uesque physique is brilliantly immortalized in a photoshoot se-
quence, where she strikes poses. Françoise Blanchard plays the
role of blood-crazed, mournful Catherine in *La Morte Vivante*. The
horror elements of the film are drawn exclusively from the juxta-
position of her fragile beauty and the gruesome violence she per-
petrates. The blonde-haired Castel twins are arguably Rollin's most
naïve and playful performers, bringing an aura of charming mis-
chief to the screen. But undoubtedly, the most iconic female per-
former is Brigitte Lahaie. An adult film star, her wide-eyed presence
immediately exudes power, sensuality and danger. Rollin recalls:

> I had met Brigitte on the set of an X-rated movie. She was statuesque,
> she had a very special physique that could be used in a certain fashion ...
> she radiated a strange uncanny presence, even in the X-rated films ... I
> remember she would knit in between takes ... an interesting person all
> round.*

* Jean Rollin, interview by Lucas Balbo, *Two Orphan Vampires* DVD.

Each of these actresses possesses an unusual grace, which is the reason Rollin cast them in the first place. Their visual presence is so strong that we understand what they represent in a single shot with very few words or very little background information, much like in classical silent cinema.

Unlike male protagonists, the horrors perpetrated by Rollin's female characters are almost exclusively down to survival. With the male, violence is drawn from ignorance and plain brutality.

The male is also often at the centre of a mystery, in which he is enticed and led by seductive females. *Lèvres de Sang*, *La Vampire Nue*, *Fascination* and *La Fiancée de Dracula* all feature male protagonists obsessed or haunted in this way. Delving into these mysteries, the male can never overcome them, but simply succumb to the lure of the vampires. The one thing the two sexes share, however, is doomed fate. Indeed, everyone in Rollin's films is doomed, victims

FASCINATION

Dualism. Previous page: *Les Démoniaques* (top), *Les Échappées* (bottom left) and *Fascination*. This page: *La Nuit des Horloges* (top), *La Vampire Nue* (bottom left) and *Le Frisson des Vampires*.

as well as aggressors, human and the non-human.

Throughout Rollin's films and literature runs duality. The majority of Rollin's personal films feature two lead characters who share a strong relationship, whether they are twins, lovers or friends. The twin theme recurs most commonly in the presence of the Castel sisters, who bear an uncanny resemblance and share the same naïve charm. Both *Requiem pour un Vampire* and *Les Échappées* have two female characters on the run, while *Les Deux Orphelines Vampires* and *Les Démoniaques* feature predatory or vengeful doubles. Although the demonic girls in *Les Démoniaques* are not twins per se, their visual appearance is undeniably similar. In *Fascination*, a lesbian couple is key. *La Morte Vivante*, *La Nuit des Traquées* and *Perdues dans New York* are further examples.

This element of duality can also be seen with the male charac-

ters, although not as strongly. The professor and Eric in *La Fiancée de Dracula*, the bourgeois cousins in *Le Frisson des Vampires* and the ill-fated male heroes of *Les Raisins de la Mort* are central characters bound by blood, fate or friendship. Reinforcing the theme further, if less obvious examples: Pierre and Robert in *La Vampire Nue*, the two sailors from Rollin's unfinished *L'Itinéraire Marin*, and the two gravediggers in *Requiem pour un Vampire*.

These recurrent doubles evolve with each film, their significance altering slightly in the context of each new narrative and serving as a nostalgic reminder of their previous incarnations. Rollin once stated, 'I even discarded a book because I had set out to create a story with only one character and without realizing it, another one kind of slipped in.'*

The Literary Fantastique

JEAN ROLLIN was not only a filmmaker, he was also a prolific writer. His novels and novellas outnumber his personal feature films. Outside France, however, very little is known of Rollin's literary work — that is to say, even less than so than his movies — with only one of his books having been translated into English: the first instalment of *Les Deux Orphelines Vampires* (published by Redemption in the UK). But even this has not seen print since 1995.

As a young boy, Rollin was fascinated by storytelling. His love of the craft had been with him since childhood, when he would listen avidly to adults telling campfire stories. Through his teenage years, he was obsessed with cinema and comic books. At the age of fifteen, he received a typewriter, a gift from his mother, which he immediately put into use, developing film ideas and short stories.

His career in writing progressed alongside his film career. During the mid-sixties, prior to his debut feature *Le Viol du Vampire*, Rollin worked on a bizarre adult comic book called *Saga de Xam* (*Saga of Xam*) with publisher Eric Losfeld and artist Nicholas Devil. Inspired by the success of Jean-Claude Forest's *Barbarella* comic serial, *Saga de Xam* was a science fiction tale following the adven-

* Jean Rollin, interview by Lucas Balbo, *Two Orphan Vampires* DVD.

Films ABC edition of *Les Deux Orphelines Vampires* (front and back).

tures of a space girl who comes to earth. Rollin would work on the story and arrangement of the imagery, while Devil drew the pictures. *Saga de Xam* only received a small print run. It pushed the sexual elements to the limit and its outrageously bizarre content alienated many readers. Its initial print was presented in book form in full colour, though it was later reprinted in black and white. The original carries a hefty price tag, but both editions are sought-after collector's items.

The majority of Rollin's books explore similar territory to his films. Rollin also wrote a well-received critical study of one of his favourite authors, Gaston Leroux, titled *Aujourd'hui, Gaston Leroux* (*Today, Gaston Leroux*). It was published in Eric Losfeld's art journal *Midi-Minuit Fantastique,* in two parts, over issues twenty-three and twenty-four. Losfeld also planned to publish Rollin's first novel, *Les Pays Loins* (*The Far Country*), but this never came to fruition. The only comparable detail between this unpublished novel and his 1965 short film is the title.

As his motion picture output declined in the mid-eighties, due to ill health, Rollin's literary output increased. In hospital receiving kidney dialysis treatment over an eight-year period, he began to

Little Orphan Vampires is the only English language translation of Rollin's many novels.

made use of his time writing novels. Writing suited Rollin's artistic temperament, it pushed his imagination to the limit and allowed him complete artistic freedom. Compared with the stresses of film-making — of worrying about hiring and directing actors, finding locations, budgeting and the rest — writing was easy.

In 1988, a company by the name of Les Cahiers du Shibboleth publishing Rollin's *Une Petite Fille Magique*. Its narrative consists solely of female characters, and details the journey of two strangers who meet by chance in a deserted house in the woods. From here on, their lives are greatly affected until they meet their fate on the shoreline of Dieppe. The book shares many similarities with *Perdues dans New York*, which was made shortly after its publication.

His next book, *Les Demoiselles de l'Étrange* (1990), again features two women as central characters, re-enforcing his theme of female duality. Edwige and Estelle, escape from a mental institution with the help of a spiritual master, who guides them on a strange, exotic adventure in which they battle various dangerous and evil elements. The book was not as successful as Rollin had hoped.

After writing the thriller *Enfer Privé* in 1991, he began work on his most famous tale, *Les Deux Orphelines Vampires*. Whereas Roll-

FASCINATION

in's female leads in *Les Demoiselles de l'Étrange* had represented ultimate good, and the book itself classic French melodrama, he went in the opposite diection in *Les Deux Orphelines Vampires*. The two females here are deceitful, blood craving orphan vampires. Published as a five-part serial by the huge Paris-based Fleuve Noir company, *Les Deux Orphelines Vampires* was well received. The other volumes in the series include *Anissa*, *Les Voyageuses* (*The Wanderers*), *Les Pillardes* (*The Vagabonds*), and *Les Incendiares* (*The Arsonists*). It was later released by Rollin's own Éditions Films ABC publishing company, in a volume that collected the entire work. A comical in-joke is evident on the jacket of the complete volume; on the back cover there is a picture of a child surrounding by fish in an aquarium. It is an image of Rollin as child, photographed in 1941.

The novel *Les Deux Orphelines Vampires* is much more fantastical and extravagant than Rollin's film of that name. Certain scenes could not be translated to the screen without a huge budget or extensive use of CGI. Of course, as a filmmaker, Rollin didn't have either. In the book, the two orphan vampires dream of holding a huge blood sacrifice in which they are the goddesses:

> The year is 1488. Before us, for us, they are preparing the four day festivals to celebrate the inauguration of the Grand Temple of Mexico. The successor to Montezuma 1^{st}, the emperor Ahuitzotl himself, stands at the summit of the pyramid, readying the first sacrifice. The priests surround him. For many moons the population has been in a state of ecstasy. All the town is decorated, everywhere there is singing, dancing and rejoicing ... Down below I see the long, endless procession of victims. There are rumours that there are more than one hundred thousand of them. These four days will stand as the biggest voluntary suicide in all the history of the world ... In fact it is a ritual communion: blood and flesh. Blood that will flow without ceasing, sacrificial flesh that the faithful will devour at the foot of the pyramid. There is talk of at least twenty thousand victims on this very first day[*].

Given his miniscule shooting budgets, it is not difficult to see the problems Rollin would have had in recreating the above passage for the screen. The sheer number of actors involved would be daunt-

[*] Rollin, J., *Little Orphan Vampires*, 47.

ing enough, but then the scene goes on to describe the massacre of many individuals in explicit detail, revelling in the carnage and mutilations. Thus the tone of the novella is very different to the subsequent, appropriately subdued, film.

Rollin made a mixture of personal and pseudonymous films, as dicated by finances and financiers. But he only wrote personal novels and novellas. His books function as an undiluted representation of his ideas and themes. Recurrent locations in Rollin's films, such as train yards, graveyards, castles and deserted shorelines, can also be found in his literature. Core themes of nostalgia, memory, childhood, and the importance of the past are also persistent. Admirers of his unique films should find plenty to enjoy in his equally distinctive literature. For those of us who do not fluently understand the French language, we can only hope that his books receive translation now that his cult reputation is on the increase. It has taken almost three decades for his films to receive the recognition they deserve, we can only hope it doesn't take as long for his literature.

The Films of Jean Rollin

JEAN ROLLIN'S FILMS fall into three very distinct categories; his pseudonymous work as a director for hire, his X rated adult features, and most importantly, his personal feature films. Of the fifty-three titles he directed, only twenty fall into the latter category. These personal films are the true representation of Rollin as a filmmaker and an artist. Each one possesses his unique signature themes and visual style.

Rollin contributed to the financing of these personal films and for the most part maintained creative control. They are deeply individualistic, obsessive and self-referential with characters, imagery and themes recurring again and again, taking on greater meaning with each new film. These melancholy personal visions are saturated with nostalgia, vampires, doomed romanticism, blood and erotica. They are also the only films he credited with his real name. These were the films that mattered to Rollin.

Le Viol du Vampire: Un Mélodrame en Deux Parties
The Rape of the Vampire: A Two Part Melodrama

AKA: *The Vampire Women; Queen of the Vampires (USA); La Reine des Vampires*
1967 / Les Films ABC
100 Mins, B&W, 35mm, Original Ratio: 1:66:1
Director: Jean Rollin **Screenplay:** Jean Rollin (with dialogue by Alain Yves Beaujour) **Producer:** Sam Selsky **Director of Photography:** Guy Leblond, Antoine Harispe **Editors:** Jean Denis Bonan, Mireille Abramoviei **Music:** Yvan Gerault (Act One only), François Tusques, Barney Eilen, Bernard Guerin,

J.F. Jenny Clark, Eddy Gaumont **Sound:** Jacques Duval, Jean Vermelen **Cast:** Solange Pradel (Brigitte), Bernard Letrou (Thomas), Jacqueline Sieger (Queen of the Vampires), Catherine Deville, Ursulle Pauly, Nicole Romain, Marqies Pohlo, Louise Horn, Doc Moyle, Don Burhams, Yolande Leclerc, Philippe Druillet, Jean Aron, Mei-Chen, Edith Ponceau-Larfie, Jean Denis Bonan, Ariane Sapriel, Eric Yan, Alain Yves Beaujour, Annie Merlin, Olivier Martin, Barbara Girad

'We are all damned souls, haunted by our desires.'

ACT ONE: Four vampire sisters live in rural isolation. They are guarded by a sinister old man, who foretells their doom upon the arrival of three strangers. Soon after, a psychoanalyst named Thomas, and his two assistants, Brigitte and Mark, arrive. The old guardian informs Thomas of the cursed history of the vampire sisters. Thomas strongly disbelieves the tale and feels the sisters have been brainwashed into thinking they are the walking dead. He attempts to cure their brainwashed minds. He begins by burning the wooden crosses that surround the house, symbolically destroying the religion which has persecuted them their entire lives. The four sisters worship a bizarre statue in the woodland.

The sinister old man uses the statue to control the four sisters. He instructs one of the vampire girls to murder Thomas and his interfering companions, but before she can carry out the grisly deed she meets her own demise at the hands of her three sisters. Thomas finally begins to make progress with the three remaining sisters but it is short lived as the old guardian manipulates the local villagers into taking vigilante action against the vampires. The past repeats itself as the villagers lay siege to the isolated château. Thomas helps the vampire sisters fight back. Mark's lover, Brigitte, is murdered and the vampire women are hunted and killed until only one remains. With death closing in, Thomas begs the final vampire to transform him into one of the undead. She sinks her teeth into his neck and they escape together through a secret passage that leads them to a secluded beach. The waves gently wash against the shingle shoreline as Thomas and his female companion run to the ocean. With two blasts of Mark's shotgun they both fall dead into the surf.

ACT TWO: The sinister old guardian examines the dead bodies in the surf. He is suddenly surrounded by cloaked figures and the exotic Queen of the Vampires. She plunges a knife into his chest, killing the

FASCINATION

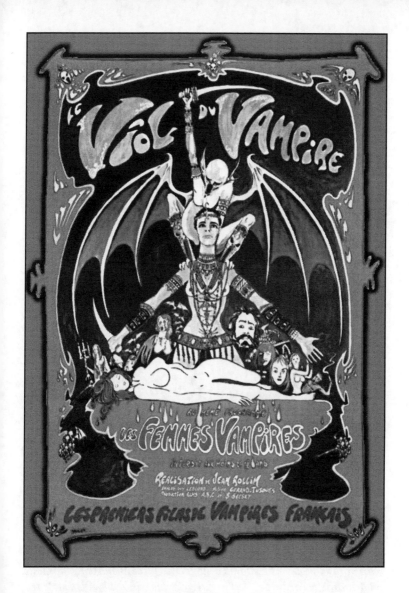

old guardian for his betrayal of her species. The vampire queen instructs her cloaked followers to sever the heads of Thomas and the vampire sister but the task is not carried out. The blood of the old man drips onto Thomas' body, reviving him. He drinks the flowing blood and awakens the final vampire sister. The vampire queen re-

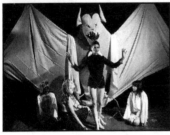
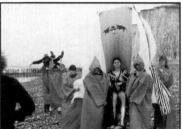

The scandalous *Le Viol du Vampire*.

sides in a private medical clinic, where her servant doctors search for an antidote for vampirism. They revive the body of one of the murdered vampire sisters. The queen informs her that another of her sisters is still alive, but that she has been blinded by the villagers during their attack. The body of Brigitte is revived and she returns to her lover, Mark, as though nothing had happened. Brigitte wanders in a trancelike state to the vampire clinic, followed closely by Mark. She enters a room housing comatose vampires that are intravenously fed with bottled blood. The vampire queen has lured Brigitte to the clinic with a tape recording of her seductive voice. Mark switches off the recording and Brigitte instantly collapses and dies. Two cloaked figures approach Mark but he kills them with his pistol. The clinic doctor turns against the vampire queen and a gun battle ensues.

The vampire queen presides over a theatrical vampire wedding ceremony. Thomas and the vampire sister assist the doctor in his at-

FASCINATION

tack. The queen makes her escape and feasts upon some bottled blood. She collapses in a series of painful convulsions and dies — the blood was poisoned. The doctor perfects his antidote on his female assistant and, cured of vampirism, she finally succumbs to death. Thomas and the remaining vampire sister are walled up within a stone building, away from civilization, so they cannot be tempted to feed on human blood again. They passionately kiss and prepare to spend an eternity together within the four walls, while Mark carries Brigitte's dead body through the deserted streets of Paris. He solemnly intones, 'I am the little boy who went to fish your scarf out of the sea. The presbytery has lost none of its appeal, nor the garden its radiance...'

Within the first ten minutes of Rollin's experimental and deliberately bizarre *Le Viol du Vampire* (*The Rape of the Vampire*), the audience is presented with a variety of connected narratives that blur the past and the present. To add to the confusion most of the characters are killed off after half an hour, yet they return for the second half.

It is of little surprise that its initial audience, no doubt expecting a Hammer-esque gothic vampire romp, were shocked by Rollin's deranged and surreal vision. At the premiere and subsequent theatrical showings (of which it received very few, and only in Paris), the audience howled in protest at the screen and caused riots. Cinema chairs were ripped from their stalls and thrown at the screen, along with anything else that might came to hand, such as food and drinks. At one screening, Rollin himself was actually pursued from the cinema and attacked by the audience. During the film's screening at the Scarletta Cinema, the police were called to repel the angered viewers.

Despite these vitriolic public reactions, *Le Viol du Vampire* remained obscure. Its controversy didn't endear it to French cinemagoers. The public reaction was not dissimilar to that of Luis Buñuel's *Un Chien Andalou* or *L'Age d'Or*, both of which are now considered classics. Whether you consider the film to be good or bad, *Le Viol du Vampire* is notable for provoking one of the most extreme reactions from a viewing audience in the history of motion pictures, something its gifted creator had never intended nor expected.

Le Viol du Vampire was destined for obscurity. The timing was bad, if nothing else. Home video was still over a decade away. Its outlandishness prevented it from airing on TV. Also, it was released

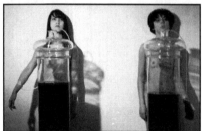

Le Viol du Vampire

during the Parisian revolution. The violent reactions to the film were overshadowed by the devastating riots occurring en masse in the French capital.

Several political and social issues were causing conflict and controversy in 1968. Most notable were the protestations against the war in Vietnam, France's poor educational system, and misrepresentation of news in the French media. Violence loomed oppressively in the air, and exploded on May 10, 1968, on the streets of Paris, a date now referred to in French history as 'The Night of the Barricades'. A massive strike ensued, putting ten million people out of work.

But to compound matters, French audiences were simply not ready for a film as strange and challenging as *Le Viol du Vampire*. After its release, French cinema critics blacklisted Rollin, writing him

off as a hack. His later connection with the French hardcore porn industry would cement this terrible reputation.

It is easy to see why audiences that expected a sort of Hammer Horror tale found the film hard to comprehend. Rollin's film isn't deeply plotted or slow moving. It relies on its stark, atmospheric images to carry it. Its intentions are very different to contemporary vampire offerings. *Le Viol du Vampire* is driven by its dreamlike ambience rather than a three-act narrative structure.

Made by an inexperienced film crew and largely improvised, Rollin's first, and only black and white feature film, remains his most idiosyncratic. Originally conceived as a thirty-minute short film, *Le Viol du Vampire* was born by pure chance. Motion picture distributor Jean Lavie, an associate of Rollin's, had bought the rights to an old American film directed by Sam Newfield titled *Dead Men Walk* (1943). Lavie's plan was to reissue the film to French audiences under the title *Le Vampire, Creature du Diable* (*The Vampire, Evil Creature*). There was a problem, however, as, being an American B-picture, *Dead Men Walk* only ran for one hour, thus was too short to be released as a major film in France. Lavie was left with two options: not release the film at all and cut his losses, or shoot another half hour of footage to fill up the running time. Rollin seized the opportunity and approached producer Sam Selsky with a short film idea titled *Le Viol du Vampire*. This could either be edited into the main feature or played before it as a short film. Either way, it was a winner for Lavie. The total cost of the film was around 100,000 Francs (approx £10,000). Rollin's small script was altered so much due to time restrictions and lack of finances that it bore little resemblance to what he had originally planned to make.

The final cut came out longer than expected at forty-five minutes. After viewing the footage, Selsky came to the realization that, with a little extra funding, they could turn their short film into a feature. There was no reason to pair the film with *Le Vampire, Creature du Diable*; they could just produce and release their own movie. Rollin prepared another script, *Les Femmes Vampires* (*The Vampire Women*), which would follow on from the final scene of *Le Viol du Vampire.* The final edit was a continuation piece in the same style as the American serials that Rollin loved so much as a child. Rollin simply continued the story at the exact point in which *Le Viol du Vampire* had originally ended — after the death of Thomas and the

final vampire sister on the beach. In this respect, *Le Viol du Vampire* can be seen as two films, with the second part working as a sequel.

Nonetheless, it works incredibly well as a whole. The opening titles credit the film as *Le Viol du Vampire: Un Mélodrame en Deux Parties* (*The Rape of the Vampire: A Two Part Melodrama*). At the climax of the original film another title sequence begins, complete with full credits, as *Les Femmes Vampires: Deuxième Partie* (*Queen of the Vampires: Part Two*), signalling the beginning of the new footage. Without these prompts, the viewer would have no idea that one film had ended and another begun.

It is interesting that Rollin didn't remove the title credits from the middle of the film. It would have been easier to fool an audience that it was a feature rather than two short films.

However, the rhythms of the two parts are noticeably different. *Le Viol du Vampire* uses fast editing techniques and alternates timelines, moving between past and present. The setting is very traditional yet impossible to pin down to a specific place or time — it could be set in the present or 100 years ago. A moving vehicle is seen in the distance during a wide shot of Brigitte stumbling through vast, barren fields. But this does not appear intentional.

Les Femmes Vampires is much calmer and somewhat simpler, with no further cutting between past and present. It is also obviously set in the present-day, as it features telegraph poles, busy city streets, a high speed car chase and a modernized medical clinic.

This distinct clash of style and location gives *Le Viol du Vampire* a dynamic edge, which works — it doesn't appear inconsistent. Obscure representation of time is a recurrent Rollin theme. The film possesses a classical gothic sensibility with its depiction of the present world being overwhelmed by the past.

The production was almost entirely improvised, and Rollin was still an inexperienced filmmaker. The second half looks smoother and more visually refined, signifying that Rollin learned a lot from making the original forty-five-minute short.

Le Viol du Vampire is visually complex and rich with symbolic imagery, containing many of Rollin's key themes and visual motifs. His feature debut can be seen as a model for his entire output. The locations echo throughout Rollin's work. *Le Viol du Vampire* presents us with a crumbling château, picturesque countryside and the sombre shoreline of Dieppe. The latter makes a particularly effective

backdrop for the lead protagonist's tragic fate; the vampiric curse spreading through their veins, the frantic couple are pursued to the shoreline and have nowhere left to run. Here they are gunned down in the surf. The deserted beach at Dieppe would continue to appear in Rollin's work, often at the end of his films, representing themes of fate and closure.

The locations and interiors are sharp with detail, and exquisitely captured via crisp black and white photography. The lighting is stark; ominous shadows continually surround the characters, engulfing them.

There are lasting images here, images that are difficult to forget once seen. The peculiar statue in the forest clearing is at once unsettling and beautiful. The opening scene offers the viewer the typically Rollin-esque image of a beautiful woman tied to a tree, with a bat crawling across her neck and bosom. A recurring shot of wooden skittles washed by gentle waves is another unique and playful image. It is also symbolic of the lead characters and their sombre fate: as the tide draws closer, the skittles will be engulfed and washed away by an unstoppable force of nature — they are unable to prevent the inevitable.

Rollin cleverly refers to this image again in *Les Femmes Vampires*. Seemingly minor images such as this perfectly affix the two films. Another memorable image is that of a bat skewered upon a sword. Bats would recur throughout Rollin's imagery in the seventies and eighties, most notably in *Requiem pour un Vampire* and *La Morte Vivante*. A vampire funeral procession is one of the most striking scenes in the entire film, along with an eerie shot of a vampire priest and inverted crucifix.

The camerawork is fluid, featuring some wonderful tracking shots — particularly when one of the vampire sisters goes to meet Thomas at the château gates; she steadily walks along a pathway lined by skeletal trees, the camera lurking behind her at a low angle. During an argument towards the end of the film, the camera circles the two protagonists at great speed, demonstrating their confusion and disorientation — a technique Brian De Palma would later use in *Body Double* (1984).

The strong symbolism and rapid cutting of the first segment is less evident in *Les Femmes Vampires*, which relies more on static shots and richer *mise en scène*. We are also suddenly plunged into the

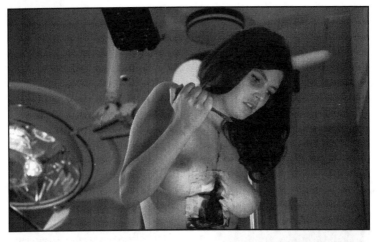

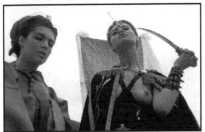

Blood, breasts and surrealism. *Le Viol du Vampire.*

present, without warning, and the majority of the film takes place in a vampire clinic run by the seductive vampire queen. The subplot in which the servant doctors attempt to create a vampire antidote is the first of many medical and modern technological themes that appear in Rollin's pictures, such as *La Nuit des Traquées*, *La Vampire Nue* and *La Morte Vivante*.

Les Femmes Vampires' sterile laboratory backdrop is very brightly lit compared with the gloomy locales and dark interiors of *Le Viol du Vampire*. This stark contrast effectively signifies that we have moved from the gothic past to the modernized present. But abrupt changes like this no doubt caused confusion and consternation for its original audience.

The final scenes of the theatrical vampire wedding are suitably chaotic. The music that accompanies this sequence is erratic and experimental. Rollin integrates it wonderfully into the action as we

FASCINATION

see a vampire band (possibly an influence on *From Dusk Till Dawn*, 1996) churning out the unique, unsettling sound for the surreal ritual (one of the musicians is Rollin's score composer).

Rollin's vampires are not presented as objects of fear or power. They adhere more to the traditional gothic mode and are represented as weak and doomed. The vampire queen in *Les Femmes Vampires* is far from a terrifying force of evil and stands removed from other bloodsuckers from sixties horror cinema. Even the opening monologue delivered by the sinister old man reveals the impending doom of the lead characters.

The final shot of *Les Femmes Vampires*, and the final shot of the whole film, is a wonderful composition of Mark carrying Brigitte's dead body. Photographed from a low angle, we see Mark wandering into the distance towards a stone landmark that resembles a tombstone, a fitting symbol that brings the film to a close.

Considering the film was made in 1967, the visual representation of erotic, sexualized imagery is quite daring. Although the nudity and violence are not dwelt upon, certain scenes depicting 'sexualized violence' remain contentious for the BBFC in the UK, where the movie is still censored by forty-one seconds. The US DVD by Image entertainment is uncut and features an extra shot of nudity missing from other release prints. UK horror magazine *The Dark Side* released a double bill (mail order only) with *La Morte Vivante*, which is uncut (although it wasn't re-certified by the BBFC). *The Dark Side* seem to have taken a chance with this one, preserving the full version and cheekily bypassing the censor completely.

Le Viol du Vampire: Un Mélodrame en Deux Parties is a very ambitious film. Fans of surrealism will no doubt find it a fascinating experience. Rich in gothic atmosphere and stark visuals, the film is a wonderful introduction to Rollin's style and themes and is a clear precursor of his visions to come.

Despite its scandalous reputation in 1968, *Le Viol du Vampire* was eventually appreciated several decades later in a similar theatrical environment when Rollin obtained a 35mm print of the film for a screening at the Cinémathèque Française, a semi-mainstream theatre in Paris. The audience sat respectfully and in silence throughout the entire film, a striking contrast to the screams and howls of protest that greeted the picture on its initial distribution.

'You persecute them because they are different … you're the ones

who are crazy', pronounces Thomas in the *Le Viol du Vampire*. It's a sentiment that might easily have been directed to the original audience in 1967 and the critical mistreatment of Rollin's unique debut. In any case, Rollin continued to make films and his passion for cinema and desire to tell stories never diminished.

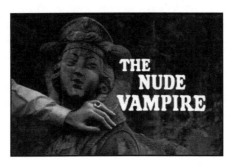

La Vampire Nue
The Nude Vampire

AKA: *The Naked Vampire*
1969 / Les Films ABC
88 Mins, Colour 35mm, Original Ratio: 1:66:1
Director: Jean Rollin **Screenplay:** Jean Rollin **Producer:** Jean Lavie
Director of Photography: Jean-Jacques Renon **Music:** Yvon Gerault
Set Décor and Costumes: Jio Berk **Masks by:** Jacques Courtois
Cast: Caroline Cartier — credited as Christine François (Vampire Girl), Olivier Rollin credited as Olivier Martin (Pierre Radamante), Maurice Lemaitre (Georges Radamante), Bernard Musson (Voringe), Jean Aron (Fredor), Ursule Pauly (Solange), Catherine and Marie-Pierre Castel — credited as Cathy and Pony Tricot (George's Servant Girls), Michel Delahaye (Grandmaster), Pascal Fardoulis (Robert), Paul Bisciglia (Butler), René-Jean Chauffard (Old Man), Natalie Perrey (Old Woman), Ly Lestrong (Ly), Jacques Robiolles (Mutant)

'We are the prototype of future man. The first mutation of the human race, announcing tomorrow's race. Vampires have never existed, but there are mutants.'

In a secret laboratory several masked figures strip a woman of her

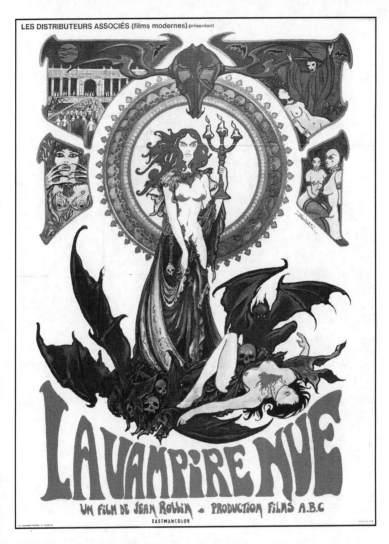

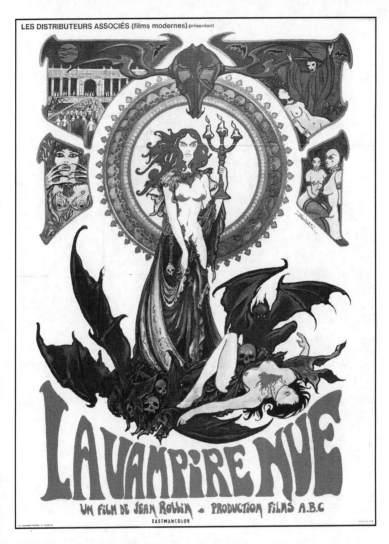

LES DISTRIBUTEURS ASSOCIÉS (films modernes) présentent

LA VAMPIRE NUE

UN FILM DE JEAN ROLLIN · PRODUCTION FILMS A.B.C

EASTMANCOLOR

clothing and take a sample of her blood — she is unafraid. A gang of
individuals wearing animal masks pursue a beautiful woman through
dark city streets. She happens upon a young man, Pierre, who tries to
help her, but she is shot dead by a masked figure. Pierre escapes into
the night and the masked murderers sombrely carry the woman's
body away. Pierre follows them to a secluded building that belongs to
his father, Mr Radamante. A group of well-dressed individuals arrive

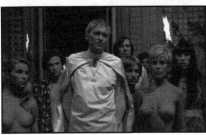

Mysterious Cults in
La Vampire Nue.

at the gates. Pierre tries to enter but he is not permitted without a ticket. The next day Mr Radamante berates Pierre for meddling in his private affairs.

Pierre sets out to unravel the mystery and sneaks into one of his father's bourgeois parties. The guests observe an image projected onto a wall, it is that of a beautiful young woman who is also a guest at the party. The woman steps forward from the crowd and the projectionist hands her a revolver. Smiling, she calmly shoots herself in the head. The beautiful woman from the opening sequence, who was presumably shot dead, drinks the blood of the dead woman. The projectionist shows the next image. It is Pierre. He shoots his way out of the party

FASCINATION

and escapes. Next, Pierre sneaks into his father's private clinic with his friend but he is caught by a beautiful vampire. Radamante claims that the beautiful woman is an orphan, suffering from a rare blood disease and a severe allergy to sunlight. It transpires that the bourgeois suicide club belongs to a cult that worships the vampire. The vampire girl is but a tool for Radamante's greedy quest for immortality, and his suicide group was concocted in order to feed the vampire. The authorities discover several dead bodies, forcing Radamante to relocate to the outskirts of Paris. The vampire girl wanders the darkened corridors of Radamante's secluded château and drinks from the bleeding breast of a cult member. The cult that worships the vampire sets out to liberate the bloodsucker from Radamante. By candlelight, the vampire cult stalks the château grounds and a bloody battle ensues. Radamante and his men are overpowered.

Pierre is guided by a mysterious voice that leads him to an abandoned theatre in the countryside, wherein an old couple wait behind a desk. They offer him a red ring and he disappears beyond a deep red veil of curtains on the stage. He is suddenly transported to a cold shingle beach and is surrounded by the cult leader and his vampire servants. Pierre's pistol has no effect on the cult leader, who verbally indicts Radamante for his exploitation of the vampire girl. She had been forced into vampirism and tricked into believing sunlight would harm her. A red coffin on the beach opens and the vampire girl emerges. She and Pierre are united together in the surf. Radamante disappears into thin air as he proclaims his unique sect to be the first mutation of the human race ...

Rollin's second feature film is a highly original and colourful mystery that blends science fiction with the vampire myth. He had loosely explored scientific and medical themes in relation to vampires in *Le Viol du Vampire*. In *La Vampire Nue*, these themes are more important to the development of the characters and the narrative.

La Vampire Nue was more conventional in structure and did not provoke a violent reaction like his previous work. Although not a huge commercial success on its initial Parisian theatre run, it did manage to acquire wider distribution. It played English cinemas in a dubbed form in 1973, where it was quite successful amidst the native, more formulaic, Hammer and Amicus horror productions.

Rollin's intention was to make a more conventional mystery pic-

The Celluloid Dreams of Jean Rollin 71

ture. The narrative is much simpler and has more in common with the traditional three-act structure found in mainstream films from this same period.

Rather than plunge the viewer into the timeless void and erratic structure of *Le Viol du Vampire*, Rollin takes his time here setting up his story. The characters are established in a more typical manner and the mystery of the narrative is unravelled by progressively revealing pieces of information. When the film shifts into more bizarre territory in the second half, it has greater impact because the viewer has already built a firm understanding of the characters and their reality within the framework of the narrative. Rollin lures the audience in by conventional means and then allows events to become more unsettling and weird. The title sequence is a good example of this. It is composed of a single static shot of old statue. An obscured individual rests a hand upon the stone surface; a large red ring is visible upon the finger. At this point, we are unaware of the image's relevance or even the gender of the person the hand belongs to. As the narrative progresses the relevance of the red ring become apparent: it belongs to the cult leader, and so this small puzzle is completed. Yet there are many more puzzles to be solved. What exactly is Radamante trying to achieve and for what purpose? How is Pierre linked and why is he so obsessed with these events? Who are the suicidal masked cultists? Is the film about vampires or other 'monsters'? All of these questions are eventually answered and Rollin cleverly feeds us bits of information as Pierre pieces the puzzle together. With *La Vampire Nue*, Rollin invites audiences to revel in a playful mystery rather than challenge or provoke them.

La Vampire Nue had a bigger budget (it actually went over-budget) and was intended for a wider audience. This is not to suggest that *La Vampire Nue* is a typical horror film. It is filled with extremely bizarre imagery and offbeat sequences quite out of place in the mainstream. Rollin isn't content to recycle the vampire as a one-dimensional monster, but plays with the mythology.

Nevertheless, it is certainly a film of its time, with its loud colour schemes, outlandish, camp costume design and strange set decoration. Everything has a distinct late sixties psychedelic flavour, particularly in the first half set in Paris. When the story takes us to the outskirts of the city and to the isolated château, the colour scheme takes a blander, darker turn, reflecting the events of the

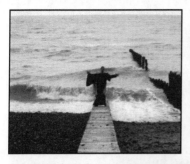

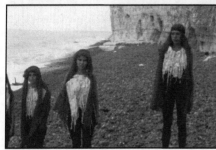

The beach at Dieppe (top & bottom left). Hypnotic seduction (above). *La Vampire Nue*.

story. The gothic tradition of the past overwhelming the present becomes overt and literal when the characters flee the modernized city, heading to the country retreat, lit by candles rather than light bulbs. From here on in, the film plunges into a timeless world of old architecture and eerie graveyards. These past/present, modern/archaic themes lie at the core of *La Vampire Nue*, and Rollin's filmography as a whole.

Take the laboratory sequence at the beginning of the film, which mixes colourful surroundings and modern technological equipment with the eerie, handmade animal masks. The shots of the masked individuals roaming the cobbled city streets force the natural world and the modern world to collide. These pagan-esque masks bear a strong similarity to those later featured in Robin Hardy's *The Wicker Man* (1973), another film were past and present are in collision, and were inspired by Georges Franju's *Judex* (1963).

With *La Vampire Nue*, Rollin evolves the vampire mythos, as per Radamante's pursuit of immortality through scientific blood research. At the end of the film, the cult leader suggests further evolution of the vampire, pronouncing, 'You are powerless against evolution. Tomorrow, today, at any moment, the day of the mutants will

arrive'. Several years later, the American production *Grave of the Vampire* (1974) would echo this concept with the idea of the 'day-walker' — mutant bloodsuckers that can stand sunlight. The comic book blockbuster franchise *Blade* (1998), from developed the idea further. Also ahead of the curve is Rollin's concept of conditioning a child to believe they are a vampire. This pre-dates George A. Romero's *Martin* (1976), in which a disturbed young man has been conditioned to believe he is a vampire and therefore must feed on human blood (lacking elongated canines he utilizes razor blades). Even the final sequence depicting Pierre disappearing beyond a huge red curtain recalls David Lynch's representation of the void in the cult hit TV series, *Twin Peaks* (1990–91).

The beach at Dieppe is the setting for finale and again presents us with a scenario in which a lead character is trapped between the high cliffs and the seemingly endless ocean.

In another scene, a female cult member cuts her breast to allow a girl conditioned into vampirism to suckle from the wound. Breast milk is substituted for blood here — an arresting visual metaphor for the nourishment of the vampire. (Another idea also incorporated into *Grave of the Vampire*.)

Rollin represents the upper-class bourgeoisie as sinister figures. Radamante treats his servant girls as objects and playthings, dressing them in revealing, kitsch costumes. Eventually, the servant girls rebel, joining forces with the cult to contribute to the downfall of their evil master. The servant girls are played by the Castel twins, who would appear in Rollin's next film, *Le Frisson des Vampires*, where they undergo a similar journey. (Another face in *La Vampire Nue* that would return in other Rollin movies belongs to Michel Delahaye.)

The blend of beauty with subtle horror would become one of Rollin's trademarks. When Pierre is reunited with the orphan 'vampire' her innocence is tainted by her trancelike expression and the single speck of blood on her lips. The sequence in which Robert paints a naked woman is also noteworthy. The scene begins with voyeuristic overtones as Robert watches his model. The camera lingers upon her body as she caresses herself with her golden fingernails. The painter is hypnotised by his seductive subject. The strangeness of the scene is enhanced by the unusual jazz-influenced soundtrack, which does not adhere to any tempo or obvious rhythm.

The slide projection suicide scene is a standout in terms of its eerie atmosphere. Where has the photograph of Pierre come from? When was it taken and who took it? Has Pierre been there before? How did they know he was coming? There are so many questions, but few or no answers, generating a sense of helplessness and horror. This terrific sequence is marred only by the poorly rendered execution of its victim; she places a gun to her own head and with a smile she pulls the trigger. On a visual level it's extremely effective, but the pathetic sound effect of the gun diminishes the impact — it sounds like a toy. No doubt this caused some unintentional laughs amongst audiences.

Rollin's films teeter on the precipice between exploitation and arthouse cinema. The rainbows of colour, flamboyant characters, and naked female flesh give *La Vampire Nue* a distinct 'Eurotrash' sensibility. It's too odd and kitsch to be taken seriously, though rich with metaphors, as well as striking visual motifs and ideas. For instance, near the beginning of the film we are treated to an exotic dance sequence featuring a woman dressed entirely in red, with blood red hair and golden fingernails. Although it could certainly be perceived as exploitative and trashy, the scene can be read on a deeper level. It is symbolic of the vampire orphan's relationship with Radamante; she is merely a puppet, controlled by her master for his own ends. The jazz-influenced music score incorporates elements from *Le Viol du Vampire*. Several eerie audio effects were also reused in Rollin's next feature, *Le Frisson des Vampires*, such as the manipulated audio of a woman's scream and the enhanced sound of birds. These audio effects are also used in graveyard sequences in both films.

Beauty is again forefront in the visual presentation of the film. *La Vampire Nue* is rich with exquisite colour and detail courtesy of cinematographer Jean-Jacques Renon. Static shots are beautifully framed and synchronized, particularly the wide angle shots of the cult members with flaming torches wandering the château grounds. Rollin's trademark use of pale blues is prominent towards the end of the film. We witness a striking contrast as the cold blue stone walls of the château are overcome with warm orange colour tones upon the arrival of dozens of flaming torches. Another striking composition features Pierre watching the servant twins as they descend a staircase either side of him, disappearing and reappear-

ing simultaneously amidst the architecture. Even simple shots are a joy, such as the cult leader snuffing out the candles on a candelabra, despite its excessive length.

Fans of Hammer and Universal Pictures monsters will probably be disappointed. *La Vampire Nue* is not a traditional vampire film. It blends elements of the supernatural and conventional vampire lore with modern science and mystery. However, the erotic imagery and trippy sixties trappings will find its fans.

Although the film played uncut in France, it wasn't so lucky with the UK censors. It received a theatrical run in England as *The Nude Vampire* in a censored and dubbed form (running 84m 45s) with an X certificate. The mid-nineties UK VHS release from Redemption was fully uncut but dubbed in English. Redemption later released the film on DVD in the UK and USA completely uncut in French language with English subtitles. The French DVD features the original version, but is in full screen and without the option of English subtitles. Redemption have recently released the film on Blu-ray in the USA in a stunning transfer that shows off the complex colour palette and the depth of framing.

Le Frisson des Vampires
The Shiver of the Vampires

AKA: *Sex and the Vampire; Strange Things Happen at Night; The Terror of the Vampires; Thrill of the Vampires; Vampire Thrills*
1970 / Les Films Modernes, Les Films ABC
95 Mins, Colour, 35mm, Original Ratio: 1:66:1
Director: Jean Rollin **Screenplay:** Jean Rollin, Monique Natan **Producer:** Robert Picard **Director of Photography:** Jean-Jacques Renon **Editor:** Olivier Grégoire **Music:** Acanthus
Sound: Jean-Paul Loublier **Makeup:** Eric Pierre
Art Director/Decors: Michel Delesalles **Cast:** Sandra Julien (Isle), Jean-Marie Durand (Antoine), Jacques Robiolles (Vampire), Michel Delahaye(Vampire), Marie-Pierre Castel — credited as Marie-Pierre (Maid), Kuelan Herce (Maid), Nicole Nancel (Isabelle), Dominique (Isolde)

'I belong to the world of darkness, whose eternal joys will be yours.'

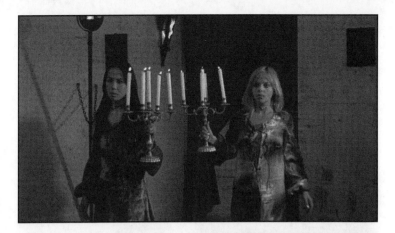

Le Frisson des Vampires

Dressed in funeral attire, Isabelle and her two servant girls watch silently as two coffins are taken inside a crypt. In a huge isolated castle, the two servant girls visit their dying masters, two male vampires in their final, agonising death throes — both staked through the heart. The master informs the servant girls the curse must be stopped, and upon his death, they should instantly proceed to the castle cemetery and destroy the final vampire, Isolde. They fail and the servants are forced to serve Isolde in order to spare their own lives.

Newlyweds, Isle and Antoine, drive through the French countryside. They plan to spend their honeymoon at Isle's cousins' isolated castle. Upon arrival, they are told Isle's cousins are both dead, but the servant girls welcome them regardless. Isle visits her cousins' tomb and meets Isabelle who also mourns there. She informs Isle that she was destined to marry both of the deceased. It is her wedding night, but Isle wishes to sleep alone. Upon undressing at the stroke of mid-

The Celluloid Dreams of Jean Rollin 77

night, a sombre female vampire, Isolde, emerges from a grandfather clock and seduces Isle. She is led in a trance to the cemetery where the two servant girls are waiting. Isolde caresses Isle's naked body before sinking her teeth into her neck. Meanwhile, Antoine witnesses a bloody murder within the castle walls: the two servant girls hammer a wooden stake into a dead girl's heart, as two well-dressed men look on, with bloodstained lips. The next day, the newlyweds discover that Isle's cousins are not actually dead but still reside in the castle. At nightfall, Isolde emerges from a smoking well to drink from Isle's neck again.

In the nearby village, the mourning Isabelle recalls that her two lovers, the bourgeois cousins, used to be vampire hunters and were killed by vampire bites. Isabelle visits the castle in her grief and comes face to face with her supposedly dead lovers. Isolde kills her with tooth-like spikes that protrude from her nipples. Antoine becomes progressively more uneasy with the sinister cousins and the strange events that are occurring. He tries to persuade Isle to leave but she refuses. Isle becomes weaker and weaker, suddenly developing an aversion to sunlight and a craving for blood, which she satiates with a dead dove. Antoine revolts against the two bourgeois cousins but they overpower him and tie him up. The time has come for Isle to receive her final vampire kiss and join her cousins in eternity. The servant girls free Antoine and he and Isle manage to escape. Isolde returns to her coffin only to find it ablaze. The servant girls remove the covers from the crosses and Isolde dies upon their sight, gorging herself on her own bleeding wrist. The two servants dance together in happiness in the cemetery — free from their curse and their masters. Antoine and Isle reach a dead end, a deserted shingle beach. Isle is forced to choose between her cousins and her husband, the living and the dead. As daybreak arrives she chooses her bloodline and the sunlight wipes her and her cousins from the earth, leaving Antoine alone on the deserted beach, screaming Isle's name ...

Alongside *La Plus Longue Nuit du Diable* (1971) and *Vampyros Lesbos* (1971), this film is considered an exemplary slice of 'Eurotrash' cinema. It is full to bursting with outlandish images, nudity, camp scenarios and arresting symbolism. On a technical and artistic level, it is a step up from *Le Viol du Vampire* and *La Vampire Nue* and it stands as one Rollin's most accomplished, poetic films.

Rollin doesn't waste a single frame. His direction is tight and

FASCINATION

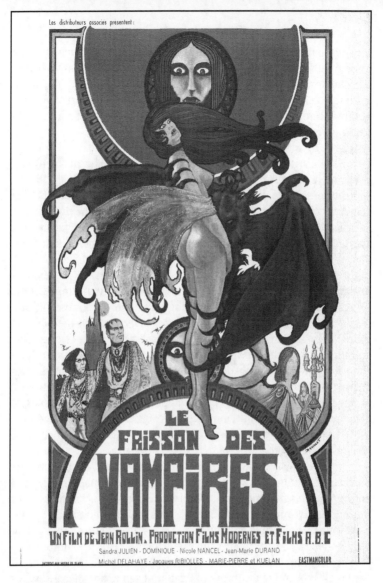

thoughtful and Olivier Grégoire's editing is fast and fluid. Rollin creates a strong sense of mystery as the film drives towards its sombre climax. Nothing is quite as it seems on first glance and Rollin builds unease and tension by revealing pieces of information one at a time. The sepia-tinted opening sequence makes for a great begin-

The Celluloid Dreams of Jean Rollin 79

ning, generating an eerie mood with its imagery and unanswered questions: Who lies within the coffins? Why are they dead? Who are the sinister women who preside over the entombment? The sombre faces of the mourners and the desolate tolling bell add further disquiet to the proceedings and are reminiscent of the classic Universal horror era.

The first fifteen minutes are a spellbinding fusion of lush images and vibrant music that moves at a fast pace. The perfectly appropriate soundtrack by the experimental rock group Acanthus is reminiscent of Black Sabbath's calmer instrumental moments. The score, dictating the rhythm of the film, is integral to the movie.

After the solemn sepia-toned opening, the movie abruptly cuts to the title sequence. The vivid red title fonts play over a static image of a rain-soaked, mist-enshrouded graveyard in the black of night. Accompanied by a driving instrumental rock piece that instantly grabs the viewer's attention, this single two-minute static image is made enigmatic and exciting. After this loud music-driven intro, the tempo drops as the camera prowls through the isolated castle to reveal the servant girls played by the Castel twins. The soundtrack is tightly synchronized with the onscreen action and the score develops with their movements. The camera pans with the servant girls as they intermittently pass by the castle windows, a single guitar note playfully accompanies each brief appearance. The music evolves with the images. A good example is the scene in which Isle discovers Isolde's coffin and places a bleeding dove upon the polished wood.

Acanthus' wonderful score was improvised and it perfectly accompanies Rollin's improvised visuals to create a sublime fusion of sound and image. The band's soundscapes cover a range of styles and moods, from driving rock segments, subtle and sinister compositions (for example, during cult sacrifice sequences), through to gentle pieces. Isle's arrival at the castle and her first encounter with Isolde is a great example of the latter. The soundtrack is wonderfully playful as Antoine attempts to fix his car while one of the servant girls laughs innocently at his futile efforts.

Le Frisson des Vampires is endlessly beautiful, possessing a colourful and hypnotic quality. Vibrant lighting dominates the screen, the striking colour design being comparable to Italian horror cinema of the seventies and early eighties, if less garish (think Mario

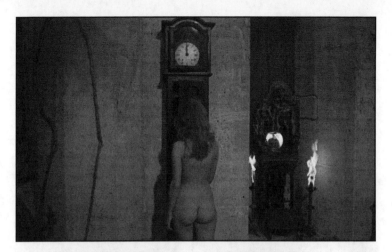

The hour of seduction (top). The beautiful Marie-Pierre Castel in a playful mood (bottom left & right). *Le Frisson des Vampires*

Bava). Certain shots linger in the memory. Most notable are the blue-tinted finale on the beach at Dieppe, a goldfish bowl encased inside a grotesque red flesh-like statue (a skull with burning eyes can be seen through the water), and a static shot of Isolde with undead eyes standing frozen on the fog drenched castle steps. Even shots of the old castle at night are exquisite — lit up in pink and purple against a darkening blue sky.

The camera itself is very limited, in terms of actual movements, other than pans and tilts. Rollin makes full use of these techniques, however, particularly during the dining scenes when the bourgeois vampire cousins circle the small room spouting their weird dialogue. One particularly bizarre static composition frames two characters slightly out of shot to the left and right of the frame, and the

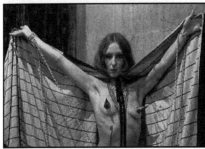

Striking images in *Le Frisson des Vampires*.

characters take it in turns to lean into shot and address the camera directly. At first the effect appears clumsy, but then works its magic as an interesting POV shot from Isle's perspective. The viewer is forced to feel her disorientation.

The use of jarring jump cuts is not quite as successful. The scene in which Isolde is first introduced is very poorly executed. Jump cuts make the concrete slabs that cover her grave magically disappear one by one. The shadow of a crewmember is evident in the bottom of the screen between edits, and an item of purple clothing intrudes into the top of the frame, making the edits more noticeable and spoiling the effect. This sequence is only salvaged by its unsettling soundtrack and manages to retain some of its intended chilling atmosphere; as each slab disappears, a distorted animal-like scream is audible. Another jump cut is utilized later on in the film to signal the arrival of Isolde over a smoking well. Again, this is clumsily rendered because the mist differs between each cut.

More effective are scenes that are intercut with 'random' shots that further express situations and emotions, a technique he had previously used in *Le Viol du Vampire*. The scene in which Antoine recalls the cult sacrifice is suddenly intercut with an incestuous les-

bian interlude between the two servant girls. Cutting from such a tense sequence to such an image would normally look out of place, but Rollin creates from it an atmosphere that is unnerving.

As is often the case with Rollin, the plot is more intricate than one first realizes and the director's intelligent use of symbolism pervades throughout, with images that foretell events and predict grave fates for the main characters. Isle's terrible destiny is hinted at from the beginning. Rather than focusing on her honeymoon and her future marriage, she is unable to resist revisiting her past. From the outset, the future is not important and we quickly leave the open roads, the power lines, and civilization, for an antiquated candlelit world where electricity is absent and unimportant. The sequence in which she enters the graveyard, still virginal in her white wedding attire, depicts her as lost in the past, and, as we lose sight of her amidst the towering tombstones, she is consumed by death.

Almost every scene is rich with metaphor. When Isolde emerges from a huge coffin-like grandfather clock, it serves as a reminder that time is endless and meaningless to the vampire. Later in the film Isle embraces the same clock, its hand stuck permanently on midnight; she is ready to embrace eternity and welcomes her fate.

A humorous portrayal of 'vampire art' can be seen on the wall when Isolde murders Isabelle. Framed in straw is an abstract image of two small black holes accompanied by a splash of blood red paint, symbolic of the vampires kiss and a subtle precursor to the scene in which Isolde penetrates Isabelle with metal 'teeth' that protrude from her nipples. The shot of Isolde holding her cloak high above her head revealing her deadly steel nipples has become an exemplary symbol of 'Eurotrash' cinema. The breasts, which in nature represent life and nourishment, become deadly without warning, contrasting life and death. Elements of the natural world linger in the film's scenes of horror. When Isolde bites Isle for the first time, piercing sounds of seagulls flood the soundtrack. Later in the film, Isle drinks the blood of a dove.

The predatory atmosphere is enhanced by the incorporation of distorted, manipulated animal sounds, which serve as a reminder of the bestial nature of the vampire. The sound of the gulls in the vampirism scene not only has natural/predatory connotations, but is also a very subtle precursor to the fate that awaits Isle on the beach. The beach signals the end of Isle's journey and upon reach-

The Celluloid Dreams of Jean Rollin 83

ing the shoreline there is nowhere left for her to go. Her destiny is sealed and she dies with her last remaining blood relatives.

Le Frisson des Vampires is a mood piece, gently flowing towards its downbeat conclusion. When the horror elements are introduced, they are rarely used for maximum shock. We see very little onscreen violence, most of it is implied, as when Isle drinks blood from a dead bird. The most striking aspect of the scene is not the horror of the act, but the memorably romantic image of vampirism, with Isle wearing sunglasses and with bloodstained lips.

Rollin uses many elements of supernatural phenomena. At the crypt, graves are uncovered mysteriously before our very eyes and iron gates open on their own accord. Antoine is attacked by an unseen force in the library and is drowned in books. Characters literally disappear into thin air.

Seconds after a vampire is struck down by sunlight, we abruptly cut to a low angle shot of the castle. Like a tombstone, its towers reach up into the sky. A torrent of blood pours from a dark window and runs down the stone walls, accompanied by a crescendo of drum cymbals. Such visual effects are crude and cheap but in the context of the film it doesn't matter. (Although Rollin's crew struggled to remove the bloodstains after shooting the above scene, and the owners of the castle were far from impressed.) The emphasis is not on detailed flesh wounds and images of bodily dismemberment. When a vampire is staked through the heart, the effect consists simply of the actor holding the pointed wood in place. When the servant girls pound a stake into a dead woman's chest, the victim can clearly be seen breathing. The emphasis is on mood rather than grotesquery, but it also creates a childlike, fairytale atmosphere.

All told, *Le Frisson des Vampires* is a great place to start for anyone interested in discovering more about Rollin's work.

The film received wider distribution than Rollin's two previous films but, unsurprisingly, it was hated by critics, who regarded it as a typical slice of dispensable Euro-sleaze. Released theatrically on September 13, 1971, in the UK by the English Film Corporation Ltd, the film was re-titled *Sex and the Vampire* and badly dubbed. Heavily edited by its distributor, it ran for only 71m 31s. The BBFC granted this worthless version an X certificate without further cuts and it was marketed as a softcore sex film.

The UK, USA and French DVD releases are all uncut. The US

Blu-ray from Redemption is by far the best version, sourced from a beautiful print that showcases the varied and vivid colour tones.

Rumours persist that all commercially available DVD versions are censored but this is untrue. A longer version does indeed exist but it contains extra sex footage not shot by Rollin, which was edited into the American version to spice up the sleaze content. The versions available from Redemption and Image Entertainment represent Rollin's preferred cut.

Monique Natan, Rollin's script collaborator for *Le Frisson des Vampires*, announced another vampire project to be directed by Rollin and also starring Sandra Julien. The film was to be titled *Docteur Vampire* but Natan died in a car crash and film was never made.

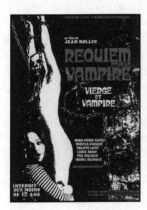

Requiem pour un Vampire
Requiem for a Vampire

AKA: *Caged Virgins; Caged Vampires; Crazed Virgins; Dungeon of Terror; Sex Vampires; Vierges et Vampires; Virgins and Vampires; The Crazed Vampire; Virgins and the Vampires (USA)*
1971 / Les Films ABC
88 Mins, Colour, 35mm, Original Ratio: 1:66:1
Director: Jean Rollin **Screenplay:** Jean Rollin **Producer:** Lionel Wallmann **Executive Producer:** Sam Selsky **Director of Photography:** Renan Pollès **Editor:** Michael Patient **Music:** Pierre Raph **Sound:** Patrick Dard **Cast:** Marie Pierre Castel (Marie), Mireille d'Argent (Michelle), Philippe Gasté (Frédéric), Louise Dhour (Louise),

Michele Delesalle (Old Vampire), Dominique Toussaint (Erica), Dominique, Antoine Mosin, Olivier François, Agnès Petit, Agnès Jacquet, Anne Rose Kurra, Paul Bisciglia

'All the paths lead back to the château ...'

Gunshots shatter the peaceful countryside during a high speed car chase. The car being pursued has three occupants — two women dressed as clowns (Marie and Michelle) and a male getaway driver, who is shot during their escape. After evading capture the two women kiss their dead driver goodbye and set fire to the vehicle. They wander into the rural countryside, removing their face paint in a pond. At their rendezvous point they obtain a motorcycle and steal food from a roadside vendor. After dumping their motorcycle, they rest in a deserted cemetery, only to be disturbed by two gravediggers. Unaware of the girls' presence, the gravediggers almost bury one of the girls alive but her companion saves her just in time. Entering an ominous stretch of woodland, they stumble upon a hoard of vampire bats and ancient castle ruins. They explore the deserted stone interiors and find a maggot-ridden, decomposing corpse and a bloodied hand chained to a wall. The two girls are then pursued by a female vampire named Erica. Their gunshots have no effect upon their predatory pursuer. Three bestial servants suddenly appear and attempt to rape the women but are prevented by another female vampire, who whips her brutish slaves into submission. The two girls are presented before an ageing head vampire, who releases bats from his cloak that suckle upon their blood. They are led to a candlelit dungeon and forced to watch the vampires murder a young woman. A rape orgy ensues. The two women reveal they are on the run after murdering a man at a New Year's Eve party and they have become lost. The ageing head vampire sinks his teeth into their necks and initiates them into the world of the undead. The next day, the two women awake on a fur-lined bed and the previous night's events seem like a distant dream. They try to escape the castle grounds but all the paths lead back to the crumbling ruins. The two girls are forced to lure innocent victims to the castle for the vampires to feast upon. Two male victims are brought to the castle and Erica quickly dispatches one of them before instructing one of the girls to drink the dead man's blood. The second girl lures a man, Frédérique, to the castle and makes love to him. She

FASCINATION

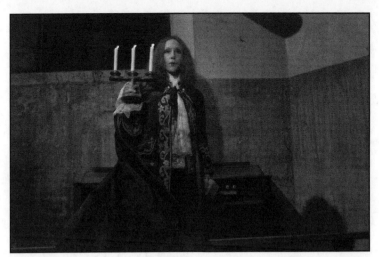

Dominique Toussaint as Erica. Gothic imagery
from *Requiem pour un Vampire*.

tells him to hide and says she will explain everything to him later.
When the vampires learn of Frédérique, they call for his death before
the next sunset. Later, in the dungeon, the blonde girl is suspended
naked and her companion is forced to whip her to obtain information
about Frédérique's whereabouts. Tears flood her torturer's eyes as
she is forced to hurt the one she loves. No longer able to continue the
interrogation, Erica enters and threatens to plunge a dagger into the
tortured girl's eye. She reacts quickly and unfastens her lover's chains.
Erica allows them to escape in an attempt to flush out Frédérique.
The two girls help Frédérique escape and shoot down the bestial as-
sistants. As Erica closes in for the kill, the head vampire appears and
spares their lives. He instructs his vampire followers to lock him in the
tomb until his death, then bury his remains and seal off the entrance
to the dungeon ... 'there will be an end to crimes and bloodshed'. The
two girls flee into the night and the final female vampire guards the
head vampire's tomb.

Requiem pour un Vampire is Rollin's most successful, celebrated
film and it was also his personal favourite. It is fair to say that, with
his fourth feature, he had found his cinematic voice and honed his
unique style as an auteur filmmaker.

The film takes the viewer on a sublime dreamlike journey, rich
with emotion and beautiful imagery. The sumptuous photography

The Celluloid Dreams of Jean Rollin

Naïve innocence: Marie-Pierre Castel (top). Erica (Dominique Toussaint) claims a victim in the dungeon (right). *Requiem pour un Vampire.*

by Renan Pollès lovingly dwells on picturesque rural locations. The gentle rhythm of the film is guided by lyrical visuals and gives the impression of a freeform celluloid poem.

The screen is often bathed in deep reds, greens and blues — permeated with detailed stone structures, including crumbling castle grounds and graveyard headstones. For the night-time graveyard sequences, Rollin cleverly used lighting techniques to remove structures and buildings that did not interest him or that would have detracted from the timeless ambience of the film. Even in the darkness, the film has a tremendous sense of depth with illuminated headstones glowing far into the distance.

Once again, the director introduces bizarre elements to a natural landscape. Early scenes, depicting the two beautiful female leads dressed as clowns wandering the countryside, are priceless and evoke a strong sense of the surreal typical of Rollin's work. The se-

FASCINATION

quence in which they kiss their dead accomplice goodbye is incredibly startling. Their painted smiles contradict the tears in their eyes, while the solitary speck of blood that adorns one of the girl's lips also provides an unsettling suggestion of the vampirism to come.

Requiem pour un Vampire is Rollin's purest film, and was largely improvised from pre-production to final edit. The original idea began with a single image: Rollin's friend, Louise Dhour, sitting at a piano in the dead of night in a cemetery. This sequence made it into the final cut and was actually the most expensive scene to shoot, as the piano had to be driven from Paris to the graveyard location. Rollin completed his initial script over the course of one night, writing one random sequence before moving directly onto the next without overanalysing the narrative. Even the romantic title, *Requiem pour un Vampire*, wasn't conceived with much thought. It was literally pulled from a hat when Rollin and Selsky couldn't agree on a title. It was actually Selsky who came up with the title.

An overwhelming dreamlike intensity drives the logic of the film. Bizarre set-pieces occur without warning: a woman is buried alive but manages to escape her doom, thieves dressed as clowns are pursued through the French countryside. There are several erotic seduction scenes, lesbianism, rape, as well as ageing bloodsucking vampires. The scene in which the two leads attempt to escape the castle after their first night of terror offers the viewer a classic nightmare scenario: no matter how fast or how far they run, they are unable to escape their doom and always wind up back at the beginning. The only thing that changes is the escalation of their panic and alienation (Rollin also explored this concept in *Les Pays Loins* and *La Rose de Fer*). Even seemingly minor details enhance the dreamy ambience, such as the conveniently discovered motorbike at the water tower that allows the leads to escape their pursuers.

Of all Rollin's films, *Requiem pour un Vampire* is the closest to classical silent cinema. Apart from a few ambiguous words spoken during the car chase and the cemetery sequence, there is no dialogue for the first half of the film. The two main characters do not confer and everything exists in a purely visual sense, making every lavish image feel like a moving painting. The whole film features only a couple of pages of spoken dialogue from beginning to end. When dialogue is incorporated, it is delivered in such a sparing and direct manner that it sounds fractured and unnatural. Everything is

expressed in a visual manner. Even the costume designs are camp and excessive. If you look for logic and realism in movies then *Requiem pour un Vampire* is likely to irritate the living daylights out of you.

Despite its minimal dialogue, the English dubbed print detracts heavily from the overall mood and differs greatly from the original French version. English dialogue is also present in scenes that should have no dialogue, dubbed by extremely poor voice-actors. The English dubbed version sounds like trash. The opening scene is a good example. The ambiguous dialogue of the getaway driver has been altered to explain to the viewer what we can already deduce. His final dying words, 'the water tower', are so poorly dubbed that the scene is reduced to comedy. Another change takes place in the opening titles. For some reason, the English language title — *Requiem for a Vampire* — appears in a different colour. The original French title has letters that change from black to red as the sun lights up the landscape; in the English version, they are white throughout. It's a minor detail but one more nuance lost in translation.

Requiem pour un Vampire is full to the brim with natural beauty. Rollin seduces the viewer with an exquisite Euro-gothic nightmare where nothing is quite as it seems. But *Requiem pour un Vampire* also has plenty of salacious fun in store for its viewers: kitsch vampires with oversized canines, skeletons hiding beneath shrouds, bank robbers dressed as clowns, premature burial, an ageing and not particularly threatening head vampire, bats and more!

Eroticism saturates the screen and Rollin pushes the erotic angle as far as it will go in the softcore arena. A red-tinted dungeon sequence is very explicit and depicts male slaves frantically raping several women bound in chains. It is a scene strongly reminiscent of Jess Franco and may be an early indicator of why the two directors are often compared. The *Aurum Encyclopaedia* declared that the film features 'stylized Sadean sex'', and that it can be seen as the seed for some of the more explicit ideas Rollin would later explore in *Phantasmes*. When *Requiem pour un Vampire* was produced, hardcore sex was still illegal in France. Had it been legal and commercial, no doubt a hardcore variant would have emerged.

* Phil Hardy, *Aurum Encyclopaedia Of Horror*.

FASCINATION

Hardcore penetration scenes would be incorporated into an alternate version of Rollin's subsequent movie, *Lèvres de Sang*, and with *Phantasmes*, Rollin fused porn and horror several years prior to Joe d'Amato's tropical, cum-soaked gore flicks.

The two leads, played with sensual delight by Marie-Pierre Castel and Mireille d'Argent, give expressive and charming performances. They embody a naïve innocence that would exemplify all of Rollin's female leads in his subsequent movies. The onscreen chemistry between these two beauties is strong, yet they apparently hated each other. Mireille d'Argent also appeared as a clown in *La Rose de Fer* and *Les Démoniaques*. After *Requiem*, she actually became a professional clown and hosted children's parties.

The budget for *Requiem pour un Vampire* was low, comparable to that of *Le Viol du Vampire*. Both are improvised, yet Rollin's development as a filmmaker and storyteller is evident, making *Requiem* a much more accomplished movie.

Requiem pour un Vampire exists in a variety of different versions across Europe and America. Following its uncut theatrical release in Paris, exploitation mogul Harry Novak purchased the film for a US release. The film was badly dubbed, re-cut and re-titled as *Caged Virgins*. This awful mess is a very different film and its *fantastique*, fairytale qualities are greatly diminished.

In the UK, the film was rejected outright on December 6, 1972, when G&M Productions submitted it for BBFC certification. Effectively banned from British cinemas, *Requiem pour un Vampire* didn't receive an official UK release until June 1993 by Redemption Video. Even then, the BBFC had an issue with the film, granting it a home video certificate with a staggering 6m 55s seconds of cuts. They completely deleted the murder of a chained woman and the subsequent dungeon sex sequence thirty-five minutes into the film. This censored sequence is made obvious by the nasty jump in sound and also reduces the running time from 83m 4s to a scant 76m 8s. On a more positive note, Redemption appear to have released the video in an uncut version — falsely displaying a BBFC 18 certificate — as catalogue number RED0009. The print censored and certified by the BBFC is listed as being in French with English subtitles, yet Redemption's uncut video is in English, leading to the conclusion that the company released two versions at the same time but only certified one.

Recent reissues of the film remain cut in the UK. *The Dark Side* magazine issued a double DVD via mail order, paired with *Fascination*, but their limited release matched Redemption's cut print running approximately seventy-seven minutes.

The unrated US DVD from Image Entertainment is the complete version and features both the English and French dialogue audio tracks. A lavish collector's edition from Holland's Encore Entertainment offers a three-disc package and collector's book on the making of the film (limited to 2,500 pieces). The recent US Blu-ray from Redemption is jaw dropping, with deep blacks and rich colours, and presented totally uncut in its original language.

Requiem pour un Vampire was the first of many Rollin movies produced by Lionel Wallmann, who warmly recalled this first experience and regarded it as 'the beginning of a nice adventure' that would last 'for the next forty years'.

La Rose de Fer
The Iron Rose

AKA: *Rose of Iron; Nuit du Cimitière*
1973 / Les Films ABC
86 Mins, Colour, 35mm, Original Ratio: 1:66:1
Director: Jean Rollin **Screenplay:** Jean Rollin (with poems by Tristan Corbière and dialogue by Maurice Lemaître) **Producer:** Sam Selsky
Director of Photography: Jean-Jacques Renon **Editor:** Michael Patient **Music:** Pierre Raph **Sound:** Gilles Aubry **Cast:** Françoise

* Lionel Wallmann, interview with the author. See appendix.

Pascal (The Girl), Hugues Quester — credited as Pierre Dupont (The Boy, Natalie Perrey (Lady at Cemetery), Mireille Dargent — credited as Dily d'Argent (The Clown), Michel Dellessalle, Jean Rollin

'Dying in his sleep, he lived in his dreams,
his dream was the tide, flowing up the side,
the tide flowing down,
your eyes in those eyes, your lips on that lip,
it is to you that I bade farewell to life,
you who mourned me to the point, I wanted to mourn myself'
— Tristan Corbière

A woman in red stands alone before the ocean on a deserted beach. In the surf she finds an ornamental rose made of iron. She caresses the dull metal before casting it out to sea, where it disappears beneath

the waves. The woman embraces her lover in front of a dead locomotive shrouded in mist.

The guests of a wedding party talk amongst themselves, the man and women are present. He is drawn in by her beauty and recites a poem to attract her attention. They meet in the garden and make arrangements for a date.

The following day, the young couple meet at a deserted train yard and proceed to the city cemetery for a peaceful picnic. At first the young woman is apprehensive but the man is unperturbed by the surroundings. They share food and discuss life, death and love. Soon after, they make love in a subterranean crypt. Leaving the tomb, they discover night has fallen and they are unable to find the exit. Fear

begins to take hold as they run aimlessly through the tombs in a futile attempt to escape the endless cemetery. The man realizes he has left his watch in the tomb. The two lovers find themselves back where they started — at the crypt. Their fear continues to grow and there appears to be no escape from the sea of graves that surround them. The man betrays her trust causing an argument that spirals out of control and they fight and struggle. They wander though the graveyard and the woman rests, corpselike, atop a tomb. She playfully rises like a zombie and the man becomes angry and upset. She screams into the night before contemplating to the graves around her, 'they've locked you in with their railings and their crucifixes. You're not death ... they are. They've shut the door to the castle of crystal.' The man falls into a grave full of bones and skulls. His companion comes to his aid and jumps into the grave with him, where they kiss and caress. In the distance, the sound of cars can be heard. The woman decides she does not want to leave and she asks her partner to stay. She runs and hides, jovially taunting him, as he desperately tries to find her.

She uses the iron rose to guide them back to the crypt, and the man enters to retrieve his watch. The woman locks him inside with the iron rose, leaving him to suffocate while she sits peacefully on the tomb.

Back on the deserted shoreline, the woman wanders the beach naked with the iron rose, toppling steel crucifix forms that are planted there. Dawn arrives and the cemetery is covered with morning mist. The gates open and the mourners return. The woman opens the crypt that holds her lover and she descends into the tomb with the iron rose. The heavy doors close behind her. A mourner leaves them a pot of roses on the tomb.

La Rose de Fer is Rollin's most personal film and also his biggest commercial failure. It is a beautiful exploration of life, love and death, represented with rich visual metaphors. The film constantly presents us with objects and places that were once filled with life but are now nothing more than static structures condemned by time. Their significance has greatly altered. The monstrous locomotive, the beach, the graveyard and the derelict once possessed life and power, but not anymore. Objects and items that were once important now have a different meaning, having evolved from life to death. A sense of tragedy and dark romance pervades the film. A beautiful past is as haunting as a troubled history, because one can

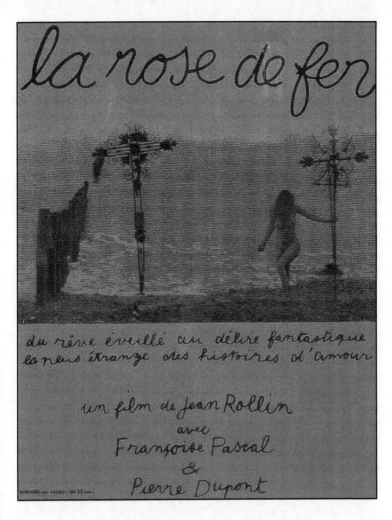

la rose de fer

du rêve éveillé au délire fantastique
la plus étrange des histoires d'amour

un film de Jean Rollin
avec
Françoise Pascal
&
Pierre Dupont

interdit au moins de 13 ans

never relive those perfect moments. They fade in time.

After a brief introduction, we are presented with a sublime title sequence: two lovers embrace before a silent, motionless locomotive in a deserted train yard as mist envelopes them. Their romantic tryst, contrasted with the dead locomotive and creeping mist, lends the sequence a sinister and haunting tone that permeates until the finale. Rollin holds this shot for several minutes and the image remains in the mind long after viewing the film. This single image represents the core themes and obsessions of the film, capturing life

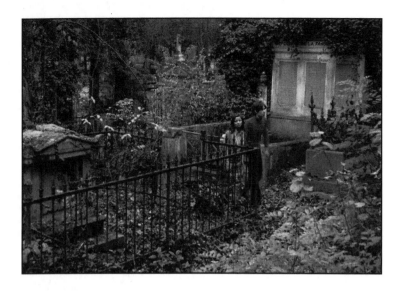

and death in one shot.

The whole film plays like a dream within a dream, bookmarked by unforgettable opening and closing scenarios. Even the characters seem displaced. When the leading man is asked simple questions at the wedding party, at the beginning of the film, he responds with meaningless and irrelevant answers. He is detached from reality and has no direct effect on those around him, other than the beautiful woman he is unable to tear his gaze from. Everything else is unimportant, abstract. During this sequence he recites a sombre poem which is met with laughter and applause — a disquieting and bizarre reaction that is at odds with his poignant words. Touches like these imbue the film with a dreamlike ambience, and in Rollin's world such peculiar moments never seem out of context.

The daylight sequences are frequently enshrouded with mist, enhancing the otherworldliness. The haunting music is used sparingly. Male and female vocals are mixed together and the use of manipulated audio is eerily effective. This is most evident during the final sequence in which Françoise Pascal uproots iron crucifixes planted on the beach at Dieppe.

The sequence in which Pascal stands over an open grave, while her lover lies trapped below, alternates from 'reality' to the outright bizarre through the clever use of photography. The camera spins in a circle, from each character's point of view for several seconds,

FASCINATION

Lost among the dead (previous page). Gothic romance: Françoise Pascal (this page), *La Rose de Fer.*

contrasting with the previous static shots and tracking shots. The couple then embrace in the grave itself, as though their earlier fights never happened. The camera turns anti-clockwise, time going backwards, manipulating the characters' emotions and the viewer's perception of cause and effect, past and present.

The film has a romantic and emotional backbone. The narrative and its basic structure are very simple, but the film is layered with Rollin's typically rich symbolism and double-meaning. *La Rose de Fer* offers the viewer a visually rich puzzle and an emotional journey that is more rewarding with each viewing.

The locations are a vital part of the film's effectiveness. The train yard is desolate and still, shrouded in mist. Although there is no movement on the tracks, we can clearly hear the sound of trains in action, creating a ghostly mood — almost as though the archaic wagons are speaking of their past. This idea of passing time is plainly addressed when the woman raises a skull to cover her own facial features — beauty is tragic, one day this beautiful face will be nothing more than bone, and its future appearance will offer a different meaning.

Each key location emanates beauty and sadness. It is interest-

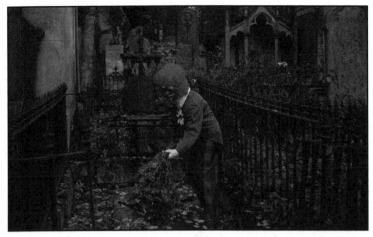

The mourning clown. *La Rose de Fer.*

ing to note that each of these locations (the sea, the train station, the cemetery) are classic romantic backdrops in traditional love stories. They are places where lovers are separated, in life and in death. No matter where the characters take us, the past pervades the present, and death and fate surround them. This may sound morbid, but Rollin presents us with so much beauty, tragic or not, that his vision never becomes depressing or bleak. The beach at Dieppe is used to its maximum potential and has a much stronger emotional impact than in his other films. The wooden surf-breakers that protrude into the air are strongly reminiscent of the gravestones in the cemetery.

A conflicting and ironic quality pervades the film's beautiful locations. A mourning clown with a painted smile adorns a grave with flowers. The noisy, polluted modern life on the streets of Paris contrasts with the peaceful graveyard scenes. The graveyard is more attractive, and less frightening, than the city beyond its iron gates. The home of the dead becomes ultimately a place of the living — it is the only part of the city shown to cultivated with vegetation and trees. The world of the dead is the most beautiful aspect of modern life. The more time the characters and the viewer spend in the graveyard, the more distant and abstract the real world becomes.

The significance of the characters and locations and objects they interact with can be interpreted on many levels. The iron rose itself is a powerful object that again enhances the film's core themes of

FASCINATION

Entombed: Françoise Pascal. *La Rose de Fer*

the past and present. An item of vivid colour and beauty, a classic symbol of love, has become nothing but a rigid, dull, colourless ornament. The iron rose is a recurrent element within the film. The characters refer to it as a crystal rose, despite the fact it is made from iron. Perhaps they are clinging to some forgotten dream we are not privy to?

Similarly, the man's watch, which he leaves behind in the tomb, could be of great significance but may also mean nothing. Time is important to the film, but no one is keeping track of it. Past, present and future become more blurred as the film progresses.

Rollin's dialogue is noticeably stronger. Elements of poetry, philosophies on life and death, and even astrology, are dialogue subjects that hold great significance to the events and themes hinted at in the narrative.

At the beginning of the film, the nameless leads' relationship is playful and childish. As the night continues, these childish characteristics take a darker tone and result in sinister arguments and threatening behaviour. The sequence in which Quester betrays Pascal's trust as he guides her with her eyes closed, supposedly towards the exit, is a good example. An innocent game suddenly turns serious. Considering this, the film could be viewed as a metaphor for life's journey. The woman's appearance from the mist at the beginning of the film, could be interpreted as birth. The characters then journey through life, which becomes more serious as time

goes by. At the end of the film the couple both reside within the crypt and a mourner places a beautiful pot of roses on the tomb. The scenes at Dieppe could be read as dreams or a representation of the afterlife. The innocence of youth is tainted by the corruption of time. But then, the cemetery is frequently refered to as a garden, so maybe the nameless couple are Adam and Eve? There are no clear answers. As with *Lèvres de Sang* and *Les Raisins de la Mort*, everything is circular for the characters and themes often wind up back where they began.

Unfortunately, *La Rose de Fer* received only a minor theatrical release and was poorly received. It was granted a '13' certificate in France and was shunned by horror fans in search of more blood-thirsty thrills.

Redemption released the film uncut on DVD in the UK with a 15 certificate in 2005. The uncut US Blu-ray from Redemption is the best way to see this haunting piece of work. If you only ever see one Jean Rollin movie, make it this one.

Les Démoniaques
The Demoniacs

AKA: *Curse of the Living Dead; Deux Vierges Pour Satan; Les Diablesses; L'Isola Delle Demoniache; Tina, La Naufrageuse Perverse*
1973 / Nordia Films, Les Films ABC, General Films
100 Mins (Unrated US Version), Colour, 35mm, Original Ratio: 1:66:1
Director: Jean Rollin **Screenplay:** Jean Rollin **Producer:** Jean-Pierre Bouyxou, Lionel Wallmann (and Gilbert Schnarabach Yann) **Director**

of Photography: Jean-Jacques Renon **Editor:** Michael Patient
Music: Pierre Raph, with vocals by Louise Dhour (written by Jean
Rollin) **Sound:** René Penot (Dubbing by Raymond Hassid)
Cast: Joelle Coeur (Tina), Lieva Lone (Demoniac Girl 1), Patricia
Hermenier (Demoniac Girl 2), John Rico (Captain), Willy Braque
(Bosco), Paul Bisciglia (Paul), Louise Dhour (Louise), Ben Zimet
(Sinister Guardian), Mireille d'Argent (Clown), Miletic Zivomir
(Demon), Isabelle Copejans (Barmaid), Yves Colignon (Barmaid's
Lover), Veronique Fanis (Girl in Tavern), Monica Swinn — credited
as Monika (Girl in Tavern), Jacqueline Priest (Girl in Tavern), Anna
Watican — credited as Anne Watticant (Girl in Tavern), Jean-Pierre
Bouyxou (Sailor in Tavern), Ralph G. Marongui (Sailor with Dracula
Puppet), Sylvio Dieu (Sailor). Gilbert Schnarrbach (Sailor in Tavern),
Yann (Sailor), Jio Berk (Sailor in Tavern), Burr Jerger (Satanic Priest)

'Un Film Expressionniste de Jean Rollin'

*A narrator introduces us to a gang of vicious pirates: Bosco, Tina,
Paul, and their ruthless leader, the Captain. On an isolated shoreline
the pirates, known as wreckers, lure an unsuspecting ship onto the
rocks in order to loot its washed-up cargo. As they hunt for the treas-
ure on the beach it becomes apparent that two women, dressed all in
white, have survived the shipwreck. The wreckers wait for the terri-
fied survivors to reach the beach before savagely raping and murder-
ing them.*

Afterwards, the wreckers retire to a local bar for an evening of

debauchery and music. As the captain drinks himself into oblivion he is haunted by visions of the two murdered girls. His paranoia and fear is increased when the clairvoyant bar owner accuses the wreckers of their hideous crime. The wreckers are informed that two dead girls have been seen wandering through the town.

Through a graveyard of dead ships, they search for the two girls. The boats are set alight. Tina locates the girls and a hand-to-hand fight ensues. The two dead girls escape by swimming to a cursed part of the island where the wreckers fear to tread — local superstition tells of a demon that dwells in the ruins of a haunted abbey. The living dead girls explore the island and befriend a woman dressed as a clown. The mysterious jester leads them to a sinister man who acts as the guardian of the legendary demon. Later that night, the demon transfers his supernatural power to them via sexual intercourse so they may exact their revenge. They must act quickly, for the magical power will only last until daybreak. The arrival of the living dead girls causes panic amongst the locals. Bosco plunges a knife into one of the girls but it has no effect. Tina murders the bar owner, and with her fellow wreckers pursues the two girls to the cursed ruins, where they also kill the female clown and the sinister guardian. The two girls make a pact to give their lives for the guardian and the female clown. The sun rises and the two girls return to the beach to destroy the wreckers and fulfil their promise. Paul attacks them in a drunken frenzy and accidentally cuts his own throat on a glass bottle. Bosco and the captain capture the girls and beat them. They tie their bodies to the remains of a wrecked boat and rape them while Tina masturbates ecstatically at the brutality. The power of the living dead girls forces the captain to kill Bosco and Tina. The tide comes in, washing Tina's body out to sea. The two living dead girls begin to sink as the boat to which they are tied drifts out to sea. Overcome by guilt the captain swims out to save them but drowns. The dead girls and the wreckers are consumed by the sea, as the guardian and the clown watch from the cliff tops, their lives replenished.

Producer Lionel Wallmann pitched the original idea for this film to Rollin, who then wrote a screenplay entitled *Les Diablesses*. The name was changed to *Les Démoniaques* due to copyright issues. This was Rollin's most turbulent production and was fraught with problems. It was the first time the director had received outside financing. At the time, *Les Démoniaques* was Rollin's biggest budg-

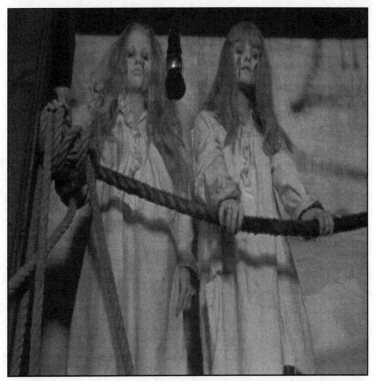

Living Dead Girls. *Les Démoniaques*

eted film, but with this extra financial freedom came several other burdens that would alter the finished product. The majority of the money came from Belgian financing, and Rollin was forced to use Belgian actors and technicians rather than his familiar crew. The production was populated by strangers with whom Rollin had never worked. Even Rollin's lifetime assistant Nathalie Perrey avoided working on the film after Jean-Jacques Renon had apparently treated her badly on the set of *Jeunes Filles Impudiques* (*Schoolgirl Hitchhikers*) (1973), a film Rollin directed pseudonymously.

To add to Rollin's troubles, his lead actress, Lieva Lone, turned out to be a nightmare prima donna. She was a cover girl and the idea of making independent cinema did not interest her at all. She sulked throughout the entire production, being as difficult as possible. Rollin found her perpetually grumpy, lacking in personality and impossible to work with — unlike the rest of the cast and crew-

Les Démoniaques

members who put in 100 per cent. When shooting the climax, in which the girls are tied to shipwrecked boats and taken by the tide, catastrophe almost struck. The scene was basically a one-shot-only take due to the costly expense of re-shooting on location. The cover girl walked off the set because she was cold. This was the last straw for Rollin, who chased after her and dragged her back to the set by her hair while she screamed and protested. The crew actually tied her to the boat and let the tide carry her out. They left it until the very last minute to save her from drowning.

Another difficult scene to shoot involved the wreckers setting fire to the ship graveyard while hunting for the demoniac girls. This time it wasn't the star who was the problem, it was the locals.

Just as they were about the start shooting, the crew were surrounded by sailors armed with guns. They had only been given licence to set fire to one shipwrecked boat; the locals were seriously intent on shooting them if they burned the wrong one. Again, this was a one-take-only sequence, and timing was everything. Once the boat was burned up there was no opportunity to burn another. Add to this the pressure of filming at gunpoint, there was no alternative but to capture the sequence effectively in one long take, with

FASCINATION

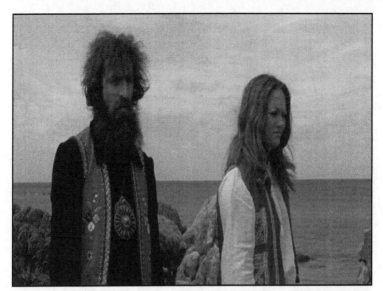

Ben Zimet and Mireille d'Argent solemnly watch the sea claim the bodies of the wreckers and the living dead girls. *Les Démoniaques.*

Rollin and Renon frantically running around the boat, shooting everything from a variety of angles. The edited scene is saturated with this sense of frantic energy and dangerous atmosphere. Hardly any shots are repeated and every edit delivers a new angle. The scene is flawless.

Further tension mounted when producer Lionel Wallmann viewed the rushes for the first week of shooting. Wallmann virtually had a fit and demanded everything be re-shot. He considered the footage awful. But it was a false alarm: Wallmann did not comprehend the difference between rushes and the finished film. When Rollin saw the footage everything was as he had intended it.

Les Démoniaques has been referred to as an expressionist film, and with good reason. Rollin tells the story purely through imagery, relying on exaggerated facial expressions and movements (particularly those of Mexican-American actor John Rico, who plays the captain) to convey emotion and ambience, much as in silent cinema. The film can be watched without sound and every scene still makes complete sense. Rollin agreed with his crew and friends on the style the film should take, and himself added the phrase 'Un Film Expressionniste de Jean Rollin' into the title sequence.

The Celluloid Dreams of Jean Rollin

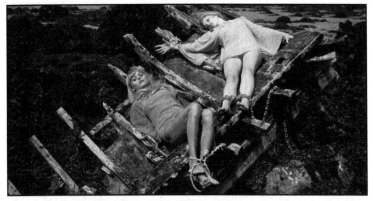

The living dead girls await the tide and their fate. *Les Démoniaques*.

Despite its production problems, there is a lot to savour here for Rollin fans. His keen eye for striking compositions and beautiful *mise en scène* is in full force, delivering rustic coastal locales filled with night surf, rotting ships, and beautiful women. Interestingly, Rollin decided not to use any footage of Dieppe, despite the film being set entirely on the coastline. The exterior sequences were shot on the Normandy coast at Chausey Island.

Visually it is one of Rollin's most pleasing efforts, full of the opulent beauty that strongly pervades his work, particularly in the opening and closing sequences, and in the ship cemetery. Even the tavern scenes are visually rich with detail. Coils of rope and candles protrude from waxen bottles to create a keen coastal flavour. A small Dracula model can be seen in the bar recalling Stoker's classic tale (Dracula's ship docks in Whitby) as well as Rollin's previous vampire offerings.

The opening sequence delivers some excellent photography of the shoreline at dusk. The lighting on the beach is particularly stunning, as the wreckers plunder the washed-up loot. Renon's photography captures great depth during these night-time beach sequences, making effective use of blue gels. Similarly, the finale on the shoreline is beautifully composed, featuring Rollin's trademark use of wide shots and deep blue colours. The haunted, crumbling ruins, reminiscent of Amando de Ossorio's *Tombs of the Blind Dead* (1971), bring a gothic sensibility to the proceedings. The film also features one of Rollin's most haunting shots. As the wreckers loot the washed-up trinkets they look out at the night sea, where, far in

FASCINATION

Ghostly apparition (left); Joelle Coeur and
John Rico (right). *Les Démoniaques.*

the distance, two white figures silently approach through the wa-
ters. It's an incredibly eerie vision and one that leaves a lasting im-
pression on the viewer. As the figures stumble through the waves,
their reflections cast a white glow in the waters around them, oth-
erwise shrouded entirely in the blackness of night.

Rollin loved swashbuckling adventure films in his childhood, and
their spirit has worked its way into the fabric of this magical film.
The opening sequence is directly inspired by such movies and is
delivered in the same style. A narrator introduces the pirates one
by one, their faces superimposed over a backdrop of a burning ship.

Everything in *Les Démoniaques* is exaggerated to an expression-
istic degree, from the violence to the dialogue, characters and cos-
tume design. The stereotypical representations of the wreckers,
with their stripy sailor jumpers and hats, would be laughable if this
were not a Rollin film. Instead it lends the movie genuine flavour
and a pantomime atmosphere that fits well in this dreamy alterna-
tive reality.

The wreckers themselves are a real motley crew. Willy Braque's
performance as Bosco is excellent. He loved the role so much he
actually purchased his own costume for the film and personal-
ly created his character. Braque also fancied himself as a director,
but it seems he would go slightly mad halfway through production
and the project would terminate. (IMDb suggests he completed a
couple of shorts, and one feature length film in 1971, *La secte du
diable.*) Braque later made his living as a pilot and salesman of sec-
ondhand aeroplanes. The stunning, statuesque Joëlle Coeur steals
the show as the nymphomaniac Tina. Her character personifies

The Celluloid Dreams of Jean Rollin 107

eroticism and horror. Of all Rollin's female leads, she is the most dangerous and insatiable. Her presence is electric and she appears to be ravishing every moment of her sex scenes. In one scene she masturbates frenetically, her sexuality exploding on the screen, as her brutal cohorts gang rape the lead girls. Despite her exuberant sexual displays here, Coeur stopped acting after *Les Démoniaques*, when hardcore porn flooded the French film industry.

Paul Bisciglia, who appeared in *La Vampire Nue*, also offers a good performance as Paul. Miletic Zivomir, who plays the demon in the haunted ruins was actually a medium and hypnotist, and he apparently hypnotized a Chausey Island sailor in the local bar during production. One of the most striking characters in the film is the female clown played by Mireille d'Argent. Her makeup is so heavy she appears androgynous. The sequence in which she is murdered by the wreckers is well-realized and carries a subtle sensitivity. As the woman dies, afraid and in pain, the false smile painted on her face remains, creating another unforgettable ironic image, similar to the tear-streaked faces of the clown-girls at the beginning of *Requiem pour un Vampire*. Jess Franco regular Monica Swinn also makes a small appearance — at the time she was Jean-Pierre Bouyxou's girlfriend, one of the producers.

Les Démoniaques is essentially a tale of revenge and guilt with a gothic sensibility. The sex and violence are harder than previous Rollin films. Likewise the rape scenes, which are rather nasty and have a fevered aspect to them. It is also one of Rollin's most peculiar films, due to its extremely expressionistic approach. The pumped-up sexual assaults and bloody violence sit well with the film's overall exaggerated presentation. Overall, it makes for an interesting, if at times shocking, addition to Rollin's filmography.

Upon its original theatrical release, the French censor passed *Les Démoniaques* uncut. They thought the film was too terrible and poorly shot to be taken seriously, clearly misunderstanding Rollin's artistic intentions.

There are several DVD versions of *Les Démoniaques* available, the best being the limited (only 2,500 pieces) Encore release, which was personally approved by Rollin. Several 'lost' scenes appear as supplementary material. The sequence in which Tina masturbates as the wreckers rape the two women is one of these scenes. Another version featured hardcore inserts of Tina's masturbation,

shot for alternative markets. These inserts were not shot by Rollin and appear to be culled from another source, featuring a different actress. But there are several other sex scenes, shot and removed from the final edit by Rollin, including a very long sequence with a barmaid and a drunken sailor. It's easy to see why these are absent from the final cut, as they slow down the pacing and pull away from the main narrative.

The UK version was trimmed of fifty-four seconds by the BBFC, reducing the original running time from 94m 2s to 93m 7s. The cuts were made to comply with the BBFC's no tolerance policy on images of rape and sexualized assault. The film is still cut in the UK. The US Blu-ray from Redemption contains an unrated extended cut, reinserting a missing dialogue scene in the abbey and some very explicit masturbation/rape footage at the end of the film. The footage is not mismatched in any way and appears to have been struck from the same master negative, meaning this footage was most likely in Rollin's premiere cut of the film. The transfer is impeccable and the best way to watch this unique film.

Lèvres de Sang
Lips of Blood

AKA: *Bloody Lips; Jennifer* (Shooting Title)
1976 / Off Production, Scorpio V, Nordia Films
87 Mins, Colour, 35mm, Original Ratio: 1:66:1
Director: Jean Rollin **Screenplay:** Jean Rollin (adaptation and dialogue by Jean Rollin and Jean-Loup Philippe) **Director of**

Photography: Jean-François Robin **Editor:** Olivier Grégoire
Music: Didier William Lepauw **Sound:** Gérard Tilly **Cast:** Jean-Loup
Philippe (Frédéric), Annie Belle — credited as Anne Brilland (Jennifer),
Natalie Perrey (Frédéric's Mother), Serge Rollin (Frédéric as a Child),
Catherine and Marie-Pierre Castel (Vampire Twins), Claudine Beccarie
(Claudine), Paul Bisciglia (Psychiatrist), Willy Braque (Killer), Martine
Grimaud, Hélène Maguin, Anita Berglund, Béatrice Barnois, Sylvia
Bourdon, Mireille d'Argent

'Scents are like memories – the person evaporates but the memo-ry remains'

In an isolated cemetery, an old woman presides over the secret burial of two bodies wrapped in white sheets. Inside a crypt, they are placed into separate coffins and the lids are sealed. Beneath the white sheets the bodies are still breathing. The old woman erects a crucifix by the entrance of the crypt.

During a party, a painting catches Frédéric's eye. He is entranced by an image of desolate ruins by the sea, and it awakens a distant memory in him. In a flashback, we see him as a child speaking to a beautiful girl in white at the entrance of a castle. She leads him in-side and offers him shelter and he falls asleep. The woman in white awakens him and tells him to go home to his mother. As he leaves, and enters the misty night, he assures the girl, 'I will be back. I love you.'

Frédéric's mother is dismissive when he enquires about the im-age and the photographer who took it. Since the death of his father, Frédéric has been unable to recall his childhood. Determined to unrav-el the mystery of his vague memory, he meets the photographer, who refuses to tell him of the location's whereabouts as she has been paid to keep it a secret from him. After seducing him, she resolves to meet him at the aquarium at midnight where she will tell him the truth. Killing time, Frédéric visits a cinema. As the film plays, the woman in white from his memory appears in the auditorium. She turns and slowly walks away, and Frédéric pursues her through the city streets into a graveyard. He comes across the two coffins that were seclud-ed in the opening sequence and he opens them. Bats lie within each coffin and he flees into the night. The bats turn into seductive female vampires, two of whom are beautiful blonde twins, and they stalk the night in search of blood.

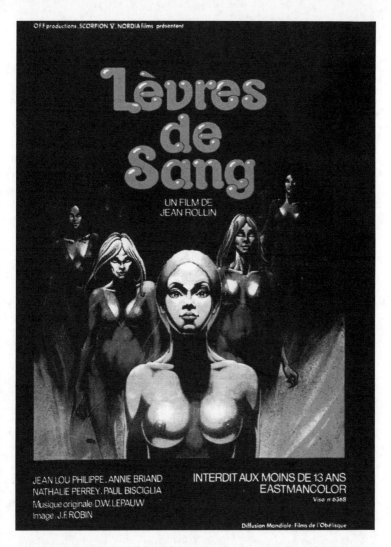

Lèvres de Sang

UN FILM DE
JEAN ROLLIN

JEAN LOU PHILIPPE. ANNIE BRIAND
NATHALIE PERREY. PAUL BISCIGLIA
Musique originale: D.W. LEPAUW
Image: J.F. ROBIN

INTERDIT AUX MOINS DE 13 ANS
EASTMANCOLOR
Visa n° 6368

Diffusion Mondiale: Films de l'Obélisque

Frédéric makes his way to the aquarium to meet the photographer but finds her dead. He is pursued by a man with a gun but is saved by a group of seductive vampires. Reciting the evening's events to his concerned mother, she has him committed to a mental institution. Frédéric is about to undergo electro-shock treatment when the female vampires save him again and feast on the doctor. A blind woman approaches Frédéric in the street and gives him a postcard of the

Ghosts and memories by the silver screen. Annie
Belle as Jennifer in *Lèvres de Sang*.

landscape from his childhood, credited as Sauveterre Castle. Frédéric
makes his way there.

He arrives at the castle and, in the seclusion of a stone vault, finds
a picture of himself as a child and a coffin surrounded by red drapes.

His mother has followed him and tells him the truth of his past.
The lady in white is a vampire named Jennifer, who was hidden away
at the age of sixteen. She reveals that she drove a stake into Jennifer's
heart but was unable to sever her head so she still lives, locked inside
her coffin.

The female vampires are hunted and staked by Frédéric's moth-
ers' associates, their heads severed and their bodies burned in a well.
Frédéric is instructed to kill Jennifer and he heads back to the vault.
Opening the coffin, Jennifer, the lady in white, resides within and the
two fateful lovers are finally reunited.

Frédéric returns to the burning well with a severed head and dis-
cards it into the flames before wandering back to the vault to mourn.
Inside the vault, the head of a statue is missing and Jennifer remains.
Together at last, they embrace naked on the beach and Jennifer sinks
her teeth into Frédéric's neck. They seal themselves inside a coffin and
the ocean takes them out to sea. The severed head of the statue lies
in the surf...

Lèvres de Sang is a more conventional effort compared with

FASCINATION

Rollin's previous vampire films. It echoes the intriguing mystery elements of *La Vampire Nue* and follows a three-act structure. The original script was considerably different to the final film. But because one of Rollin's key backers withdrew their funding a week before shooting began, the four-week shoot was reduced to three. (Rollin had two choices: either scrap the entire project or rewrite the script.) Despite this setback, and the limited time for rewrites, Rollin crafted a tight erotic-horror-mystery that remains his most developed tale. The number of different locations is kept to a minimum and this is most likely accountable to the drastic rewrite. Rollin keeps his characters in the same place for long periods of time. The middle of the film, in which Frédéric wanders around the city, could possibly be tighter, and characters, such as the photographer, may have initially been more important to the story. But the film does not suffer because of these factors.

There is a sweet sadness to *Lèvres de Sang*, in its themes of vampirism, incest, tragic romance, lost love and childhood nostalgia. Rollin contrasts horror, beauty, sex and death, pushing these elements to the forefront of the film. He also populates it with plenty of scantily clad vampire seductresses and full frontal nudity. In many instances, the sexual elements are stronger than the horror. The scene in which a model masturbates for Frédéric's camera is a good example. When the female photographer is murdered, she is found with her breasts exposed. Whenever a female vampire launches an attack they do so virtually naked; they are simultaneously seductive and sinister. A flashback sequence of a naked woman chained to a block of wood, pursued by vampires is another salacious image for 'Eurotrash' fiends. When women are present in the film, it is with a sense of danger and female empowerment. Even the title itself, *Lips of Blood*, promises sensuality and fear.

Like *La Vampire Nue*, the main character, Frédéric, is thrust into a world of paranoia in which he can trust no one and nothing is quite as it seems. He acts impulsively, emotionally driven towards his fate. The mystery is simple but cleverly presented. Rollin's improvisational shooting method sits extremely well behind a fully-realized story. From the very beginning, we are thrust into a dreamlike mystery with Frédéric's mother and her assistants placing bodies into coffins and sealing them up in a crypt. Motivations and intent are uncertain at this point, but as the story unfolds they become clear.

The dialogue has naïve, fantastical connotations, take, for instance, lines such as 'I got lost following the big black dog with the ripped ear' and 'The tide will carry us out into the ocean to a desert island. They won't find us. It's called Sand Island. Come. There we'll lure rich sailors'.

The castle ruins that haunt Frédéric are first introduced in the form of a photograph stuck to a mirror. Frédéric is transfixed by the black and white image of the old stone structure. In this, Rollin creates a beautiful visual metaphor for Frédéric's dilemma: the mirror and the photograph become a single object, symbolic of Frédéric's past creeping into his present life; the real reflection and the memory. Also in frame, in the left corner of the mirror, is a small crimson bottle, which hints at the blood to come, and also Frédéric's true identity. Throughout the film, Frédéric is seen in mirrors, enforcing the idea that no matter what he looks like now, his true self and his destiny remain at a distance. Frédéric's house is decorated with many old pictures. Objects are cluttered about rooms, like memories from a photo album. Despite it all, he still doesn't know who he really is. Something constantly nags at him from his childhood and this ultimately shapes his future. Rollin would also investigate lost identity and family roots in *La Nuit des Traquées* and *Emmanuelle 6*.

The truth of Frédéric's identity is all around him but he has failed to see it. It takes a blind woman to reveal this fact, the clue being the postcard she offers him.

Rollin references water a number of times throughout the film. The aquarium, the water fountains and even a toad in a derelict building. The toad is out of place. Just like Frédéric.

The photography is mostly confined to night-time imagery and the lighting appears very natural, particularly in the derelict city areas. As Frédéric comes closer to the truth, the tones in the film become more colourful, particularly the striking ruins lit with orange and blue in the final reel. The aquarium sequence is also worthy of mention. Filmed at night, its rich colours and cascading water create a genuinely eerie and dreamlike ambience.

Lèvres de Sang is much grittier than Rollin's other vampire tales. Its grubby urban locations have a sense of abandonment. The introduction of seductive female vampires with bloody lips and brightly coloured transparent veils makes for a startling contrast. The undead are alluring and dangerous and sharply contrast with the di-

Seductive vamps
(top left); Annie Belle
(above); Jean-Loup
Philippe and Annie
Belle at Dieppe (left).
Lèvres de Sang.

lapidated city blocks. They are walking relics of the past haunting the present. Frédéric's world is drab. He longs to return to Jennifer — the lady in white — and fulfil his destiny, even if he doesn't fully realize it early on. It is fitting that he should first meet her in a cinema (watching a Rollin film, no less! *Le Frisson des Vampires*, erroneously advertised as *La Vampire Nue* on the poster outside the cinema). It is here, in an auditorium of flickering dreams, that Frédéric's own world comes into contact with fantasy.

The ending of the film is both tragic and romantic as Jennifer and Frédéric drift out to sea in a coffin to spend an eternity together, feasting on sailors.

Anne Brilland, who plays the alluring vampire Jennifer, also appeared in Rollin's pseudonymous softcore sex film *Tout le Monde il en a Deux*. She also acted under the name Annie Belle and appeared in Aristide Massaccesi's *Absurd* (1981) and Ruggero Deodato's vicious *The House on the Edge of the Park* (1980).

Lèvres de Sang received a theatrical release as *Lips of Blood* via Gemini Distribution in the UK in 1975. The BBFC imposed several cuts to achieve an X certificate. Many years later, Redemption

The Celluloid Dreams of Jean Rollin 115

picked the film up for release in the UK on VHS, completely uncut. A DVD later followed. Redemption issued the film in the USA on DVD via Image Entertainment in a sharp, uncut NTSC transfer. Encore Entertainment released an uncut collector's edition DVD (limited to 2,500 pieces). This lavish set was spread over three discs and included a small booklet. The recent USA Blu-ray from Redemption is a gorgeous transfer and uncut.

Suce Moi Vampire
Suck Me Vampire

1975 / **Credits:** [See 'Sexual Vibrations: The Hardcore Years' chapter]

Plot: Lèvres de Sang with XXX inserts.

Lèvres de Sang received theatrical distribution in France in its original intended form. The film was a commercial flop. Its failure at the box office only served to confirm that Rollin's personal visions were not appreciated by mainstream audiences.

Lèvres de Sang was his most personal film to date and the lead character a loose reflection of himself. Rollin took the negative criticism personally. It was at this time he took his first step into the world of hardcore pornography. To help recoup some of his losses and also save his investor Jean-Marc from financial ruin, Rollin painfully re-envisioned his poetic masterpiece as a cheap hardcore sex flick. He stripped the narrative to its bare bones and hastily shot a series of XXX sex scenes. This new footage utilized performers from *Lèvres de Sang*, notably Claudine Beccaire, Anita Berglund, Béatrice Harnois, Martine Grimaud, Sylvia Bourdon, Eva Quang and

Scenes from *Suce Moi Vampire*, including one hardcore image (top right), obscured by this book's publisher for its sensitive readers.

Jean-Loup Philippe. The new cut, *Suce Moi Vampire*, was a theatrical hit in the XXX cinemas of Paris.

Suce Moi Vampire makes for strange viewing as it shifts uncomfortably between beautiful footage from *Lèvres de Sang* and hastily shot hardcore sex scenes. The hardcore adds nothing to the film and cheapens the atmosphere and intentions of the original. However, if you can track it down this cut down, it makes for fascinating viewing as a fan of the original. The final scene is particularly outlandish and contains some of Rollin's most extreme imagery: a female vampire fellates a slightly bloodied cock to orgasm, running her elongated canines along the tip in agonising detail.

Suce Moi Vampire is an important part of Rollin's filmography, because with it he disappeared into the world of French hardcore porn for three years before returning to personal films. It was during these early forays into pornography he first met Brigitte Lahaie. He would later cast her in *Les Raisins de la Mort* and she would go on to become his most iconic performer.

Incredibly rare, *Suce Moi Vampire* has survived on the bootleg circuit. A grubby, washed-out French language VHS transfer can be found online from cult movie websites.

Raisins de la Mort
The Grapes of Death

AKA: *Pesticide; The Raisins of Death*
1978 / Rush Production, Les Films ABC, Off Production
90 Mins, Colour, 35mm, Original Ratio: 1:66:1
Director: Jean Rollin **Screenplay:** Jean Rollin, Jean-Pierre
Bouyxou **Producer:** Claude Guedj **Production Director:** Christian
Ruh **Director of Photography:** Claude Bécognée **Editor:** Christian
Stoianovich, Dominique Saint-Cyr **Music:** Philippe Sissman
Sound: Henry Humbert, Claude Panier **Special Effects:** Alfred
Tiberi, Raphael Marongiu, Yannick Jasse **Cast:** Marie-Georges Pascal
(Élisabeth), Felix Marten (Paul), Serge Marquand (Lucien), Mirella
Rancelot (Lucie), Patricia Cartier (Antoinette), Michel Herval (Michel),
Paul Bisciglia (Lucas), Brigitte Lahaie— misspelled in the opening
credits as Lahaye (Sinister Blonde), Evelyne Thomas (Brigitte), Patrice
Volota, Olivier Rollin, François Pascal, Jean-Pierre Bouyxou

'Generally I don't drink alcohol, but here
I allow myself a little wine.'

Vineyards are sprayed with a new pesticide, procured by a vineyard
owner named Michael. The workers exposed to the substance suffer
side effects, and are afflicted with pain and disorientation. The grapes
are harvested and deep vats of red wine are prepared.

Two young women travel alone on an empty train. Élisabeth
is heading for her hometown of Roubelais, deep in the heart of the
French countryside. The train stops at a small station and a sinister
worker from the vineyard boards the train. His complexion is un-
healthy and his breathing becomes stifled, then his face swells and
peels and blood seeps through his blistering skin. Élisabeth runs ter-
rified through the deserted train and finds the bloodied body of her
travelling companion. Using the emergency brakes, she exits the train
and escapes into a darkened railway tunnel. The murderer sits con-
fused on the railway tracks, sombrely contemplating his actions as his
face disintegrates. Élisabeth stumbles across a small farmhouse. Her
situation worsens when she realizes the father of the family within
is afflicted with madness and suffers the same malady as the man
on the train. He has murdered his wife and he intends to keep Élis-

FASCINATION

abeth and his family prisoner so the deed is not discovered. Élisabeth attempts to leave and the man erupts with rage, stabbing his daughter with a pitchfork. As she lies dying, he is overcome with emotion and the realization of his hideous crimes. The confused man demands that Élisabeth destroy him, and after threatening her, she crushes him with his car.

Stopping at another isolated village for help, Élisabeth is attacked by another rotting madman. She flees and comes across a lost blind

girl, named Lucy, searching for her guardian, Lucas. Upon finding her village, they discover the buildings ablaze and the inhabitants grotesquely murdered. When Lucy finds Lucas, he is in a psychotic state. Tears in his eyes, he strangles Lucy to death before decapitating her with a hatchet. Élisabeth finds refuge from the hoards of rotting maniacs and encounters a beautiful, sinister blonde woman. They decide to leave together, but away from the secure abode, the blonde woman attempts to offer Élisabeth to the madmen. Two men, François and Paul, both armed with shotguns, manage to save Élisabeth from the maniacs. The three of them continue their journey for help and realize the terrible events stem from the local wine. They proceed to the vineyard of Roubelais, owned by Élisabeth's fiancé, Michael. The vines are bare and the vineyard is vacant. Élisabeth searches the vineyard for her fiancé. He, too, is afflicted with the disease. Élisabeth and Michael share their last embrace, before Paul coldly guns him down. Élisabeth responds to the murder of her lover by turning the gun on Paul. François arrives and is also coldly shot by Élisabeth, who wanders trancelike into one of the wine vats. The blood of her fiancé drips down through the roof hatch and onto her pale face. She savours the crimson rain, first with sadness, and then pleasure.

Les Raisins de la Mort was the first French horror film to openly wallow in gore. Rather than Rollin's vampires, we are presented instead with a hoard of rotting zombie-like maniacs. Rollin takes cues from two other contemporary horror movies: George A. Rome-

Crop dusting in the opening scenes of *Raisins de la Mort* (previous page), and wine, death and decay (this page).

ro's *The Crazies* (1973) and José Larraz's *The Living Dead at [the] Manchester Morgue* (1974), a deranged township in one and zombies borne of pesticide (be it electronic) in the other. It follows a more conventional narrative framework than Rollin's other work. We might say the same for his previous effort, *Lèvres de Sang*, but where that film was steeped in mystery and symbolic imagery, *Les Raisins de la Mort* offers a much simpler story with little room for deeper interpretation. *Les Raisins de la Mort* is essentially one long chase sequence and fight for survival. The actions of the characters are ultimately in vain as they travel in one large circle, ending up

where they began: at the vineyard.

Rollin's vampire movies are not traditional horror films, but *Les Raisins de la Mort* belongs firmly in this genre. The viewer is plunged into a terrifying ordeal right from the start when our lead heroine is attacked and pursued by rotting zombies. We are in the middle of nowhere, surrounded by countryside. Time and place are unimportant; the chase is. We do not even learn Élisabeth's name until the final scene.

Mankind's technological advances are again the cause of the surmounting horrors (as in *La Morte Vivante* and *La Vampire Nue*) due to a cheap experimental pesticide used to spray the vineyards. Those who inhale the toxic fumes or ingest the wine begin to deteriorate and decay and seek human blood. One of the first noticeable distinctions between *Les Raisins de la Mort* and Rollin's previous films is the graphic representation of horror. The violent gore scenes are designed to shock and revolt and are presented with the same unflinching impact as Italian gore movies of the same period. But its method of representing horror is completely different. Rollin puts his unique stamp on the violence by making each murder emotional and tragic. Rather than wallowing in mindless cinematic slaughter, the explicit gore scenes are accompanied by an unusual touch of sadness. Although the maniacs are represented with zombie-like traits, they remain emotionally human and are aware of their actions. They become overwhelmed with disgust and horror at their own atrocious actions.

The most startling example of this emotional conflict takes place when the blind girl, Lucy, eventually finds her guardian, Lucas. Upon their reunion we realize he is one of the maniacs, and, as she kneels at his feet, overwhelmed with love and appreciation, his face begins to bubble and melt. Tears flood his eyes as he proceeds to strangle her to death — forced by an uncontrollable rage to commit murder. Harrowing conflicts are recurrent in the film. The instruments of horror, the rotting people driven into frenzy, remain human; they never become typical 'bogeymen' characters. They are at once the mourner and the murderer, forcing the audience to fear them and feel sorry for them.

Gore fans will certainly not be disappointed. The screen is frequently awash with violence and glimpses of blood-drenched madness, courtesy of excellent special effects. There are morbid details,

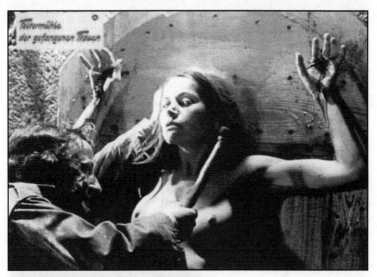

Lobby cards for
Raisins de la Mort.

too, such as a man decapitating a loved one and then madly kissing the severed head; a grisly and sexualized pitchfork murder that still packs a savage punch (several years before *The Prowler*, 1981); and the grotesque sight of swelling and bleeding faces.

In addition to the gore, Rollin creates an unsettling, eerie atmosphere, particularly in the scene where Élisabeth takes refuge in a house occupied by none other than French porn queen Brigitte Lahaie. Her detached and creepy performance lends this scene an overwhelming sense of unease. It references Mario Bava's *Black Sunday* (1960) — Lahaie descends the steps in her nightgown with two black dogs by her side. Little wonder, as Rollin saw in Lahaie the statuesque features of Barbara Steele, who had starred in Bava's classic.

Another extremely eerie scenario features a hoard of rotting

maniacs staggering through a deserted village at night, murmuring 'Lucy, I Love You' over and over — these being Lucas' haunting words before killing the blind girl.

Fitting for Rollin, *Les Raisins de la Mort* ends on an ambiguous note. Élisabeth survives her terrible journey and, having found safety, inexplicably murders her innocent lover François, feeling no remorse for her actions. She wanders into an empty wine vat and allows his blood to drip onto her face. After the shock of the first few drops, she takes pleasure in the blood and allows it to fall into her mouth, effectively signing her own death warrant. Has Élisabeth gone mad from her ordeal and all the horror she has witnessed? Or has she succumbed to the insanity-inducing virus from drinking the wine in the farmer's house at the beginning of the film (blink and you'll miss it)? Élisabeth's journey begins with a trip to see her lover, and ends with them united by his blood.

Les Raisins de la Mort is hardly typical of Rollin's output, for reasons noted. Horror fans who are not usually congenial to Rollin's dreamy visions, will find plenty to hold their attention here. Nonetheless, the film still gives the viewer sumptuous green valleys against blue skies and misty, rural locales. The picturesque locations work well in contrast to the macabre violence and horrific setpieces, jolting the viewer with their disparity. The luscious music score makes for the perfect companion.

Rollin had a bigger budget to work with here and he even delivers some gratuitous explosions at the halfway mark. The film moves at a quick pace and dialogue is used sparingly — a noticeable departure from the gentle pace of Rollin's previous vampire films. Tight the film is, but it was still mostly improvised. When it came shooting, Rollin disregarded the screenplay he had completed three months prior, his ideas having since changed, and improvised the production at the last minute. Clearly comfortable with this approach, Rollin improvised his next film, *Fascination*, in the same manner.

The uncut version was banned in Germany on video but was later reissued in a censored form. This version, along with the cut US release, entitled *Pesticide*, were the most available versions until Synapse released their DVD in 2002, featuring an uncensored print with newly translated subtitles. The same version was later released in the UK by Redemption films in 2005, remarkably passed

FASCINATION

uncut by the BBFC. The film has recently been released in a stunning transfer, completely uncut, on Blu-ray in the USA by Redemption.

Fascination

AKA: *Fascination: Das Blutschloss der Frauen; El castillo de las vampiras; Diavoliki goiteia; Goiteia; Pathos gia aima*
1979 / Comex Productions, Les Films ABC
81 Mins, Colour, 35mm, Original Ratio: 1:66:1
Director: Jean Rollin **Screenplay:** Jean Rollin **Producer:** Joe de Lara **Production Director:** Christine Renaud **Director of Photography:** Georgie Fromentin **Editor:** Dominique Saint-Cyr **Music:** Philippe d'Aram **Sound:** Claude Panier **Makeup:** Eric Pierre **Cast:** Franka Mai (Elisabeth), Brigitte Lahaie (Eva), Jean-Marie Lemaire (Marc), Fanny Magier (Hélène), Murial Montossé (Anita), Sophie Noel (Sylvie), Evelyne Thomas (Dominique), Agnes Bert, Alain Plumey, Myriam Watteau, Joe de Lara, Jacques Sansoul

'Blood is the life that flows in you. But it is also death when it escapes … The love of blood may be more than that of the body in which it flows.'

1905: Two women dance together on a moat bridge to the music of a nearby gramophone. In an abattoir, several distinguished women drink the fresh, warm blood of a butchered ox while the butcher quietly observes. A young thief double-crosses a group of local villains and takes a female member hostage, fleeing into the countryside. The

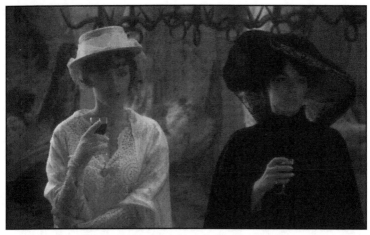
Bourgeois blood drinkers in the slaughterhouse. *Fascination*

woman manages to escape her captor and the other villains are soon in pursuit of the opportunist thief. As the men gain ground, the young thief stumbles across an isolated château surrounded by water. Seeking refuge within, he is trapped by his angry pursuers, who guard the only exit. Inside the château he discovers two seductive young women, Elisabeth and Eva, who taunt and tease him, completely unafraid of him. Elisabeth and Eva are lovers and the sexual tension builds, along with the mind games. The young thief plans to depart, but the two women implore him to stay until midnight, as they are expecting some very important guests. Eva ventures from the château grounds and is snatched by the villainous party outside. One of the men takes her to the barn and forces her to have sex. As the man is about to reach his climax, she plunges a knife into his chest. Selecting a monstrous scythe from the barn, she proceeds to dispatch the other troublesome villains, before returning to the castle. Midnight arrives and so, too, several bourgeois women. They taunt and tease the man until the shocking truth is revealed and the blood feast begins. These wealthy ladies have a taste for more than just ox blood ...

Fascination is a brooding tale stained with eroticism and sudden punctuations of violence. Rollin's most iconic and renowned film represents many of his key themes and obsessions. It stands alongside *Requiem pour un Vampire*, *La Rose de Fer* and *Lèvres de Sang* as a pure Rollin film, in the sense that Rollin had complete artistic freedom. The film was funded, written, and directed by Rollin and

FASCINATION

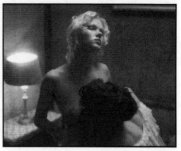

Jean-Marie Lemaire and Franka Mai (left). Brigitte Lahaie and Franka Mai are sinister lovers. *Fascination*.

the finished result is well paced, wonderfully developed and truly breathtaking, with its alluring mixture of sex and horror.

The plot is simple and effective. Rollin maintains an element of mystery throughout by keeping the motivations of the sinister women vague. We watch the chauvinist male protagonist be cleverly manipulated to his death.

Supporting the strong, character-driven backbone of the narrative, are the three leads, Franka Mai, Brigitte Lahaie and Jean-Marie Lemaire. They play their characters with gusto.

Once again, a fairytale ambience pervades the cautionary tale. The pacing is deliberate, achieving a genuinely eerie atmosphere as the events grow progressively more twisted and macabre. *Fascination* is a much more evolved and mature Rollin movie. Here the director plays with the theme of vampirism while avoiding the supernatural, treading a fine line between monster and mental illness.

The seductive and threatening Brigitte Lahaie makes for a mesmerizing screen presence. The sequence depicting Lahaie, complete with black cloak and scythe, on a castle drawbridge has become an iconic 'Eurotrash' image. It is atmospheric and possesses a raw energy, typical of Rollin's work when he is on top form.

Whether intentional or not, it is easy to read an underlying class issue within the fabric of the film, as we are presented with a wealthy clique of women who literally control and prey upon the 'lower' classes, gleefully cannibalizing them. Rollin had also previously poked fun at the bourgeois in *Le Frisson des Vampires*. The shot of the slaughterhouse makes for an unforgettable opening to the film and is a wonderful example of the surrealists' influence on Rollin. Here, a well-dressed, well-to-do woman, stands alone in a

slaughterhouse. Blood soaks the floor and walls, animal carcasses and steel hooks hang from the roof, yet her white dress remains pristine. Given that nothing moves in the frame, the viewer could be temporarily fooled into believing the image is a painting, but then the sound of dripping blood tells us it isn't. Rollin's obsession with arranging beautiful women in strange locations comes to the fore, as several more bourgeois individuals join the woman, drinking ox blood from crystal glasses.

Fascination is overflowing with foreboding and unease. The beautiful château in which the lead character finds himself is both a place of sanctuary and further torment. Virtually the entire film takes place within its increasingly claustrophobic walls, with the constant sense of threat from the criminals outside, and soon enough the mysterious and seductive women within. There is no place to hide and nowhere to run, and the protagonist is manipulated until his demise.

The photography by Georgie Fromentin is extremely subtle . For the most part, it is static, only moving to emphasize mood. The set decoration and costume designs add a rich and colourful texture. Interiors are frequently lit with a warm orange glow, which underscores the sexual tension, becoming more oppressive and eerie as the film moves on.

In one memorable sequence, Lahaie stabs a male villain as she has sex with him, plunging a knife deep into his chest. Although not unexpected, the abrupt outburst of violence is still shocking. What's more, the effect is highly convincing — for a moment, at least. Then the camera lingers for a second too long (letting slip the fact that the knife has a retractable blade) and spoils the illusion.

Fascination took less than two weeks to shoot and was scheduled to open in twelve cinemas around Paris. The cinema chain UGC initially agreed to distribute the film but backed out of the deal at the last minute, and the film never received the distribution it deserved, only playing to a limited audience in its native France.

There are several releases of *Fascination* available. In the UK, the film was released uncut on video and DVD by Redemption and *The Dark Side*. Image Entertainment released it in the US under Redemption's moniker. A rare German DVD release features the original poster artwork and has some interesting extras. All versions are uncut, but the best quality version to date is, once again, the

FASCINATION

American Blu-ray from Redemption.

The European trailer for *Fascination* includes an alternative shot that does not appear in the actual film. It depicts the barn seduction scene where Lahaie stabs her first victim. The shot lingers in close up on the knife blade penetrating the victim's chest before slowly gliding over Lahaie's naked body. Although Redemption's UK DVD of the film is uncut, the film's trailer was censored by a single second for an 18 certificate, the alternate shot described above proving unacceptable to the BBFC.

La Nuit des Traquées
The Night of the Hunted

AKA: *Acoso en la noche; Nyhta kynigimenon; Ragazza in amore*
1980 / Impex Films
91 Mins, Colour, 35mm, Original Ratio: 1:66:1
Director: Jean Rollin **Screenplay:** Jean Rollin **Production Director:** Lionel Wallmann **Director of Photography:** Jean-Claude Couty **Editor:** Gilbert Kikoïne (with artistic suggestion by Dominique Saint-Cyr) **Music:** Gary Sandeur **Sound:** Michel Pérv **Special Effects:** Évelyne Belkodja **Cast:** Brigitte Lahaie (Elisabeth), Vincent Gardére (Robert), Dominique Journet (Véronique), Bernard Papineau (Doctor Francis), Rachel Mhas (Solange), Cathy Stewart — credited as Catherine Greiner (Catherine), Natalie Perrey (Mother), Christiane Farina (Christiane), Élodie Delage — credited as Véronique Délaissé (Marie), Alain Plumey, Jean Hérel, Jacques Gatteau, Dominique Saint-Cyr, Gregoire Cherlian, Jean Cherlian

'Everything my body has done before this moment is forgotten'

Robert witnesses a beautiful young woman, Elisabeth, stumble in front of his car on an otherwise deserted country road. Terrified and confused, she is running from something she fears. Robert restores her calm. A naked woman, Véronique, emerges from the dark woodland and pleads for Elisabeth. Her cries go unheard and Robert drives Elisabeth to his home. Unbeknownst to them, they are followed by Elisabeth's pursuers. Elisabeth suffers from terrible amnesia and remembers not even the most recent moments. Robert and Elisabeth make love, during which she claims she will never forget him. The moment Robert leaves the apartment, two doctors enter, intent on taking Elisabeth to an ominous city location known as 'the Black Tower'. The sterile interior of the building is inhabited by people who suffer the same tortured amnesiac disposition as Elisabeth. Elisabeth is reunited with her friend Véronique. Meanwhile, the other patients grow rapidly less sane, with violent outbursts and several bloody murders. Elisabeth and Véronique attempt to escape the Black Tower which is crawling with blood-crazed patients and sinister doctors.

Their escape plan fails and the doctors inform Robert that the patients are walking corpses, they have no memory and no future. Their brain cells are rapidly dying. Elisabeth no longer recognizes her lover and walks by him like an emotionless zombie.

Elisabeth and Véronique are taken with the other remaining patients to a railway carriage in a deserted train depot. The patients are led, one by one, to an incinerator and burned to death. Véronique attempts to escape but she is gunned down by the sinister head doctor. The doctor reveals to Robert that the sickness was caused by a radiation leak and the patients cannot be saved. Elisabeth is left to wander until her final brain cells die. Robert attempts to join her and is shot in the head. Elisabeth and Robert join hands, and in their final moments, without memory, they walk towards a pale horizon.

Rollin approached one of his hardcore sex film producers with a proposal. For the cost of an average porn film, he could make a feature film that could potentially play to a wider audience, in regular cinemas. Rollin secured $40,000 and shot the feature in only ten days. The result, *La Nuit des Traquées* (*Night of the Hunted*), is one of Rollin's personal films; it is not a hardcore porn film, but it does use hardcore porn actors. The story is similar to that of David

FASCINATION

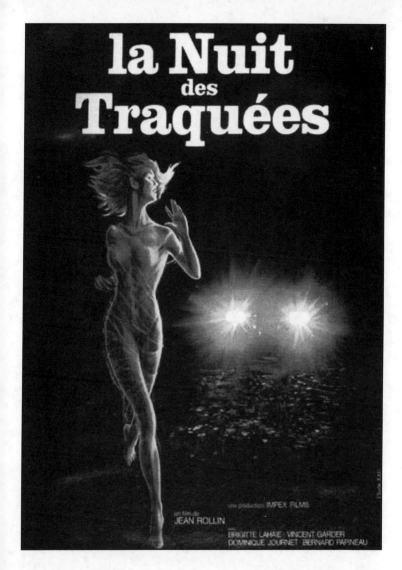

une production IMPEX FILMS

un film de
JEAN ROLLIN

BRIGITTE LAHAIE · VINCENT GARDER
DOMINIQUE JOURNET · BERNARD PAPINEAU

Cronenberg's *Shivers* (1975): an innocent couple attempt to escape a high-rise apartment block full of sexually charged murderous psychopaths. However, the similarities end there.

On first impression, *La Nuit des Traquées* is something of a departure for Rollin, with its futuristic approach and sci-fi influence. It is grim and disturbing, with a visual simplicity and lack of colour

Mutilated bodies in the morgue (previous page). *La Nuit des Traquées*.

that serve to enhance the bleak atmosphere. It is gritty and more grounded in reality than the *fantastique*. Nonetheless, Rollin imbues the film with his sense of tragedy and nostalgia. Like his other personal films, this too is obsessed with the past colliding with the present. The desire to reclaim the past and remember one's identity drives it. All of the central characters suffer from amnesia, and it is the lack of memory that haunts and tortures them.

There are no archaic ruins in *La Nuit des Traquées*, no châteaux or graveyards. They are replaced by cityscapes. The central location is a huge black tower block, which brings a sterile, medical, ambience. A mass of dark windows, it stands silhouetted against the sky like a tombstone, while its barren white interiors give the impression of a prison. Confined within are the doomed, walking seemingly endless corridors in search of their own identities.

Even Rollin's trademark imagery of bats and birds is absent. The only element of nature at work are the rising storms that pound the black tower. The wind and tumultuous rain at the end of the film signify the violent climax — emotionally and psychically.

Yet, the cause of the horror is pure Rollin with modern technology as the catalyst. All the mental degeneration and violent bloodshed stems from a radiation leak, and ultimately man's ignorance.

FASCINATION

French video sleeve (left). The modern world engulfed by the nature (top right) Brigitte Lahaie is comforted by Vincent Gardér. *La Nuit des Traquées*.

The characters are helpless, desperate and robotic. Without their memories they are trapped forever in the moment. Their lack of knowledge and personal history denies them their identity, making them are easy to manipulate. Their desire to remember and their tragic desperation is what evokes sympathy in the viewer here.

Due to his financial restrictions, Rollin had little choice but to cast hardcore porn performers, whose straight acting abilities range from acceptable to excellent. Brigitte Lahaie stands out as Elisabeth and gives a sensitive and moving portrayal. The film centres on her, as we see her evolve from a beautiful, if terrified, women fighting to live, into a zombie, without emotion or feeling. Rollin regular Nathalie Perrey also has a small but haunting appearance as one of the mentally disintegrating patients.

Jean-Claude Couty's camerawork is mostly static and each frame is filled with space, reflecting the simplistic and empty minds of the characters. Rollin's customary colour schemes are also absent, replaced with a starkness that is white and cold, befitting the isolation and emotional state of the characters. Light is put to startling use, manifesting Elisabeth's mental state, a character utterly surrounded by darkness and the unknown. Examples are found in the opening scene with the car headlights emerging from the darkness,

The Celluloid Dreams of Jean Rollin 133

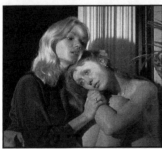

Into the furnace (top). Brigitte Lahaie comforts Dominique Journet (left).
Windows to the soul: Ocular trauma. *La Nuit des Traquées.*

and the first shot of Robert's apartment with its single light shrouded by blackness.

The sequence in which Lahaie's roommate commits suicide stands out as the most shocking moment: she plunges a pair of scissors into her eyes and brain. Not only is it a disturbing image, but it also parries Rollin's themes of technology and the human condition: the man-made surgical scissors are forced into the eyes — the windows of the soul. Another disturbing scene shows one of the patients strangling a woman to death while he fucks her.

For a film concerned with amnesia, I find it appropriate that *La Nuit des Traquées* holds so few memorable images compared with Rollin's other work. Only its disturbing images (of which there are only two) remain after the film has ended. It has more emotion-

FASCINATION

al staying power than unforgettable visuals. The final sequence is haunting, showing the two lead characters walking together like zombies, incapable of thought or memory, forever in search of who they are and who they were.

Image Entertainment released *La Nuit des Traquées* as the first instalment in their Rollin catalogue for the US market. A bizarre choice, considering the relative obscurity of the film and the immediate cult appeal of other early Rollin features. Their transfer was sharp and detailed, uncut, and presented in its original ratio of 1:66:1. Since then, it has been reissued in the US by Redemption in a beautiful, uncut Blu-ray transfer.

La Nuit des Traquées was surprisingly passed uncut by the BBFC in the UK in 2008 for home video. The mixture of sexualized violence and macabre eyeball trauma left the censor unscathed.

Although one of Rollin's personal films, as opposed to a work-for-hire sex film, *La Nuit des Traquées* was also released in a hardcore variant with XXX penetration shots culled from sources not filmed by Rollin.

Les Échappées
The Escapees

AKA: *Les Paumées du Petit Matin; The Runaways; Fuges Mineures; Anilikes Fygades*
1981 / Les Films ABC, Impex Films
103 Mins, Colour, 35mm, Original Ratio: 1:66:1
Director: Jean Rollin **Screenplay:** Jean Rollin and Jacques Ralf **Producer:** Uncredited **Director of Photography:** Claude

Bécognée (Assistant: Frédéric Bécognée) **Editor:** Uncredited **Sound Engineer:** Jean-Claude Reboul **Music by:** Philippe d'Aram **Makeup:** Eric Pierre **Production Director:** Monique Samarcq **Assistant:** Natalie Perrey **Cast:** Laurence Dubas (Michelle), Christiane Coppé (Marie), Marianne Valio (Sophie), Patrick Perrot (Pierrot), Louise Dhour (Louise), Brigitte Lahaie (Bourgeois Woman), Jean-Louis Fortuit, Jean Herel, Claude Lévèque, Patricia Mercurol, Celina Royce, Jean-Philippe Delamarre, Bernard Papineau, Natalie Perrey, Pearl June, Doriane Gaschette, Jean-Loupe Philippe, Alexandre Zagor, Patrice Chéeron, Lesley Blanc, Joëlle Ramon, Guillaume Cancade, Cyrille Gaudin, Raymond Soriano, Pascal Poirot, Marie-Ange Baratier

'I know what you're thinking. I don't want us to part. Ever.'

Michelle, a streetwise and confident young woman, is hosed down in a shower and forced into a straight jacket at an isolated psychiatric clinic. Determined to flee, she enlists the help of a catatonic, terrified young girl called Marie. Michelle escapes under cover of night and is forced to take Marie with her to avoid exposure. Marie becomes instantly dependant on Michelle, breaking down in tears whenever she leaves her behind. Michelle allows Marie to join her and the next day they meet a gang of gypsy performance artists. They help them during a performance in a junkyard and then spend a day at a grim, windy beach. Their travels lead them to a seedy, dangerous cabaret bar where they meet two bourgeois couples, accompanying them to their luxurious house. It's not long before the sexual shenanigans start. The two bourgeois women try to seduce Marie. Terrified, she reacts violently and stabs them both to death, and Michelle shoots the two men dead. The police arrive and a shoot-out commences. The two friends agree to shoot each other simultaneously but Marie backs out of their pact, leaving Michelle alive and alone. The policemen are shocked to realize the two women are but 'children' and they watch solemnly as Michelle carries her friend's body through the fog drenched Parisian streets.

For over two decades *Les Échappées* was Rollin's most frustratingly elusive title and was considered a lost film. When Redemption announced the film's DVD world premiere, sourced from the original 35mm negative, it held the potential promise of being a lost classic from the director's filmography.

FASCINATION

Images of madness, nostalgia and catatonia, *Les Échappées*.

Sadly, *Les Échappées* is a far cry from Rollin's films of the seventies and early eighties. It is incredibly cheap-looking and lacking in colour. It is also overlong. There simply aren't enough ideas or interesting imagery to hold the viewer's attention and the movie drags interminably. Even trimmed to eighty minutes this would still be hard going. There are some parallels with the previous year's *La Nuit des Traquées*, with both films depicting mentally unstable women in psychiatric clinics, but the similarities end here.

After a striking opening involving the escape of the two young women from the clinic and its pleasant setting, the film sinks into grim dreariness with backdrops of junkyards, a cheap cabaret club and dockyards populated with ugly cargo ships. The 35mm photography looks more like 16mm with its drained colour palette and graininess (although this may partially be attributed to the age and condition of the original negative). Visually, the film has more in common with the later and lower-budgeted *Les Trottoirs de Bangkok* and *Killing Car*, but fails to match either in terms of mood or entertainment.

Things drag on for far too long. The junkyard scene seems to last forever and does very little. Even the images of exotic dancers are

Come and play with us. Seduction in *Les Échappées*.

dull and nudity is kept to a bare minimum. As noted, the rest of the film is in contrast to its opening, which is in keeping with Rollin's more melancholy approach. The shots depicting the catatonic girl in a garden, squeaking back and forth on a rocking chair, convey an air of sadness and isolation that never materialize again.

Brigitte is visually striking as always and her role as a troublesome thrill-seeker is well-realized, but her appearance is too little too late and not enough of a part to make a difference. She briefly frolics naked with another woman but winds up getting stabbed by our troubled heroine.

The violence is kept to an absolute minimum with a couple of hardly-graphic bullet wounds and a well-realized stabbing via retractable blade (the same prop from *Fascination*, incidentally).

The plot ambles along, through one overplayed scenario to another. Only one of these, besides the opening sequence, is of any note. It is a beautifully presented moment that features our catatonic lead ice skating to an imaginary audience, while her friend espies from the shadows. It's a rare highlight, aided by d'Aram's captivating score. But even this sequence is undermined by trite dialogue add needless melodramatics.

Les Échappées was fraught with issues in pre-production and production. Rollin was advised by his producer to try another genre, as vampire films were growing less commercial and more difficult to turn a profit with. He was further instructed to work from

The tragic finale of *Les Échappées*.

a screenplay written by theatre-writer Jacques Ralf. Had Rollin stuck to it, the finished product might easily have been three hours long. Rollin disliked Ralf's long-winded dialogue and interminable set-pices and wrote his own draft of the screenplay that was much more scaled down. The film became a compromise and footage was shot from both scripts. Typically, the production was rushed, with minimal funding and only a small number of locations.

The sad finale, with its two heroines and theme of duality, is archetypal Rollin, but here it doesn't work. It's overworked by dialogue, while the general apathy of the scene ruins any chance of atmosphere. What could have been a minimalist, romantic piece is stifled by boredom. This in spite of the fact that Rollin, editing the film, cut out whole chunks of Ralf's dialogue. Tellingly, Rollin wasn't renowned for leaving costly footage on the cutting room floor.

Rollin hated the film and couldn't get any distributor to buy it. It was never screened theatrically but was briefly made available on Greek video as *Anilikes Fygades*, which was virtually impossible to track down. It is unlikely this film will garner the adoration and appreciation of viewers new to Rollin's oeuvre. It certainly doesn't require repeat viewings.

Nathalie Perrey worked as a continuity assistant on *Les Échappées* and Rollin's dear friend Louise Dhour has a large part as a cabaret singer (a role she played previously in *Les Démoniaques*). Rollin, complete with signature pipe, makes a cameo appearance in the cabaret bar and introduces Dhour's cabaret act.

Les Échappées is available from Redemption in the UK and has also played on French cable. The UK DVD is uncut and presented in full screen with English subtitles.

La Morte Vivante
The Living Dead Girl

AKA: *Zombie Queen; I zontani nekri; Scare — Dead or Alive?; Lady Dracula; Den levande döda flickan*
1982 / Les Films ABC, Films Aleriaz, Films Du Yaku
89 Mins, Colour, 35mm, Original Ratio: 1:66:1
Director: Jean Rollin **Screenplay:** Jean Rollin (French Dialogue by Jean Rollin and Jacques Ralf, English dialogue by Gregory Hellen) **Producer:** Sam Selsky **Production Director:** Lionel Wallmann **Director of Photography:** Max Monteillet **Editor:** Janette Kronegger **Music:** Philippe d'Aram **Makeup:** Eric Pierre **Special Effects:** Benoit Lestang (asst. Alain Dayen) **Cast:** Marina Pierro (Hélène), Françoise Blanchard (Catherine Valmont), Mike Marshall (Greg), Carina Barone (Barbara Simon), Fanny Magieri (Victim), Sandrine Morel (Teenage Catherine Valmont), Jean Cherlian (Graverobber), Jean-Pierre Bouyxou (Graverobber), Sam Selsky (Old American Man), Patricia Besnard-Rousseau, Veronique Pinson, Delphine LaPorte

'If you die first, I'll follow you. I swear it with my blood.'

Three men dispose of several toxic waste barrels in an isolated crypt. They proceed to steal jewellery from the corpses. A minor earth tremor causes a barrel of radioactive waste to spill. The liquid emanates a putrid gas that revives the body of a beautiful young woman, Catherine Valmont. Upon awakening she murders the three men and leaves her tomb, heading back to her family's castle. Meanwhile, an American photographer, Greg, is holidaying with his wife, Barbara. Deep in the French countryside, Barbara witnesses the mysterious living dead girl in the distance and captures several photographs of her in her burial attire.

Catherine's castle is up for sale, and the property agent resides within, using the building for a tryst with her boyfriend. The living dead girl silently tours her old homestead and the memories flood back. Opening a music box, she recalls a conversation with her childhood friend, Hélène, in which they become blood sisters and swear to follow each other forever, even in death. Catherine's childhood companion telephones the castle to speak with the estate agent and Cath-

LA MORTE VIVANTE

un film de
JEAN ROLLIN

avec
MARINA PIERRO | FRANÇOISE BLANCHARD

Mike MARSHALL - Carina BARONE Fanny MAGIER - Patricia BESNARD-ROUSSEAU
Adaptation, dialogues Jacques RALF. Musique originale Philippe D'ARAM. Image Max MONTEILLET
Effets spéciaux Benoist LESTANG. Une production - FILM A.B.C. - FILMS ALERIAZ - FILMS DU YAKA - SAM SELSKY
Diffusion mondiale : LES FILMS DE L'OBELISQUE 78 CHAMPS ELYSEES 75008 PARIS TEL. 359 11 12
interdit aux moins de 13 ans

erine answers the telephone. She does not speak but plays the melodic music box. As realization sets in, Hélène sets off immediately for the castle. The estate agent and her boyfriend are violently murdered by Catherine, and she devours their spilled blood. Hélène arrives to find her dead childhood companion sitting naked by a piano — a vacant stare upon her pale, bloodstained features. Hélène realizes Catherine requires blood to survive and lures an innocent female victim to the castle, who is grotesquely dispatched and feasted upon.

The Celluloid Dreams of Jean Rollin 141

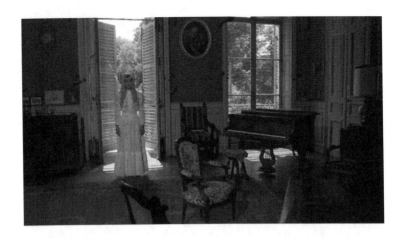

Barbara becomes obsessed with locating the girl in her photograph, and her interest increases when the local villagers proclaim that the girl in the picture has died two years previous. She sets out for the Valmont castle and is attacked by Hélène. Barbara manages to escape and tells the tale to her sceptical husband. Hélène continues to lure innocent victims for Catherine to slaughter and feast upon. During this time, Hélène becomes more and more unstable and the cursed Catherine despises herself for the monster she has become.

Barbara convinces her husband to visit the castle with her, to prove her tales are not a fiction of her imagination. Upon their arrival, Hélène kills them both.

Catherine releases her final intended victim, unable to murder another innocent person. Hélène and Catherine sit before the imposing castle beneath the night sky. Catherine tells Hélène that she is her death and proceeds to tear her companion's throat out with her teeth. Catherine feasts upon Hélène's dead body in cries of anguish, despair and sadness.

La Morte Vivante is an outstanding, extremely moving piece of cinema that ranks alongside the very best European horror films. The film embodies beauty, even during scenes of shocking bloody mayhem, and features some of the most striking compositions of Rollin's career. The cast is minimal, while the characters are more complex and involving than Rollin's previous protagonists.

Marina Pierro plays Hélène, and her gradual descent into madness is brilliantly realized. She is the film's lynchpin and emotional backbone. Pierro also appeared in Dario Argento's *Suspiria* (1977),

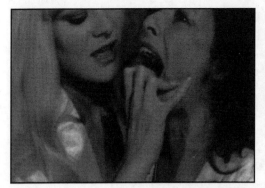

Françoise Blanchard (previous page); here she claims
another victim (this page). *La Morte Vivante*.

Walerian Borowczyk's *Bloodbath of Dr Jekyll* (1981) and *Behind
Convent Walls* (1978). Apparently Rollin found her difficult to work
with and incredibly stubborn. But she is perfectly cast. Amongst a
handful of other female regulars (Lahaie, Coeur, the Castel twins)
she stands as one of Rollin's strongest and most striking leading
ladies. Her expressions and mannerisms tell all. Statuesque, dan-
gerous, seductive, she is perfectly cast in *La Morte Vivante*.

Theresa Ann Savoy (Malcolm McDowell's co-star in *Caligula*,
1977) was originally considered for the role of the tragic Catherine
but declined the part, refusing to be associated with Rollin — most
probably due to his connection with the hardcore porn industry. In
her place, Françoise Blanchard's performance is outstanding. The
final tragic scene in which she is driven by bloodlust to devour her
childhood companion is both emotionally painful and grotesque.
This blood-soaked finale was shot in the early hours of the morn-
ing. Blanchard was physically exhausted and the dreadful smell of
the fake blood irritated her further. She eventually collapsed. A local
doctor was called, who arrived to find Blanchard still unconscious,
naked and covered in stage blood. The doctor almost called the po-
lice, thinking that something extremely sinister was occurring at
the isolated location.

The end sequence also offers some of Rollin's most compelling
and symbolic imagery, if purely by chance. Rollin recalled:

As we were shooting, it was three in the morning, we were in a castle,
and all of a sudden what do we see? A small bat attracted by the lights.

The Celluloid Dreams of Jean Rollin 143

Scenes of horror in
La Morte Vivante.

It was really small and was flying around the corpse [Pierro], so in this case, all we had to do was include the bat in the scene, and we ended up with two or three shots of the bat flying around.[*]

The image of the bat crawling and fluttering around the blood-stained corpse remains one of Rollin's most powerful images in the film. Rollin experienced another bizarre encounter with a bat, although not in relation to this or any other of his films. On his window ledge in Paris he found a genuine vampire bat, frozen and dying from the cold. He brought the creature inside and nursed it back to health, feeding the animal morsels of meat. He then let the vampire bat go the same way it had arrived, from his window ledge.

La Morte Vivante has Rollin's signature blue skies, lush country-side and picturesque château, all imbued with recurrent themes of melancholy and loss. The beautiful locations serve as a brilliant con-trast to the stark brutality of the murders, and the degradation of the two beautiful leads as they succumb to bloodlust and madness.

[*] Jean Rollin, interview by Lucas Balbo, *Two Orphan Vampires* DVD.

The carnage positively explodes on the screen, Catherine's inno-
cent expressions suddenly changing to those of a frenzied predator
when she attacks her victims. In one disturbing bloodstained rage,
Rollin uses slow-motion to great effect, drawing from it Catherine's
suffering, revulsion and despair.

Catherine isn't presented as a zombie in the George A. Romero
mould. She arguably possesses more traditional vampiric traits
and would be well at home with the bloodsuckers of *Les Frisson des
Vampires* and *Lèvres de Sang.* She dines on blood, speaks intelligibly
and embodies the ill-fated romanticism of the traditional vampire.
Catherine is not presented as an emotionless monster but rather a
catatonic and seemingly innocent girl, which enhances the subtle
atmosphere of dread and fear.

The horror elements of *La Morte Vivante* are more overt than in
Rollin's previous work. Nevertheless, it is horror distinctly alien to
that of his contemporaries (the slasher and zombie movies were
popular at the time of its release) and the film still feels fresh today.

Rollin cleverly manipulates the audience's expectations, never
allowing the simplistic tale to become predictable. This is particu-
larly evident with the demise of Barbara (Carina Barone) and Greg
(Mike Marshall); just as we feel they are about to reveal the truth
and potentially end the horror, they are very suddenly dispatched
and the film continues without them.

It is blood that binds the two girls' childhood promise and yet it
is blood that destroys lives and ultimately their friendship. A shot
of blood spraying onto the music box of their youth effectively fore-
shadows the inevitable conclusion.

Max Monteillet's camera lovingly details the striking landscape
and gothic architecture, as well as the explicit flesh wounds and ar-
terial spray. The Valmont castle is atmospherically lit, particularly
the cellar sequences and the final shocking scene, which has further
impact through clever use of shadow and colour: the castle that has
been presented with a warm glow throughout is suddenly rendered
blue and cold as Catherine feasts on her childhood companion. Roll-
in keeps the photography simple, with occasional tracking shots,
and each frame is opulently composed thanks. The photography
itself commands the viewer's attention, no matter how horrific or
potentially diverting the bloodshed.

The only weak element of the story is the toxic waste subplot

that serves only as justification for Catherine's return from the dead. Despite pre-empting the key plot device for Dan O'Bannon's punk hit *Return of the Living Dead* (1985), one cannot help but feel the film would have worked better on the whole if the men who enter the tomb were simply grave robbers, and Catherine's return from the dead was associated with a more supernatural design. In Rollin's dreamlike world, a 'logical' reason is rarely necessary. Take the murdered girls in *Les Démoniaques*, for instance, who return from the dead without explanation.

Yet, despite the trashy toxic waste scenario, Rollin keeps the sequence workable purely through attractive visuals and the eerie atmosphere generated within the tomb. The opening shot provides an interesting juxtaposition of man-made energies, featuring a nuclear power plant polluting the air, surrounded by power lines and cables. As *La Morte Vivante*, *La Nuit des Traquées* and *Les Raisins de la Mort*, here mankind's ignorance is again at fault. Given this premise and and the fact all three films were made in the same era, maybe we can see them as a trilogy of sorts?

La Morte Vivante was one of Rollin's most well-scripted and tightly planned productions (he even had a shooting script this time). Unlike his previous, deeply personal films, it was well received amongst horror critics and won Rollin a prize at the Italian Fanta Film Festival in 1982. It's also one of his most extreme, and features several explicit gore set-pieces that include images of eye-gouging, jugular-tearing and vicious flesh-rending. More often than not, these attacks are administered to naked victims. In the UK, the censor unsurprisingly took offence and severely butchered the film. When submitted to the BBFC in March 1994, 2m 21s of bloodletting were excised, reducing the running time from 86m 10s to 83m 38s. Thus, the impact of the film was considerably lessened, especially the ultra-violent and touching finale. In 2007, Redemption re-submitted the film to the BBFC and acquired an uncut 18 certificate for DVD home video release.

The first US DVD from Image Entertainment was completely uncut, as was *The Dark Side*'s mail order release (which was not actually re-certified by the BBFC, despite displaying a BBFC 18 certificate). The Encore Entertainment DVD is also uncut and presented as a three-disc collector's edition box set. As with Encore's collector's editions of *Les Démoniaques*, *Requiem pour un Vampire* and

FASCINATION

Lèvres de Sang, it was limited to 2,500 pieces. Redemption released the film on Blu-ray in the USA completely uncut.

Les Trottoirs de Bangkok
The Sidewalks of Bangkok

1984 / Impex Films and Les Films ABC
85 Mins, Colour, 35mm, Original Ratio: 1:66:1
Director: Jean Rollin **Screenplay:** Jean Rollin, Jean-Claude Benhamou **Producer:** Lionel Wallmann **Director of Photography:** Claude Bécognée **Editor:** Janette Kronegger **Music:** Georges Lartigau **Director's Assistant:** Dominique Treillou **Assistant Director:** Kristine Etienne **Cast:** Yoko (Eva), Françoise Blanchard (Claudine), Brigitte Borghese (Rita), Gerard Landry (Phil), Jean-Paul Bride (Tong), Jean-Pierre Bouyxou (Captain Bouyxou), Jean-Claude Benhamou (Spy Leader), Andre-Richard Volnievy, Olivier Rollin, Antonina Laurent, Shokie, Tiane Poctchier, Michel Guibe, Rudy the Dog

'I ask for your forgiveness for all that I've done, and above all for what I am going to do now. I am so sorry baby, but you know too much.'

On the streets of Bangkok, a man named Rick is mercilessly gunned down and killed — his 16mm film camera lies beside his corpse. Another man arrives at the scene and takes the camera and quickly disappears.

In Paris, members of the Secret Intelligence Service (SIS) view the camera footage, which consists of Bangkok locales. Rick's mission was to obtain a tube containing a new biological weapon and the film camera was a cover for his operation. Eva, a beautiful Asian prostitute, and her pimp Tong, retrace Rick's last steps in an attempt to find the lethal weapon. Two women arrive at SIS, steal Rick's footage and deliver it to Rita, a feared gangster boss, who also wishes to obtain the secret weapon. She sends her two favourite spies to Hong Kong to find Eva before SIS. Rita's Asian contact pays Tong to kill an SIS man when he arrives at the club and she also buys Eva from him. Later, Claudine and the SIS man visit Tong's bar. Claudine arranges for Eva to be taken on a long ship journey and pays the captain, Buissi, to keep her as a prisoner. Further double-crosses, twists and set-pieces

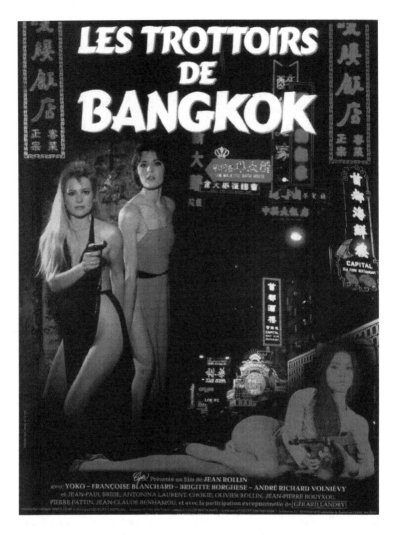

ensue, including a scene in which two SIS men are tied to the track of an oncoming train, only to be saved in the nick of time by the their trusty German Shepherd.

Rita's women strip and whip Eva to extract information, forcing Claudine to watch. Rick, supposedly murdered in the opening sequence, arrives and kills Rita. He unchains Eva and they escape from the dungeon. On the mansion grounds, Rick confesses the truth: he has always possessed the tube and he has used Eva as a decoy to keep

FASCINATION

SIS and Rita off his trail. Revealing a gun he intones, 'I am so sorry, baby, but you know too much'. The SIS dog suddenly appears and attacks Rick, forcing him to drop the gun, which Eva quickly obtains and shoots him dead, with tears streaming from her eyes.

Les Trottoirs de Bangkok is a strange departure for Rollin. It's hard to believe that this film followed his classic and well-considered *La Morte Vivante*.

The film is a spy thriller in the shade of the American serials Rollin loved as a child, incorporating a heavy dose of James Bond double-crosses, twists and turns. However, it lacks a hard edge to the action, focusing more on cheap nudity and daft set-pieces. A sequence in which SIS members are tied to the tracks of an oncoming train, only to be rescued by their dog, is typical in this respect. These attributes, coupled with the sleaze quotient, make for an uneven viewing experience.

Les Trottoirs de Bangkok was an entirely improvised project; Rollin only had a two-page idea to work from and a crew of four, including himself. He used friends and passers-by as actors. His fast, improvised approach to shooting is at odds with the subject matter here. The unrehearsed and spontaneous method lends itself better to horror and sex films as they can be driven by mood rather than intricate plotting. That said, for all its failings, *Les Trottoirs de Bangkok* is a fun frolic for Rollin fans and a great example of his skill for achieving a professional and marketable product, proving his ability to adapt his style and do something different.

Les Trottoirs de Bangkok is essentially a non-stop carousel of double-bluffs in which no character can be trusted. It is deliberately difficult to predict the journey of the narrative and Rollin pulls off a clever twist ending, which reveals Rick to be alive and well. The director had a great skill for leading the audience astray, and it is most evident in this film. Taking into consideration that the dialogue and camerawork are entirely improvised, Rollin turns out a complex plot that works surprisingly well, while the film itself is excellently paced.

It's Rollin's only film to frequently use voice-over narration (possibly Rollin himself, although he couldn't recall whether it's his voice or not). The voice-over serves only to clarify several twists and identify locations for the viewer, such as the SIS building or Rita's dwelling. The narration seems to be a last-minute postproduc-

Les Trottoirs de Bangkok

tion inclusion, but without it the film would be difficult to follow.

The idea for the film came about when Rollin saw stock footage of Bangkok locales. He realized if he shot some new scenes in suitably vague locations he could integrate the exotic Bangkok footage into the mix, thus adding production value and varied settings. The grainy Bangkok stock footage is clearly mismatched but Rollin works the clips in well. The inclusion of Asian cast members helps to sell the concept and establish the setting. The new interiors are all intentionally minimum and non-specific. Most appear to be simple furnished rooms shot in the houses of friends and acquaintances. The sordid interior locales of Bangkok, particularly Tong's bar, are well-realized. Every shot is bathed in red light and cigarette smoke, while Rollin's camera picks out architectural design evocative of Eastern culture.

The squalid underworld of Bangkok is represented entirely through Tong's establishment of opium dens, prostitution, massage parlours, exotic dancers and female mud wrestlers. Rollin's editing is completely different to the gentle pace of his previous films, using continuous cutting to emphasize the action. The photography is tightly framed throughout, and although Rollin cleverly creates a seedy and dangerous criminal underworld with virtually no props or budget, the visuals lack the beauty of his other pictures. Rollin captures as much contemporary 'technological' elements as possible, with long shots of aeroplanes, guns and moving trains adding to the 'action' and spirit of the film. Rollin gets a lot of mileage out of these production shots and sells the impression that there is a budget at work here. The exterior locations are stereotypical of the crime thriller genre and are comprised of cargo harbours, train de-

FASCINATION

Yoko guns down her deceitful lover (left). Yoko is saved after a brutal whipping. *Les Trottoirs de Bangkok.*

pots and carriages. The grim locations lend *Les Trottoirs de Bang-kok* an inherently ugliness. The only salvation from these grey back-drops is the frequent nudity. Most of the female characters have at least one nude scene and the striptease sequences are excessively drawn out.

Rollin plays with gender hierarchy, though unintentionally. At the beginning of the film, the women in Bangkok are controlled and exploited by the male characters. Yet these characters are then ma-nipulated by women; it's the women who actually call the shots. Make no mistake about it though, there are no real gender politics here, this is pure 'Eurotrash' exploitation.

Les Trottoirs de Bangkok is swamped by mid-eighties music and fashion, with the cast wearing whatever clothes they turned up in. The soundtrack is comprised of terrible disco pieces full of elec-tronic drum loops, saxophones and keyboards, occasionally slip-ping into slower pieces with soft drum tempos to stereotypically reflect Far East culture.

The characters are one-dimensional but this does not slow down the pace, which is fairly brisk. Even Françoise Blanchard, who turned in an excellent performance in *La Morte Vivante*, is some-what unexciting and underplayed. She also has one of the worst eighties hairdos of all time. However, her performance in the final, surprisingly potent, sequence is a standout: a single tear rolls down her cheek as she watches Eva get a salacious whipping. The evil Tong is more comedic than sinister and his facial hair is obviously glued on! Yoko is very good as the innocent Eva (Rollin's camera is

The Celluloid Dreams of Jean Rollin 151

fascinated with her), her petite form fitting well with her character. Yoko also worked in French hardcore and appeared in *Diamond Baby* (1983) and *Singapore Magic* (1984).

The rich symbolism and gentle, colourful visuals of Rollin's previous work are not evident here; but all told they would be out of place in a cheap and fun action thriller. Populated with industrial locales that are visually bland, this is Rollin's ugliest looking film. It never feels like a traditional Rollin film at heart. Nevertheless, *Les Trottoirs de Bangkok* serves as a reminder of what can be achieved with clever improvisation. Zero-budget independent filmmakers should find it invaluable.

Fans of Rollin's *Bacchanales Sexuelles* will no doubt recognize Brigitte Borghese as Rita. She virtually reprises her role of Malvina from the aforementioned film (a scene in which she pleasures herself to the humiliation of a female adversary is a direct reference).

The UK DVD by Redemption and US DVD by Image Entertainment both feature sharp full screen transfers and are both uncut. It has yet to surface on the Blu-ray format but it's hard to imagine much of a visual improvement on the bland palette.

Perdues dans New York
Lost in New York

1989 / 52 Mins, 35mm, Colour, Original Ratio: 1:66:1
Directed: Jean Rollin **Screenplay:** Jean Rollin **Producer:**
Uncredited **Director of Photography:** Max Monteillet **Editor:** Janette Kronegger **Music:** Philippe d'Aram **Cast:** Adeline Abitbol, Funny Abitbol, Catherine Herengt, Catherine Lesret, Sophie Maret, Marie-Laurence, Mélissa, Natalie Perrey, Catherine Rival

'Magic only works once.'

Surrounded by dilapidated buildings and cobbled streets, a lonely old woman called Michele reminisces about her life. Her memories take her back to her childhood and to a picturesque cemetery. She recalls meeting a sad young girl named Marie who had no one to play with... They quickly become friends and Marie shows Michele an ornamental statue called the Moon Goddess that contains a magical power. Together they embark on a wonderful journey that takes them through

The ethereal face of the Big Apple in *Perdues dans New York*.

time and space.

When they are older, the Moon Goddess takes them to New York City but they are separated. They wander the crowded city streets in an attempt to find each other.

Michele is attacked by a woman with a knife but turns the blade on her attacker, cutting her throat, while Marie is bitten by a female vampire. They continue to search until they are finally reunited on the Brooklyn Bridge.

Michele, as on old woman, still sits thinking of their magical past adventures. She is suddenly transported to an isolated beach where Marie awaits. She has also aged considerably. After speaking, they

disappear into thin air and reappear as young girls again. They spy a cave in the white cliff-face and enter. A narrator proclaims: 'The passageway though which Michele and Marie entered, closed behind them. You can only go inside once, and you'll never come back out.'

Perdues dans New York is another wonderful example of Rollin's improvised, experimental style, and was produced under similar opportunistic circumstances as *Les Trottoirs de Bangkok*.

In 1985, Rollin was offered a stock footage assignment to capture images of New York City for a French TV movie. Rollin optimistically used the occasion to capture some stock footage for a project of his own. Although he had no script at the time, this seed would later develop into the imaginative *Perdues dans New York*, another organic and personal vision in which Rollin achieved something unique and startling from virtually nothing.

Initially made for TV, *Perdues dans New York* is noticeably much shorter than Rollin's previous ventures, running less than one hour. A dreamlike fantasy, it not only incorporates elements of the director's previous works, but actually exists because of them, being a nostalgic summation of everything Rollin had achieved up to that point. 'Here we see how far the themes and images outlined in *Viol [Du Vampire]* have been refined and mutated over the years,' observe Cathal Tohill and Pete Tombs, 'it shows how far the two female characters, who feature in nearly all his films, have come'*.

Every scene is a sort of reference to Rollin's legacy. Again, we are presented with two young female protagonists as central characters. Following Marie and Michele on their magical journey through time and space, we revisit locations of great importance from Rollin's previous films, including graveyards, city streets and waterfronts, and, of course, the beach at Dieppe. The gothic romanticism of *La Rose de Fer* is also explicitly recalled on at least two occasions, most notably when an old man offers red roses to Marie and Michele on the beach and also the sequence were the girls find the Moon Goddess statue in the surf. Rollin even references *Emmanuelle* 6, by featuring the exotic dancer, the Black Priestess, and including jungle imagery in the book sequence. The final piece of narration is delivered by Rollin himself, nicely wrapping up the the girls' journey, that can also be read as a symbolic adaptation of Rollin's own

* Tohill and Tombs, 171.

FASCINATION

Perdues dans New York

journey through film. Elsewhere, the symbolism is a categoric fact, as in the sequence where the Moon Goddess transports the couple into the pages of a book. Here, Rollin namechecks his own films and openly declares that his leading ladies are cut from the same cloth, having grown and adapted from one film to the next, as per this dialogue from the movie:

> The Moon Goddess took us inside the picture book. The pictures had become a movie screen. A cinema of dreams ... we were all the little girls from the films ... we were inside the music box of *The Living Dead*, under the abandoned viaduct with the lovers with the destroyed brains in *Night of the Hunted*. Touched by *The Shiver of the Vampire*, where everything comes to life with the strike of the huge clock ... behind the theatre curtain of *The Nude Vampire*. We are the ones being watched by the little Asian girl from her prison cell in *The Sidewalks of Bangkok*. We have become the young ladies from *Fascination*.

After openly referencing his own filmography, Rollin then delves into his own childhood and his passion for cinema, as Michele's voice-over (provided by Nathalie Perrey) proclaims: 'We are the heroines of every serial, of every episode. We are searching for the island of *King Kong* and the *Phantom of the Opera*. And there also *Malao* and *The Mysterious Dr Satan* ...'

The minimal budget never betrays the film, and, in many ways, it brings to it a sense of raw charm that is beneficial. Indeed, the only elements that actually look cheap and out of place are the video title card and the end credit graphics. Otherwise, this experimental little film is visually strong and has two powerful moments that stand alongside Rollin at his best. The opening sequence is one of them; it intercuts images of Natalie Perrey as the 'old' Michele wandering through crumbling streets, and Mélissa, the exotic dancer, walking along deserted train tracks. Without warning, the film abruptly cuts to a wide shot of the Dieppe shoreline and Philippe d'Aram's nostalgic and haunting score grabs the viewer's attention, signifying that we are indeed back in Rollin's personal dream world. The second, and arguably most memorable scene, features Marie and Michele on the deserted beach wearing white masks. It is pure Rollin, offering the viewer images that could be read on several levels, while maybe not actually meaning anything at all. These images are captivating and require no explanation to keep them so.

Rollin makes full use of his New York location footage and fills the screen with skyscrapers and bright lights during the night-time sequences. The Brooklyn Bridge is eloquently used for the reunion of the two lost characters.

La Nuit des Horloges aside, *Perdues dans New York* is Rollin's most self-referential work. For that reason it is essential viewing for Rollin fans, if not the best entry point fro newcomers. Without knowledge of the director's work, the film's warmth and impact would undoubtedly be diminished.

Perdues dans New York was also one of Rollin's more obscure films. Prior to its DVD release, the most common copy was a bootleg from Video Search of Miami. It was presented in its original French language with English subtitles but the quality was awful. Image Entertainment subsequently released the film on DVD in the USA. It has since been reissued by Redemption on DVD in the UK and USA, and has also been made available in France as part of the Jean Rollin

FASCINATION

collection. The long out of print German DVD release featured Roll-in's even more rare TV movie *La Griffe d'Horus* (1990) as a bonus feature.

Killing Car

AKA: *La Femme Dangereuse*
1989 (original copyright date; actual completion date is 1993) / Impex Films, Tanagra Productions
89 Mins, Colour, Super 16mm, Original Ratio: 1:33:1
Director: Jean Rollin **Screenplay:** Jean Rollin **Producer:** Jacques Michel **Director of Photography:** Max Monteillet **Assistant Photography:** Véronique Djaouti **Second Assistant Director:** Michel Franck **Editor:** Janette Kronegger **Music:** Philippe Brejean **Sound:** Jean-Claude Reboul **Cast:** Tiki Tsang (The Vengeful Woman), Frederique Haymann, Jean-Jacques Lefeuvre, Karine Swenson, Jean-René Gossard, Karine Hulewicz, Pascal Montsegur, Barbara Annovozi, Pascale Lemaire, Fabienne Beze, Jean-Loup Philippe, Meline Genot, Bertrand Biget, Jack Mitchel

'1957 VV44'
— Registration of the killing car

A beautiful Asian woman (Tiki Tsang) sits silently on a moored boat on the River Seine. The film cuts back and forth between her solemn contemplation and a series of vengeful murder set-pieces with Tsang as a femme fatale.
At an autowreck yard a unique green car is for sale. Tsang appears

Avenging angel, Tiki Tsang. *Killing Car.*

*interested in the car and lures the male attendant to a secluded area,
seducing him before gunning him down. Tsang then enters into a
gunfight with a group of prostitutes and the shoot-out continues at a
deserted fairground. Tsang dispatches all of the women and when po-
lice discover the dead bodies at the autowreck yard, they find a small
souvenir left on a bullet-ridden corpse ... a toy car.*

*In a rural dwelling, Tsang stalks and shoots a man and woman af-
ter becoming involved in a gunfight with them. Elsewhere, she kills a
young man and woman, shooting the man and attacking the woman
with a scythe and pitchfork. Police officers find another toy car at the
scene of the crime.*

*In New York City, a female photographer is taking pictures of her
naked lesbian lover. Later, in Paris, Tsang poses with the same model
and photographer. She stabs the photographer in the stomach with
a large hunting knife before pursuing them onto the foggy Parisian
rooftops where, dressed as a jester, she coldly guns them down. Anoth-
er toy car is left at the scene.*

*At a sleazy strip club, Tsang performs an erotic dance for the own-
er before murdering him and a female companion. Further scenes de-
pict a woman being attacked in an office building and the death of an*

FASCINATION

Jean-Loup Philippe (left). The green death (right). *Killing Car.*

antique dealer and his mistress.

In a green car, a man sits wrapped in bandages. Tsang caresses and embraces him warmly before shooting him dead. She meets with the two police officers and a package exchanges hands, the contents of which force the police officers to attempt to kill each other, resulting in one death. The surviving policeman follows Tsang to a barren country field and watches her lose herself in despair.

Killing Car is one of Rollin's most obscure titles and until the recent DVD releases it was almost impossible to find. It shares many similarities with *Les Trottoirs de Bangkok*, avoiding the *fantastique* and taking the form of a gritty revenge thriller. The movie is essentially a series of revenge set-pieces in which Tsang, the seductive and deadly femme fatale, wipes out unsavoury characters who have done her wrong.

Like many of Rollin's later productions, *Killing Car* was a troubled venture. The film was written as a showcase for its striking star, Tiki Tsang, whom Rollin considered extremely photogenic and full of character. It was intended for French television and a release on the home video market. With minimal funding, Rollin was forced to shoot the largely improvised film on 16mm. Production commenced in 1989 and the film was shot over ten long days, wrought with problems. Rollin found his crew dispassionate and ill-humoured. He was also becoming increasingly ill, and was frequently hospitalized around this time for kidney treatment. By the end of the demanding and physically exhausting shoot, he had fallen seriously ill and all postproduction work was forced to stop. Normally, Rollin's movies took around three to six months from script to final

The souvenir car in *Killing Car*.

edit. *Killing Car* became his longest running production. Rollin's recovery was slow and it was several months after he had fully recuperated that he commenced editing. The film was edited on video (the computer-generated end credits bear the distinct mark of an analogue video edit suite). Finally, some four years later, the *Killng Car* was complete. It didn't air on television, as was the original intention, but did receive a small theatrical run in Paris in 1993.

All in all, the production cost US $100,000, which is remarkable considering what Rollin achieved with such a comparative lowly amount. It is again another distinct Rollin film that makes many playful references to his previous pictures.

Like *Les Trottoirs de Bangkok* and even *Perdues dans New York*, Rollin focuses on grimy locations and gloomy backdrops, such as deserted industrial districts and waterside cargo bays. The film has a cold, grey, washed-out ambience, filled with fog drenched Parisian streets. Although always a key ingredient in Rollin's films, here Paris quite different from the city as it appears in *Lèvres de Sang* and *La Vampire Nue*. Rollin's representation of Paris in *Killing Car* is not at all romantic, but rain-slicked and even grubby. Shots of the Eiffel Tour and the Invalides Hotel serve as a reminder that we are still in the French capital.

The photography by Max Monteillet is stationary, murky and bleak, a result of the grainy 16mm film and the video transfer as much as it is the poor weather and urban locations. The use of

sound is simplistic and sparse, adding to the gritty reality of the film, while Philippe Brejean's low-key piano score works well with the subdued imagery. Even the action sequences and gun battles, particularly the fairground scene, play without dramatic music or sound effects making the film even more low-key.

Rollin misses no opportunities when it comes to exposing naked female flesh. Most of the revenge scenarios involve female cast members undressing and changing clothes in the most bizarre and unlikely of situations. Take the paranoid Asian girl at the end of the film, who removes her office clothes to put on skimpy garments, knowing all too well that something bad is unfolding.

In spite of it all, *Killing Car* succeeds in keeping the action flowing. The film's six murder set-pieces account for about ninety per cent of the running time. Rollin's take on the gritty revenge thriller is certainly unique. In much the same way that his vampire films fail to adhere to traditional notions of horror, *Killing Car* is removed from the straight-to-video/TV movie conventions of the market it was intended for.

There's no sense of a timeframe, or much else. Tsang's motives are cloudy even at the end of the picture, while some sequences, such as those on the boat, are totally obscure. We don't know whether they are set in the past or present or if they are fantasies. The significance of the toy car she leaves as a symbolic calling card is also left vague.

The fairground sequence has plenty of atmosphere. It has the sights and sounds expected of such a place, but here it is deserted but for Tsang and her victims. The sequence where Tsang stalks two of the women amongst a collection of statues is also unsettling and memorable.

Tsang's performance as the femme fatale is excellent. As so many of Rollin's beautifully dangerous female leads, she has a presence that is irresistibly powerful. Nonetheless, *Killing Car* remains Tsang's only film.

Admirers of the director's work will have a field day recognizing the endless references to his other films. At one point, Tsang, dressed in a long black cloak, stalks a female victim with a huge scythe while thunder broods on the soundtrack, recalling *Fascination*. Tsang then decides to kill her victim by plunging a pitchfork into her torso as in *Les Raisins de la Mort*. In another sequence she

is dressed as a clown as she commits a double murder, echoing *Requiem pour un Vampire*, *Les Démoniaques* and *La Rose de Fer*. Jean-Loup Philippe as the antique dealer at the end of the picture also makes for a nostalgic surprise. He was last seen in *Lèvres de Sang*. Rollin himself appears in a strange cameo, covered in bandages, as Tiki Tsang's lover.

The French DVD, part of the Jean Rollin collection from LCJ, was the first digital video release of this forgotten entry in Rollin's filmography. It is uncut but contains no English subtitles. The UK DVD from Redemption offers newly translated English subtitles and is the original version, passed uncut by the BBFC. All versions available present the film in an aspect ratio of 1:33:1. All negatives are considered lost and chance of a print being unearthed is highly unlikely. Whether the film was intended to be shown in this ratio is unconfirmed.

Les Deux Orphelines Vampires
The Two Orphan Vampires

1995 / Les Films ABC, Lincoln Publishing, Francam Inter Service Corp. 103 Mins, Colour, 35mm, Original Ratio: 1:66:1
Director: Jean Rollin **Screenplay:** Jean Rollin (script and montage by Natalie Perrey), based on the novel by Jean Rollin **Producer:** Lionel Wallmann **Director of Photography:** Norbert Marfraing-Sintés (asst. Véronique Djaouti) **Music:** Philippe d'Aram **Sound:** Francis Baldos **Cast:** Alexandra Pic (Louise), Isabelle Teboul (Henriette), Bernard Charnacé (Dr. Dennery), Natalie Perrey (School Teacher), Anne Duguél (Virginie), Anissa Berkani-Rohmer (Nicole), Veronique Djaouti (Venus), Tina Aumont (Ghoul) Nathalie Karsenty, Nada Le Hoangan, Brigitte Lahaie, Martin Snaric

At the Glycines Orphanage, renowned eye specialist Dr Dennery, meets two apparently innocent, blind orphan girls, Louise and Henriette. He wishes to give them back their sight and offers them a new start in life, but unbeknownst to him and to everyone else, these teenage orphans are not as innocent as they seem. They are vampires, and though they are blind by day, they can see perfectly at night. They escape the orphanage after dark and feast on warm blood. One nightly adventure leads them to a graveyard where they feast upon a stray

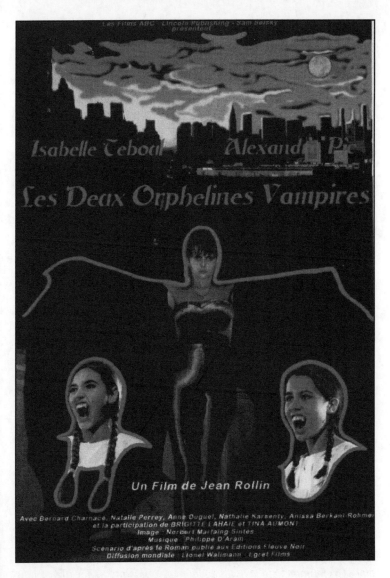

dog. Sticky with blood, they happily recall their past escapades and murderous deeds, including the murder of a man in New York City. Upon their moonlit travels, they meet another creature of the night, an ogress. The two orphans gorge themselves on literature of Aztec gods and human sacrifices and share naïve fantasies. Dr Dennery be-

The Celluloid Dreams of Jean Rollin 163

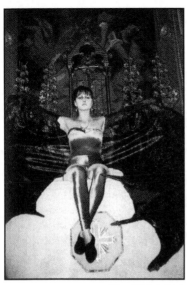

The Midnight Lady (left). Henriette (Isabelle Teboul) bears her fangs. *Les Deux Orphelines Vampires*.

comes the girls' legal guardian and he allows them to share his home in Paris. During their first night, the orphan vampires sneak out of the house and murder a woman in a circus tent. Another night they search Paris for the Père Lachaise Cemetery where they feast on the blood of a young woman. Two men pursue them but another creature of the night, a vampire bat called the Midnight Lady, saves them and gives them shelter. The next day, deprived of energy, they feast on each other's blood. They become intoxicated on brandy and stumble home. Dr Dennery mistakes them for trespassers and shoots Louise by accident. Henriette offers her own blood to the dying Louise, making her stronger and restoring her life force. They desire their freedom again and kill the overprotective Dr Dennery, stabbing him with a kitchen knife. They set fire to the house and wander the countryside.

After meeting a ghoul who eats the dead, they return to the Glycines Orphanage to feast on the blood of young girls. They are caught in the act and pursued deep into the countryside. Henriette is shot in the back with a shotgun and Louise hides her dying companion amidst the reeds of a country pond. Henriette succumbs to death, and Louise, unable to live without her friend, drowns herself.

After almost two decades, Rollin returned to explore his beloved

FASCINATION

Henriette (left). Dr. Dennery
(Bernard Charnacé) adopts the
orphan vampires (top).
Louise (Alexandra Pic) and
Henriette lost in memories. *Les
Deux Orphelines Vampires*.

theme of vampirism with *Les Deux Orphelines Vampires*. Not since
La Morte Vivante in 1982 had he tackled the bloodthirsty undead
and here he delivers one of his warmest and most astutely devel-
oped films, which many consider a return to form after the bleak
offerings of *Les Trottoirs de Bangkok* and *Killing Car*. The film began
life as a book (sharing the same title) written by Rollin, and later
translated into a screenplay. The book was part of a series of five
fantasy novellas released in serial form. *Les Deux Orphelines Vam-
pire* was the first book in the series, while the remaining volumes
explored other creatures of the night.

Given that its story is honed from novella to screenplay, this
may well be Rollin's least improvised personal film. It has a tight
cohesiveness and is more measured in its delivery, giving it a differ-
ent feel. Everything is here for a reason; nothing is haphazard. But
while Rollin's magical, improvised flourishes are less evident, make
no mistake that *Les Deux Orphelines Vampires* is pure Rollin.

The film is very faithful to its source — the structure and almost
all the dialogue remain the same. This may account for its length,
which, at 103 minutes, is one of Rollin's longer movies. Even subtle
details charmingly remain the same. The opening of the book intro-
duces the reader to the orphans by describing the sound of their

canes tapping along a linoleum corridor: *'Clack Clack Clack Clack went the two white sticks.'* They first appear in the film the same way. The main difference between the original text and the subsequent film is the presentation of sex and violence. The book is far more perverse — its murderous orphan vampires are only fourteen years old and it explicitly details their sexual experimentation with victims of a similar age. Translating the idea to the screen, Rollin wisely removed the risqué references to the age of the girls and instead presents them as young women in school uniforms. In the film adaptation the orphans are older but they still deliver childlike dialogue. Rollin recalled that his script 'was somewhat literary as I did not change the dialogue. Most of the scripts dialogue was right out of the book'.* This maintains the fairytale ambience of the original text but also brings a greater surrealism to the proceedings: which is to say we now have seductive women in school uniforms, sporting bloody fangs, having frequent childish daydreams and talking abstractly. For what it's worth, budgetary restraints seem to account for the toning down of the gory violence.

The film introduces things that do not appear in the source novella. The train yard sequence featuring a she-wolf, for instance, a sequence with a ghoul, and the death of the two orphan vampires at the end of the film are all additions. However, some of these characters would turn up in the second literary instalment.

Books play an important part in the film. Rollin uses the pages of books to create the title and end credit sequences; the orphans obsess on literature throughout, losing themselves in pages of fantasy.

Played by Louise and Henriette, the orphans, are wistfully brought to life by Alexandra Pic and Isabelle Teboul, who offer sympathetic portraits of the naïve bloodsuckers. As with many of Rollin's blood-drinking undead, they are not presented as symbols of fear and their thirst for human claret has an air of tragedy.

Rollin's clever framing subconsciously draws the viewer into the personal fantasy world of the two orphans, and realizes their inseparable friendship. The orphans always appear in the same shot together. Rollin only once breaks this rule, in the sequence where Dr Dennery shoots Louise and she is on the verge of death. Here, the dying Louise and the distraught Henriette are in two separate

* Jean Rollin, interview by Lucas Balbo, *Two Orphan Vampires* DVD.

FASCINATION

Isabelle Teboul and Alexandra Pic. *Les Deux Orphelines Vampires*.

shots, with cuts between the two. The effect enhances the threat and heartbreak of the situation: two girls may have to finally part in death. All of a sudden, the fantasy element that has pervaded throughout is shattered by a serious, life-threatening incident.

The theme of duality is further illustrated by the visual representation of the orphans, who wear matching clothing and are constantly presented side by side, virtually mirroring each other's movements and emotions. Their fantasy world is identified by colour. During their blind daylight hours, the modern world and city streets are presented in stark, cold reality. When the orphans regain their vision at night, everything is swamped in blue.

Rollin's playful use of *mise en scène* and symbolism is evident from the start. When the orphan vampires first arrive at Dr Dennery's house, they sit innocently on a bed in the foreground, partially obscuring a window behind them, making its frame appear like an upturned crucifix. In addition, on the window ledge is an ornament depicting two embracing figures.

One of the most impressive visualizations in the film was improvised on the final day of shooting in Paris. It shows the orphan vampires faced with a huge iron gate in a deserted grassy field. Rollin recalled, 'It opened on nothing and nobody.'* This image serves as an interesting metaphor for the vampires as no matter they go, they await the same dilemma on the other side. They are going nowhere,

* Jean Rollin, interview by Lucas Balbo, *Two Orphan Vampires* DVD.

Blind orphan vampire
Louise (top). The Ogress
(left). The ecstasy of blood:
Isabelle Teboul with fresh
victims (next page, left).
Brigitte Lahaie (next page,
right). *Les Deux Orphelines
Vampires*.

always on the run and forever in danger in a world that rejects them.

Philippe d'Aram's music is a perfect companion to the proceedings. His beautiful score resonates with the images of old, blue-tinted gravestones, inviting us into Rollin's celluloid dream. A sequence in which the orphans regain their sight at dusk and run euphorically through a graveyard is particularly atmospheric, heightened by d'Aram's evocative music. It is a pure celebration, an awakening.

The beach at Dieppe is substituted for a country pond, but we are once again at another fateful shoreline.

Rollin makes a cameo appearance as a gravedigger, burying a dead dog that the orphans have killed and feasted upon. Nathalie Perrey appears as a nun. Brigitte Lahaie adds a nostalgic touch. She still possesses a seductive and dangerous persona, not to mention her statuesque beauty. Keen-eyed viewers will recognize the book *Immoral Tales* in the subterranean chapel. Penned by Pete Tombs and Cathal Tohill, this overview of 'Eurotrash' cinema features an in-depth chapter on Rollin. It's placement here is no doubt a nod of

FASCINATION

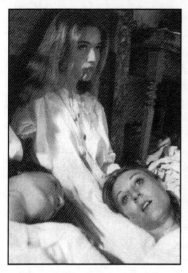

appreciation from the director.

Les Deux Orphelines Vampires is all the more impressive when one considers the conditions under which it was directed. Rollin was still suffering from severe kidney problems and had to undergo dialysis treatment every two days for four hours at a time. For this reason, Rollin was unable to shoot the New York sequences and his assistant Jean-Noel Dellamare prepared and directed these scenes under Rollin's explicit, pre-planned instructions.

The film took around one month to shoot, including the three days of location shooting in New York City. Due to the tight schedule, the actors got less and less sleep, which resulted in more and more makeup as the film progessed to hide the telltale signs of sleep deprivation.

Rollin's lifetime assistant Nathalie Perrey fashioned the meticulous shooting schedule with his assistant director, taking into account Rollin's health treatment requirements. It was tailor-made to realistically incorporate his travel time to hospital, his dialysis treatment, travel time to the set, and of course, lunchtime. Véronique Djaouti, Rollin's personal assistant and background photographer, drove the director on long trips to find hospitals that would support his treatment while shooting on location. She drove him to hospital, waited for him, drove him back, they had lunch together, then recommenced shooting. Within half an hour of completing dialysis,

The Celluloid Dreams of Jean Rollin

Rollin would be ready to film again. The hospital forced him to sign medical waivers to leave the premises, forgoing the usual four-hour convalescence. Rollin's cameraman was ready and the scenes waiting for him for when he arrived on set. Without their help and the other members of the family-like crew, the film would never have been made. Rollin recalled, 'when we were shooting, I was very sick. I remember directing some sequences as I was lying in bed. But if you really love cinema, nothing can stop you from making a movie if you have the opportunity.'* Many people would have relinquished their art under such extreme conditions, but Rollin persevered. His efforts were not in vain, for *Les Deux Orphelines Vampires* is a captivating experience and possesses his signature style, full of nostalgia, warmth and naked vampires.

Isabelle Teboul (Henriette the Orphan Vampire) strongly admired Rollin's determination and passion for cinema. She had

> a lot of respect for Jean because even with little money, he does things, he picks his actors, his workers, and he makes his films, while others hit their head against a wall for years trying to find financing ... ruminating about a project for ten years. While Jean, I find, has integrity. He is faithful to his style. Without a lot of money, Jean makes his little films, and I admire him for it ... I find it interesting, and I feel moved when I think of Jean, now in his sixties, and he's been fighting for years for this film genre. I find all of this quite moving, this integrity he has of keeping up the struggle, of continuing, not giving up, constantly striving and of being recognized in his own way. I take my hat off [to him].†

Beware the terrible English dubbed version of *Les Deux Orphelines Vampires* at all costs. The voice-overs are poorly delivered and give the film a cheesecake quality, greatly reducing its poetry and the onscreen chemistry between the two leads.

The best way to view *Les Deux Orphelines Vampires* is Redemption's recent US Blu-ray, which offers a gorgeous uncut transfer that looks infinitely better than any previous edition. The film is also available from Shriek Show in the USA as a region 1 DVD, featuring an attractive looking, uncut widescreen transfer and both the English and French language versions (English subtitles are optional).

* Jean Rollin, interview by Lucas Balbo, *Two Orphan Vampires* DVD.
† Isabelle Teboul, interview by Lucas Balbo, *Two Orphan Vampires* DVD.

The disc also contains some nice extras, including interviews with the two orphans, Alexandra Pic and Isabelle Teboul, and an illuminating hour-long interview with Rollin recorded in his home in Paris. A UK Region 2 DVD is available from Redemption with the same audio and subtitle options.

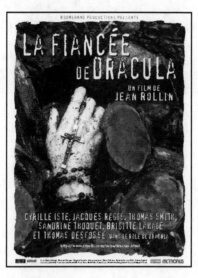

La Fiancée de Dracula
The Fiancée of Dracula

AKA: *Le Retour de Dracula*
2000 / Les Films ABC, Avia, Gold Film
91 Mins, Colour, Super 16mm, Original Ratio: 1:78:1
Director: Jean Rollin **Screenplay:** Jean Rollin **Producer:** Jean Rollin **Director of Photography:** Norbert Marfraing-Sintés **Editor:** Janette Kronegger **Music:** Philippe d'Aram **Special Effects:** Benoit Lestang **Cast:** Cyrille Iste (Isabelle), Jacques Orth — credited as Jacques Régis (The Professor), Thomas Smith (Thibault), Sandrine Thoquet (Vampire), Magalie Aguado (The Ogress), Céline Mauge (Sister Toutière), Marie-Laurence (Mother Superior), Daniéle Servais-Orth, Denis Tallaron (Eric), Sabine Lenoel (Sister Marthe), Céline Clementel (Sister Simplicity), Mira Petri (Sister Cigar), Marianne Palmieri (Sister Pipe), Bernard Musson (Sorcerer), Natalie Perrey

(Sorcerer), Cathy Castel (Sister Jump Rope), Dominique Treilloux (Man in Cemetery), Frederic Legrand (Sailor), Brigitte Lahaie (She Wolf), Thomas Defossé (Dracula)

'At two-fifteen, like always, may Jesus fill your heart. I have named the time of the Skull Clocks.'

An old professor and his young assistant, Eric, lie in wait in a cemetery at night. Unaware of their presence is a dwarf jester, Triboulet, who is also in the cemetery. All are waiting for a beautiful female vampire who arrives and drinks from Triboulet's neck; he willingly offers his blood to his loved one. Triboulet is a parallel, a creature who serves the master Dracula. The professor uses his hypnotic powers on Triboulet to discover where Dracula is hiding and learns of a place called the Tower of the Damned.

The professor and Eric find a deranged ogress at the decaying tower. She informs him that only the Queen of Shadows knows of Dracula's location, and she is held prisoner by the sisters of the Order of the White Virgin. They travel to Paris to see the Queen of Shadows, Isabelle, who is held captive by a group of insane nuns, apparently infected by her madness. She informs them Dracula resides in the 'clock chamber'. They hypnotise Isabelle, instructing her to leave her prison at midnight and join them in their search. Eric is transfixed by her beauty. A sinister group of witches arrive to take Isabelle away but she has already left. Triboulet intercepts Eric and the Professor and takes Isabelle to some old stone tunnels where the hungry ogress awaits. Triboulet has brought the ogress a feast, a baby, which she

FASCINATION

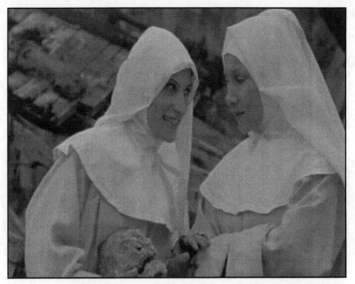

Brigitte Lahaie and Sandrine Thoquet enjoy blood (previous page). Eccentric nuns (this page). *La Fiancée de Dracula*.

devours with ecstasy. In return, Triboulet asks the ogress to help him hide Isabelle from the master's enemies.

In an isolated castle, a satanic ritual begins. A coffin is carried into the courtyard and a woman rises from it and summons the mistress of ceremonies, the she-wolf, with her violin. The she-wolf leads Isabelle, in her wedding dress, through the castle and to a grandfather clock that serves as a passage to Dracula's corpse. Dracula accepts Isabelle as his bride.

As Isabelle sleeps, Eric confesses his love to her. In her sleep she speaks of the warmth of Dracula's coffin. Isabelle rises to meet her fiancé, Dracula. In her bridal attire, she is taken to an island on a boat. The sisters of the Order of the White Virgin await her, in preparation for the marriage. A lonely bell tolls as Isabelle is taken to the beach, dressed in a white veil and roses, where the grandfather clock waits for her. She is tied to a surf-breaker as the sea rises around her. Triboulet, the witches, the mad nuns, the parallels, the ogress and the female vampire are all present for the ceremony. Dracula emerges from the clock to take his bride. Eric finds Dracula's secret chamber but is accidentally locked inside. The professor is killed by Triboulet. The ogress and the female vampire feast upon his blood. The insane nuns

An eccentric nun converses with Eric (Denis Tallaron) and
the Professor (Jacques Orth). *La Fiancée de Dracula.*

turn against the witches and parallels. Dracula and Isabelle disap-
pear from the shoreline and reappear in his secret chamber, wherein
Eric waits. Eric attempts to talk Isabelle out of her fate, but she de-
clines and enters another clock with Dracula, disappearing into an-
other dimension. In desperation he fires his gun into the pendulum
clock, the doorway sealed. Eric is trapped forever.

Dawn beckons. The nuns have tied the female vampire to the front
of a huge ship and she is engulfed in flames. At the prospect of losing
his vampire lover, Triboulet commits suicide. A witch sits before the
waning tide. In her hand she caresses a pink rose. Dracula and Isa-
belle blissfully wander the shoreline together in eternity.

This enchanting film brings together Rollin's core themes and
visual trademarks of the past four decades, developing them fur-
ther and giving them richer meaning. *La Fiancée de Dracula* is lit-
erally haunted by images from his past films. For fans of Rollin, it is
a goldmine of the artist's achievements, much as *Perdues dans New
York* had been. And, like that film, it plays best when the viewer has
some understanding of Rollin's canon. On its own, the film plays like
a very peculiar fairytale.

One line of dialogue in the film — 'the presbytery has lost none
of its charm, nor the garden its colours' — is echoed from *Le Viol*

du Vampire, and can also be applied as a metaphor for Rollin's entire journey as a filmmaker. After for troubled and challenging decades in the French film industry, he remained defiantly true to his own unique, highly personalized style.

In true Rollin style, the idea for the film began with a single melancholy image. Rollin recalled:

> For a long time I dreamed of a close up, an image of a woman, naked if possible, the whiteness of her body making a nice contrast with the pebbles on the ground ... she is tied to wooden posts, with the tide rising until it enveloped and covered her ... I described it in many of my books. In the end, my heroine dies, caught in a trap, with the tide rising all around her.[*]

This image had been with Rollin for a long time but he had been unable to incorporate it into a screenplay until *La Fiancée de Dracula*. It became the genesis for the entire project. The sequence wound up as the emotional finale of the movie, depicting Cyrille Iste (Nathalie Perrey's real-life daughter) tied to a surf-breaker, awaiting the rising tide and her vampire groom.

In its pre-production stage, the film was called *The Bride of Dracula* but later re-titled. For the screenplay, Rollin drew further inspiration from his own book, *La Statue de Chair* (*Statue of Flesh*, published in 1998), loosely adapting parts of the text. He produced *La Fiancée de Dracula* himself and had artistic freedom throughout.

As with *Les Deux Orphelines Vampires*, the production was extremely difficult due to Rollin's increasingly problematic health issues and ongoing dialysis treatment. He had to prepare the scenes, shoot them, then immediately rush to the nearest hospital for his four-hour treatment, which he required every two days. This became a major problem as there were so many different locations in the film. As his previous film, Rollin scouted for shooting locations and appropriate hospitals that were close enough to them. The whole process was exhausting: Rollin was working on both the film and his health. *La Fiancée de Dracula* is a testament to its creator's dedication and love for filmmaking. Rollin was willing to risk his life to tell another story.

[*] Jean Rollin, interview by Lucas Balbo, *Fiancée of Dracula* DVD.

Dreamlike imagery from
La Fiancée de Dracula.

La Fiancée de Dracula was Rollin's most expensive film, costing approximately three million Francs. With the help of Canal+ and recommendations from Jean-Pierre Jeunet, acclaimed director of *Delicatessen* (1991), *City of Lost Children* (1995) and *Amélie* (2001), Rollin financed the film by selling three of his films to French television.

Due to the wealth of locations and increased number of shoots, *La Fiancée de Dracula* was shot on Super 16mm to reduce the shooting costs. Although the natural grain content is higher, every single shot is filled with vivid colour, showcasing beautiful exterior locations, and detailed interior settings (for the latter the library sequence springs to mind).

The film benefits from its relatively fast pace (by Rollin stand-

ards) and the *fantastique* elements are brought to the fore. The strong script dwells on fairytale dialogue and comic book style *mise en scène*. The film is set over a small-time period, around twenty-four hours, but the essence of time is virtually nonexistent due to the persistent dreamlike atmosphere. Other than the coming of the day after the darkness of the night, time is an abstract element here. Even the locations have enchanted connotations, such as the beautiful stone ruins of the Tower of the Damned, which instantly conjures visual and emotional memories of *Requiem pour un Vampire* and *La Rose de Fer*.

Every character in the film is detached from what we know of reality and we are immersed in a secretive world of alternate dimensions and 'parallels' — creatures that live in the shadows and serve a powerful 'master'. These characters are archetypes that could be from a gothic fairytale: the Queen of Shadows, the she-wolf, the ogress, Sister Cigar and Sister Pipe.

Rollin's visualization of Dracula leans towards the classic Bela Lugosi image. As is common in his personal films, he doesn't project Dracula and the 'parallels' as evil creatures, but rather as sad and sympathetic beings.

The dialogue is wonderfully rich and delightfully surreal. Check out the scene where Triboulet the dwarf picks up Isabelle with his motorbike and sidecar ...

TRIBOULET: I won't let them have you, I'll hide you!
ISABELLE: You are the five-legged, box-like dwarf. And me, I am the Sabbath queen.
TRIBOULET: Yes, yes, this is the night, the night of your engagement. You are Dracula's girl.

Another example occurs later in the film when the ogress delivers the following, deeply descriptive passage...

I am in the bowels of Africa, pursued by a horde of cannibals ... suspended by a liana above a pond, I'm about to be swallowed by an alligator, me, my boots, my white safari jacket, my pith helmet ... I'm crying, I'm lost ... suspended by a ripped hot-air balloon ... that's slowly deflating and falling into the ocean. The sharks are circling, waiting ...

Make no mistake about it, this is Rollin's most fantastical offering, and the colourful dialogue is perfectly fitting. In the wrong hands, such line readings could have come off as raucous camp, but Rollin succeeds in establishing it as part and parcel of the fantasy and his performers do a fine job with the material.

The professor and Eric essentially lead the narrative in their quest to destroy Dracula, and in true Rollin style, they fail in their task. The tragic Eric winds up trapped forever in Dracula's tomb while his bloodsucking nemesis lives on.

The performances are strong throughout, particularly the ogress and the beautiful Cyrille Iste (Isabelle) who stands out as Dracula's fiancée. Iste spends the whole film in a sensuous daydream and delivers some of the most beautiful dialogue Rollin had ever written.

Rollin's niece, Sandrine Thoquet, was cast as the often-naked female vampire. With her alabaster complexion and fiery hair, she is both alluring and genuinely eerie, and her initial appearance in the graveyard where she seems to radiate white light is a priceless image. (Thoquet also appeared in *La Morte Vivante* where she played Catherine Valmont as a child in the flashback scenarios. She also performed in *Les Deux Orphelines Vampires* as one of the smoking teenagers who are murdered by the vamps.)

Brigitte Lahaie returns to the screen as a she-wolf. One of the most iconic and memorable performers in Rollin's celluloid world, her appearance here is both nostalgic and threatening. She enters on horseback wearing a red dress, the embodiment of power and seduction. (On a trivia note, the horse Lahaie rides here is actually her own.) A sequence in which she sensually kisses the blood-stained lips of another female vampire is a stand out scene, resonating with emotion and reminiscence.

The film also has a large dose of dark humour on offer. Aside from the pseudonymous crime caper, *Ne Prends Pas les Poulets pour des Pigeons*, Rollin tended to eschew comedy and favour the melancholy. But in *La Fiancée de Dracula* we have the bizarre insane nuns called Sister Pipe and Sister Cigar. Their peculiar lunacy includes a scene in which one of the mad duo lights a cigarette with an ornamental crucifixion lighter that sings Santa Claus Is Coming To Town. It's an otherwise dark and ambient sequence. Although their antics lend a touch of insanity to the proceedings, the humour detracts from the overall mood.

Images from
La Fiancée de Dracula.

The use of music is noticeably more prominent. Virtually every sequence has music or an atmospheric soundscape. The lavish score, by regular collaborator Philippe d'Aram, blends female vocals, piano, violin, harpsichords, and even brooding synth drones, which are strongly reminiscent of John Carpenter's soundtracks from the eighties.

There are many inspired images in the film. A shot of the naked female vampire, pale skinned, stained in blood and resting on a tombstone in the opening sequence is strongly reminiscent of *Le Frisson des Vampires*. Later in the film, she is tied to the bow of a huge steel ship as the sun rises, reducing her to bones. It is perhaps the most memorable demise in all of the vampire genre.

This startling scene is over quickly but Rollin takes his time setting it up and wrings from it a genuine sense of tragedy. The sequence that follows is also powerful. An old witch, dressed all in black, sits on a rickety wooden chair on a beach as the tide creeps in. This is intercut with Dracula and his bride happily wandering the shoreline, having escaped their pursuers, reminiscent of the fi-

nal scene of Luis Buñuel's *Un Chien Andalou*.

The final third of the film doesn't skimp on captivating images such as these. It has a shot in the library depicting Isabelle walking on the spot, treading the same ground over and over again as the camera tracks away from her. Other noteworthy scenarios include Brigitte Lahaie swallowing a nun's rosary, Triboulet's death (his heart is cut out and displayed to him by witches), and a chilling scene featuring a decapitated nun carrying her own severed head and kissing it farewell before offering it to the flames of a bonfire.

La Fiancée de Dracula once again sees a self-referential Rollin, and is populated with characters and images from his filmography. The skeletal boats on the island are reminiscent of *Les Démoniaques*. The recurring references to the book *La Reine du Sabbat* by Gaston Leroux. The ending in which Eric fires his gun in desperation strongly echoes the climax to *Le Frisson des Vampires*, while a more obvious reference is the inclusion of the pendulum clock wherein the vampire resides. The moment in which Isabelle warmly embraces the clock is cleverly emotive, feeding on the nostalgic memory of the identical sequence in Rollin's aforementioned film. The aural reference to Leroux's *Phantom of the Opera* with the dialogue 'I am the small boy who went to look for your scarf by the sea'. The old witch sat in the chair before the ocean, caressing a rose, clearly evocative of Rollin's excellent *La Rose de Fer*. Rollin himself appears in the opening graveyard sequence, pushing a man in a wheelchair to a grave. The list simply goes on and on.

The film builds to one of Rollin's finest cinematic moments when we reach the beach at Dieppe, a truly iconic image within Rollin's canon and the perfect location to close all the narrative threads here. All of Rollin's 'parallel' creatures gather to witness Dracula's wedding ceremony. The huge pendulum clock, evocative of Rollin's core themes of time and destiny, stands on the shingle beach surrounded by insane nuns. In the fading light, Isabelle, the Queen of Shadows, is tied to the surf-breakers as the waves gradually engulf her. The ogress, Triboulet and the female vampire gaze in amazement and wonder ... 'at last the night has fallen'. The witch in black stands before the roaring ocean. The sequence is imbued with a subtle blue hue and d'Aram's music gently builds with the growing crowd of characters encompassed by the towering cliffs. The whole scene plays like a Rollin character reunion, and is at once hypnotic,

FASCINATION

melancholy, and painfully beautiful. Its mood resonates long after the final credits.

For uninitiated viewers, *La Fiancée de Dracula* is likely to make for bizarre and unfathomable viewing. For those who love Rollin's work, it is a welcome and rewarding experience that echoes everything this unique filmmaker had achieved to date.

The first home video release came courtesy of Shriek Show in the USA whose DVD features a beautiful uncut widescreen transfer and some interesting extras. The Dutch DVD from Encore and the UK disc from Redemption also offer fine, uncut transfers. The film has yet to be released on Blu-ray.

La Nuit des Horloges
The Night of Clocks

AKA: *La Nuit Transfigure; Transfigurated Night*
2007 / Les Films ABC, Avia
90 Mins, Colour, Super 16mm, Original Ratio: 1:66:1
Director: Jean Rollin **Screenplay:** Jean Rollin **Produced by:** Jacques Orth **Director of Photography:** Norbert Marfraing-Sintés **Editor:** Janette Kronegger **Music:** Philippe d'Aram **Special Effects:** Anne-Marie Branca-Martiquet (Makeup), David Scherer (Prosthetics)
Cast: Ovidie (Isabelle), Françoise Blanchard, Dominique, Maurice Lemaître, Natalie Perrey, Jean-Loup Philippe, Jean Depelley, Fabrice Maintoux, Jean-Pierre Bouyxou, Sabine Lenoël, Paul Bisciglia (archive

footage), Catherine Castel (archive footage), Louise Dhour (archive footage), Cyrille Gaudin (archive footage), Françoise Pascal (archive footage), Alexandra Pic (archive footage), Isabelle Teboul (archive footage)

'All genuine riddles cannot be solved'

The writer and film director Michel Jean is dead. His cousin, Isabelle, sits by a disused railway tunnel to read a book he once cherished, which he gave to her when she was ten-years-old. Lying beside the rusty tracks, she finds an ornamental vampire doll head, which instantly floods her mind with an image of the vampire queen from Le Viol du Vampire. *The visage of a beautiful winged woman emerges from the railway tunnel and declares that Michel Jean is buried at Père Lachaise Cemetery, surrounded by his creations, which haunt the rows of tombstones and crypts. The winged woman warns Isabelle that when she visits his house in Limoges to beware the clocks as they are dangerous portals into another world. And so begins a surreal and delirious journey into the literature, films and mind of Jean Rollin/Michel Jean as Isabelle experiences visions of his films and meets many of his performers. She visits Père Lachaise Cemetery and meets Natalie Perrey and the phantom of Jean-Loup Philippe, who emerges from a crypt. A grandfather clock suddenly appears amidst the graves offering memories of* La Rose de Fer, Lèvres de Sang *and the explicit, mournful decapitation from* Les Raisins de la Mort. *During the cemetery scene Isabelle also meets Radamante from* La Vampire Nue *who encourages her to pull back an invisible curtain that transports her to a burned forest. She later visits Michel Jean's house in Limoges and Natalie Perrey gives her a tour. Perrey forces Isabelle into a grandfather clock, transporting her into a museum of macabre waxworks depicting female bodies and babies with their internal organs vividly on display. Isabelle is greeted by Françoise Blanchard and a living dead girl on a mortuary table. Blanchard encourages Isabelle to disrobe and kiss the glass coffin of one of the waxworks. Blanchard announces she is going to kill Isabelle out of love but she manages to escape. Blanchard cuts her own throat and the living dead girl stabs herself in the heart. Isabelle re-emerges in the house at Limoges and meets Dominique, the vampire with spikes for nipples from* Le Frisson des Vampires. *She comments that cinematic death is much more beautiful than real-life death and reminisces about her*

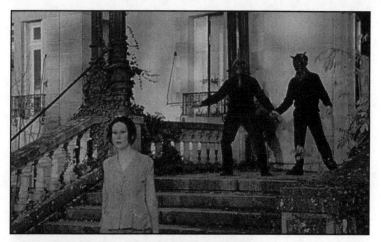

Hardcore porn star Ovidie in *La Nuit des Horloges*.

burning coffin and exposure to sunlight in Le Frisson des Vampires *and her performance in* Requiem pour un Vampire.

Jean-Loup Philippe returns and exclaims he embodies Michel Jean and he is searching for his lost film L'Itinéraire Marin. *He shows Isabelle stills and production photos from the lost and uncompleted feature before disappearing into the grandfather clock again to continue his search for the missing reels at the beach of Pourville.*

Perrey attempts to lure Isabelle back into the clock but she fears Michel Jean's universe. Isabelle forces Perry inside and sets fire to the clock. Isabelle wanders through Père Lachaise Cemetery contemplating Michel Jean's legacy and distant sounds of a train yard echo on the soundtrack.

La Nuit des Horloges was originally intended to be Rollin's final film. Its original title was *La Nuit Transfigurée*. Rollin once suggested

Natalie Perrey. *La Nuit des Horloges*.

that Redemption Films in the UK were going to contribute to financing the project but this didn't work out. Rollin's old friend Lionel Wallmann originally came on board to produce and was involved in the early stages but he isn't credited. Wallmann had placed an advertisement on the internet to help raise funding. After raising an initial $2,000 or so, they began pre-production. Jacques Orth took on the role of producer for the actual production.

Easily his most touching piece of work, *La Nuit des Horloges* plays like a who's who of past collaborators and a warm reminiscence of Rollin' celluloid legacy, with images from many — almost all — of his personal movies. It is the epitome of Rollin's career, and all the classic themes are strongly evident. Childhood memories, the *fantastique*, vampires, beautiful women, emotional violence...

The manner in which Rollin weaves his past literature and clips from films in and out of the narrative is intoxicating. His grasp of the dreamlike and the poetic has never been stronger. This use of material from past work is not a cheap, exploitative way to pad out the running time (unlike Lucio Fulci's insane *A Cat in the Brain,* 1990, for example). Instead, *La Nuit des Horloges* exists through Rollin's legacy and the inclusion of this material is essentially the point.

When Isabelle finds a child's toy, a clown in a box, it conjures images of the clowns from *La Rose de Fer, Les Démoniaques* and *Requiem pour un Vampire*. A discarded white cane recalls the two orphan vampires. When Isabelle first arrives at the cemetery, she finds a copy of Rollin's *Two Orphan Vampires* book on the steps. Reading

Françoise Blanchard slashing her own throat in *La Nuit des Horloges*.

a passage, the text beckons her to ascend the dark steps into the graveyard. She finds the iron rose, which instantly fills her mind with the beautiful image of Natalie Perrey sat before the ocean wearing mourner's attire from *La Rose de Fer*. Throughout the film, Isabelle continually happens upon fantasy books that Rollin liked when he was young. One such book introduces footage from *Perdues dans New York* of white masked women standing on the stormy beach of Dieppe. We are even treated to still images from his unfinished film, *L'Itinéraire Marin*. Aside from Rollin's own work, posters for Shunya Ito's *Female Prisoner #701 Scorpion: Beast Stable* (1973) and Bo Arne Vibenius' *Thriller: A Cruel Picture* (1974) can be seen several times throughout the film (Rollin was a fan of the latter).

The performers do a wonderful job and revel in the celebration. Natalie Perrey looks deeply moved throughout her scenes, forced to speak of her dear friend Jean as if he had already passed away. Jean-Loup Philippe is flamboyant and a welcome asset. Hardcore porn star Ovidie is fabulous as Isabelle and dominates the screen with her beauty. Her piercing eyes and gothic appearance bring the appropriate sense of mood to the proceedings and she delivers her dreamlike dialogue with dreamy aplomb. Françoise Blanchard, who still looks beautiful thirty years after *La Morte Vivante*, brings further nostalgia to the mix. As does the inclusion of Simone Rollin, Jean Rollin's wife.

Philippe d'Aram's score is captivating, driven by female choir vocals and piano as well as incorporating pastiches of music from pre-

vious movies — most notably *Fascination*. The editing by Rollin regular Janette Kronegger is extremely tight and never allows for the inserted footage to dominate the narrative flow. Marfraing-Sintés' 16mm photography is grainy but appropriately rich with colour.

Rollin, faced with old age and ill health, bravely produced a film that serves as a mediation of his legacy after his death. To his credit, the film isn't depressing, but a joyful commemoration of his memories and art. For Rollin, the cinematic world and the imagination was even more beautiful, magical and important than real-life. *La Nuit des Horloges* would have been a fine film to finish his career as a filmmaker and many expected it to be his last. Three years later he surprised everyone when he made another feature film, *Le Masque de la Méduse*, which was to be his swansong.

Highly personal and deeply moving, *La Nuit des Horloges* is an enchanting film for Rollin fans. So far, it has only been released on DVD in Germany on Andreas Bethmann's X-Kult label. The transfer is fine and colourful and offers English and German subtitles. This is a must for admirers of Rollin's work. Track it down and lose yourself in the '*dreamflight*' ...

Le Masque de la Méduse: Drama en Deux Actes
The Mask of Medusa: A Drama in Two Acts

2010 / Les Films ABC, Insolence Productions
75 Mins, Colour, HD Video (blown up to 35mm for theatrical screening), Original Ratio: 1:85:1
Director: Jean Rollin **Screenplay:** Jean Rollin **Line Produced by:** Anais Bertrand **Director of Photography:** Benoit Torti **Editor:** Janette Kronegger **Music:** Philippe d'Aram **Special Effects:** Pierre-Emmanuel Kaas, Aurélien Poitrimoult **Cast:** Jean-Pierre Bouyxou (The Guardian), Bernard Charnacé (The Collector), Marlène Delcambre (Steno), Sabine Lenoël (Euryale), Delphine Montoban (Cornelius), Juliette Moreau (Juliette), Agnès Pierron (Grand-Guignol Personnel), Gabrielle Rollin (Young Musician), Jean Rollin (Man Who Buries His Head), Simone Rollin (Médusa), Thomas Smith (Thomas)

'Time is just a human concept. It does not exist.'

ACT ONE: Surrounded by tanks of saltwater fish in an aquarium,

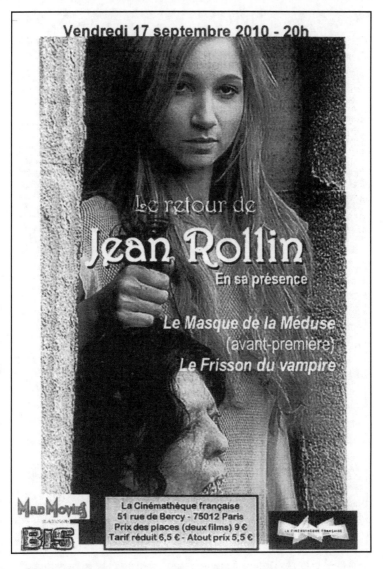

a young girl plays a large violin as a python slithers in the background. She is confronted by Medusa and is turned to stone. In the Grand Guignol theatre, a caretaker reminisces about the old stage plays, their performers and the excessive carnage that ensued during these productions. He converses with Medusa, who has amnesia, and

reminds her there was once a cave in which three gorgons lived. In a flashback, we see Medusa argue and battle with her two sisters, Stheno and Euryale, who survive by feasting on pulverised human skulls and blood. Stheno destroys Medusa's memory. The caretaker informs Medusa that Stheno and Euryale are now creatures of the underworld and only come out at night. Medusa confronts them in the Grand Guignol and demands her memory be restored. Medusa later destroys Euryale, slashing her throat as she turns her to stone. Medusa regains her memory. She recalls her victims and is tormented by them. While she is trapped in this reverie, the caretaker decapitates Medusa with a sword. Jean Rollin himself is seen burying her rotting head on the beach.

ACT TWO: Stheno recovers Medusa's severed head from a field. She lives in a lair beneath the Père Lachaise Cemetery, along with Medusa's head, the dead statue of Euryale and an unnamed hanging corpse. One day, she happens upon a beautiful black girl whom she invites to her subterranean home. The naïve girl is game for anything and they form a friendship. She allows Stheno to drink blood from her ass-cheeks. At the gates of the cemetery they go their separate ways, as Stheno cannot leave the graveyard because of supernatural forces. The black girl agrees to visit her every day and walks away. Stheno disappears into thin air leaving only the deserted, winding steps of the Père Lachaise Cemetery.

The final shot of the winding steps to Père Lachaise Cemetery is

FASCINATION

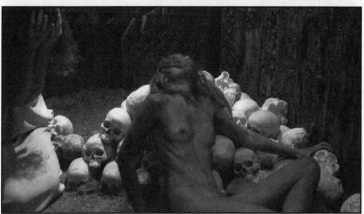

Creatures of the underworld. *Le Masque de la Méduse*.

apt, given that Rollin passed away shortly after the film was completed: a cathartic symbol of Rollin's acceptance of death and the end of his journey in film.

Had act two never been filmed, the final shot would have been of Rollin himself burying Medusa's head. This beautiful image can be read as a symbol of the end to his storytelling days and of his memories of the *fantastique*. In either case, both closing shots carry with them a sense of nostalgia and sadness.

Rollin had suggested many times that *La Nuit des Horloges* would be his final film, so it came as a surprise when the release of *Le Masque de la Méduse* was announced. He began working on

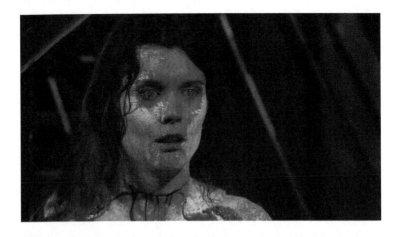

pre-production for the film in 2009 and it was inspired by Hammer's *The Gorgon* (1964), and *Clash of the Titans* (1981), which featured model work by Ray Harryhausen. Rollin reworked the classical Greek myth — that of a woman with snakes for hair who turns to stone anyone who looks into her eyes — into the present and gave it his unique signature. The film was completed with an incredibly small budget of €150,000. The original cut ran for just under one hour and was screened theatrically at the Cinémathèque de Toulouse. Shortly after its premiere, Rollin shot a further twenty minutes of footage and split the final cut into two acts, much like the structure of his debut feature, *Le Viol du Vampire*, forty-two years ago. The new material comprised act two.

Act one dominates the film, running fifty minutes — twice as long as the second act. The first act is mostly set on the stage of the Grand Guignol and is driven by softly spoken, poetic dialogue. 'My mind is not cluttered by anything except for the blurred memory of those who were part of me ... Remnants of my stolen memory somehow come back to me.' Again nostalgia and memory drive the characters and the narrative, memories that are haunting and imbued with death.

Simone Rollin's Medusa makeup is surprisingly effective with her deathly pallor, jagged teeth, bleeding mouth and writhing snake hair. For a Rollin film, these images are extremely morbid and frightening. Simone portrays Medusa with mourning and dread in a memorable performance.

Le Masque de la Méduse features crisp hi-definition photography,

Euryale (Sabine Lenoël) is turned to stone by Medusa's gaze (previous page). Jean Rollin buries Medusa's severed head (this page). *Le Masque de la Méduse*.

which contrasts striking colour with rich black levels. But it is no match in quality to Rollin's previous 35mm and 16mm films. That said, there is some wonderful imagery on offer. All the Medusa sequences stand out and stick with the viewer for some time after the film is over. The scenes of the naked Stheno smashing skulls and eating the fragments with blood are fantastically macabre. The moment when Medusa slashes Euryale's throat is also a stand out — and surprisingly bloody. The naïve black girl who befriends Stheno in act two is incredibly beautiful — Rollin certainly retained his keen eye for striking female forms! The opening scene at the Golden Gate Aquarium is also stunning and the the photography really brings out the marine life and soft colour palette of the location itself.

By intention or by coincidence, Rollin started and ended his feature film career with extremely low-budget films comprised of two acts. *Le Masque de la Méduse* hums with a love of cinema and storytelling. A fitting end to the incredible, deeply personal career of a true artist.

Although *Le Masque de la Méduse* never received an official theatrical run, it did premiere at the eleventh Extreme Cinema Film Festival at the Cinémathèque de Toulouse on November 19, 2009. *La Nuit des Horloges* also played the same night and Rollin attended

The steps to Père Lachaise Cemetery: Rollin's final image and his resting place (top). Stheno (Marlène Delcambre) with Medusa's severed head and her new friend (left). *Le Masque de la Méduse.*

as a special guest to introduce his two films.

Le Masque de la Méduse has yet to receive an official DVD release. It was only made available for a very brief period along with the first 150 copies of the French language book *Jean Rollin: Écrits complets Volume 1.*

Three months after the completion of *Le Masque de la Méduse*, Jean Rollin passed away on December 15, 2010. His body rests in his beloved Paris at one of his most cherished locations, the Père Lachaise Cemetery.

FASCINATION

ALSO KNOWN AS

The Pseudonymous Films

A LARGE AMOUNT of the negative criticism Rollin received during his career stemmed from his pseudonymous films. These directorial assignments were not personal projects and Rollin served as a director for hire, putting little of himself or his artistic trademarks into these efforts. Very often, these pseudonymous films were directed as favours for friends or were commercial side projects to help finance his own personal visions. In some cases, Rollin was hired at the last minute to ensure that these films were completed on time and within budget. It would be very unfair to group these impersonal films with his personal ventures. However, it is often the case that many critics dismiss his entire filmography after seeing trash like *Le Lac des Morts Vivantes* (*Zombie Lake*), softcore sex films such as *Jeunes Filles Impudiques, Tout le Monde il en a Deux, Emmanuelle 6*, or any of his hardcore porn offerings.

Pseudonyms were very popular during the seventies and eighties, particularly amongst the independent and exploitation genres. Even Hollywood has its recurrent pseudonym Alan Smithee, to whom disastrous or embarrassing flops are often credited. The pseudonyms were used for a variety of reasons. Some filmmakers often didn't want their names being attributed to works they had little or no creative control over, or hardcore sex films.

The films below were made by Rollin under an assumed name.

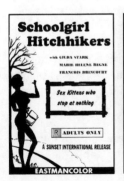

Jeunes Filles Impudiques

AKA: *Schoolgirl Hitchhikers; High School Hitch Hikers, Mathitries Se Erotikes Diakopes*
1973 / Avia Films, Les Films ABC
74 Mins (Uncut French Version), 67 Mins (USA DVD version), 73 Mins (Censored UK version), Colour, 35mm, Original Ratio: 1:66:1
Director: Jean Rollin (as Michel Gentil) **Screenplay:**
Uncredited **Producer:** Lionel Wallmann **Director of Photography:**
Jean-Jacques Renon **Music:** Pierre Raph **Cast:** Joëlle Coeur (Monica), Gilda Arancio — credited as Stark (Jackie), Marie Hélène Règne (Béatrice), Willy Braque (Fred), Pierre Julien (Detective Harry), François Brincourt (Béatrice's Associate), Reine Thirion (Harry's Secretary), Jean Rollin (Man in Red Turtleneck)

Rollin's first pseudonymous film was *Jeunes Filles Impudiques* (*Shameless Young Girls*), released in the USA as *Schoolgirl Hitchhikers* with the tagline 'Sex Kittens Who Stop At Nothing!' Despite the salacious title, this is just a mixture of comedy, sex and low-budget action. Produced by Jacques Orth, Rollin made the film under his production company Les Films ABC in 1973, a very busy year for the director — he also shot *La Rose de Fer* and *Les Démoniaques*. Whereas those two personal films didn't receive the acclaim and capital expected, *Jeunes Filles Impudiques* was a guaranteed financial success as it offered French viewers the closest thing possible to a sex film. The hardcore sex industry may have struck gold in the USA, but cinemagoing France was still only permitted softcore sex.

The softcore sex genre didn't really interest Rollin and *Jeunes Filles Impudiques* was conceived purely as a money earner. The film was quite successful and gave him the opportunity to earn back some of the money lost on his previous films and also keep him working in the film industry. It was common practice at the time to credit such films under a pseudonym, and, as the film wasn't of personal interest, Rollin chose a variant of his full name, Michel Gentil — a name that would become synonymous with the French hardcore porn movement several years later.

Among the cast of *Jeunes Filles Impudiques* are Willy Braque and Joëlle Coeur (both appeared in *Les Démoniaques*), and Gilda Arancio (credited as Gilda Stark in the American release). Rollin's music

composer, Pierre Raph, also contributed the score, having previous-
ly worked on *Requiem pour un Vampire*, *Les Démoniaques* and *La
Rose de Fer*. The plot is pretty thin but fun. Two sexy hitchhiking
girls happen upon a seemingly abandoned villa while wandering
through the woods. Unfortunately for them, a bunch of diamond
thieves are using the place as a hide-out. A series of farcical erot-

The Celluloid Dreams of Jean Rollin 195

Nipple torture and more in *Jeunes Filles Impudiques*.

ic and action-based scenarios ensue and the attractive female cast realize they can use their bodies as weapons against the thieves, seducing them and taking control.

Jeunes Filles Impudiques marked the first time Rollin worked with Joëlle Coeur and she is the strongest asset of the film. Her beauty is captivating, dominating every scene. Rollin delivers plenty of naked flesh and simulated sex as well as a few small doses of sadism. For many years this was one of Rollin's rarest films but it has been recently been issued on DVD in the Netherlands, Denmark (Another World Entertainment) and the US (Salvation Films).

Tout le Monde il en a Deux

AKA: *Fly Me the French Way; Bacchanales Sexuelles, Parthenika Paihnidia, Schiave del Piacere*
1974 / Nordia Films, CTI
106 Mins (Uncut French Version), 76 Mins (USA Cinema Version), Colour, 35mm, Original Ratio: 1:66:1
Director: Jean Rollin (as Michel Gentil) **Screenplay:** Natalie Perrey, Jean Rollin (as Michel Gentil), Lionel Wallmann **Producer:** Jean Rollin (as Michel Gentil) **Executive Producer:** Lionel Wallmann **Director of Photography:** Claude Bécognée **Music:** Rex Hilton **Makeup:** Germaine Fabbri **Cast:** Joëlle Coeur (Valérie), Marie-France Morel (Sophie), Brigitte Borghese — credited as Britt Anders (Malvina), Annie Belle — credited as Annie Brilland (Brigitte), Jean-Paul Hazy (Paul), Agnès Lemercier — credited as Jenny Trochu (Jenny the Maid), Catherine Castel (Twin Mouse 1), Marie-Pierre Castel (Twin Mouse 2), Virgina Loup (Catarina the Maid), Marcel Richard (Karl), Minia Malove (Frida), Alain Bastin (Fred), Walden Desforets (Club Member 1), Jean Dorlegeant (Club Member 2), Willy Braque

FASCINATION

The year following *Jeunes Filles Impudiques*, Rollin and his producer Lionel Wallmann set out to recapture their success with *Tout le Monde il en a Deux* (*Every One Has Two*) released through Wallmann's Nordia Films production company. The film was released in America as *Fly Me the French Way* but is most commonly known under the title *Bacchanales Sexuelles*. Again Rollin opted for his nom

de plume Michel Gentil, and this would be his second, and final, softcore sex film (excluding the additional footage he directed for *Emmanuelle 6*).

Lionel Wallmann suggested the original idea and Rollin produced the script. A threadbare blackmail plot frames the real point of the film: sex and nudity. A rich and sadistic woman named Malvina attempts to locate incriminating sexual photos of herself that are being used by a photographer as blackmail. Malvina is also the leader of a sexual cult that specializes in deflowering virgins. She sends her spies to kidnap the photographer so they can obtain the negatives but the plan goes wrong. Instead, they kidnap an innocent woman called Sophie, whose lesbian lover, Valerie, and her boyfriend, Fred, also become entangled in the mystery.

The spying and sexual shenanigans continue until the climax when Malvina throws an orgy in her isolated château. The photographer is revealed to be one of her cult members and his confrontation with Malvina results in an aggressive sex session. Meanwhile, Sophie and Valerie escape while Fred stays to have sex with Malvina's twin servant girls (the Castel twins).

Tout le Monde il en a Deux treads a fine line between hard and softcore sex, pushing the boundaries as far as legally acceptable at the time. The film has been described as avant-garde hardcore. At least two sequences feature unsimulated masturbation and oral

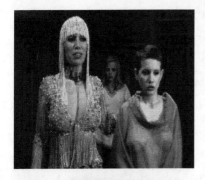

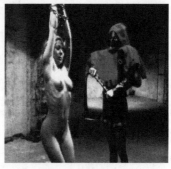

International film posters for *Tout le Monde il en a Deux* (previous page). An assortment of images from *Tout le Monde il en a Deux* (this page).

sex, the first being the lengthy lesbian encounter between Sophie and Valerie, and the second is where Sophie fucks a man named Paul in the dungeon. These shots are very brief but undeniably present. Even the simulated sex scenes have an air of reality and are shot in real-time, nothing is exotic — neither locations nor scenarios, and the gritty atmosphere is further enhanced by the hand-held camerawork.

Rollin spares no expense in capturing naked flesh in almost every shot. Before the sex sequences begin, the camera taunts the viewer with sexual suggestion when Sophie clambers along the bookshelf, her very short skirt revealing her long legs. The film crams in as many sexual scenarios and variations as the thin plot will allow, including male and female genital groping, oral sex, foot fetishism, S&M, voyeurism, threesomes, lesbianism, fighting women, a soapy bath scene, group sex and food sex. It would not be unfair to suggest that eighty-five per cent of the film is sex and nudity. If one were to censor the sex, there would be no movie left! Even in the opening sequence, Malvina sits in a journalist's office surrounded by black and white photographs of naked flesh.

Rollin layers the film with ironic comedy and frequently includes

funny situations. He starts the film as he means to go on, with a cheeky title sequence that features a glamorous cartoon of a smiling woman's face cut to the rythym of a very catchy seventies beat. She winks at the audience before fast-cut images of breasts and naked bodies flicker in her eyes, and occasionally a woman's cartoon hand enters the screen to pinch her breasts. The credits differentiate the cast as 'Mademoiselles' and 'Monsieurs' (the former outnumbering the latter), and ends with a wonderful cartoon backdrop of a haunted castle surrounded by bats beneath the full moon, evocatively capturing the essence of Rollin's gothic work. This sequence, the treatment of the spy thriller plot, and of course the bizarre costumes of the kidnappers evoke a distinct comic book style.

The French title (roughly translated as *Every One Has Two*) certainly supports the recurring formula of the film, as virtually each central character does have at least two lovers or two sex scenes. As the narrative progresses the situations become increasingly farcical. Rollin's background in horror comes into play, particularly in the early scenes when Valerie is alone in the apartment. The subtle and sinister music generates an unsettling mood. If the viewer knew nothing about the film, they could easily be mistaken into thinking it was a horror feature at this point. The dungeon sequences and the secret cult also serve to heighten the mystery and danger. Throughout, there is the constant threat that something could easily turn nasty but Rollin manages to keep a restraint on these elements. The simplistic blackmail plot serves its purpose, despite a glaring plot hole. Fred gives the negatives to a girl, who leaves the apartment to dispose of them. Later on, Fred makes a similar bargain with someone else, who also obtains the negatives from the apartment. It's a curious oversight for a movie in which the negatives are the most significant element of the story. Then again, the story is hardly the main concern here.

The cast seem to be having a great time, which adds immeasurably to the sexual chemistry between the characters and makes the film much more enjoyable. Brigitte Borghese, who plays Malvina, is fantastic as the alluring and sinister cult leader. One of the most memorable scenes in the film features Malvina shooting at mannequins in her garden before eccentrically embracing one of them as she prepares her devious revenge plans.

Tout le Monde il en a Deux is a must-see for fans of European *sin-*

ema, and despite the lengthy running time, the film never becomes dull. Rollin fans will certainly appreciate the cheeky humour and have fun spotting his regular performers, albeit unclothed, among them Annie Brilland (who later appeared in *Lèvres de Sang*), Joëlle Coeur, and the Castel twins. Keen-eyed viewers will no doubt spot posters for Rollin's *La Vampire Nue*, *Le Frisson des Vampires* and *Le Viol du Vampire* hanging on an apartment's walls.

Tout le Monde il en a Deux was released in a heavily censored and dubbed form in the USA as *Fly Me the French Way*. Almost thirty minutes were removed. The Synapse Films DVD, titled *Bacchanales Sexuelles*, includes the original uncut rench version and is presented in widescreen.

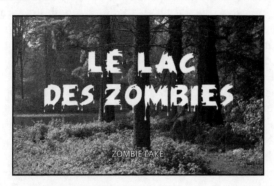

ZOMBIE LAKE

Le Lac des Morts Vivants

AKA: *Zombie Lake; The Lake of the Living Dead; Zombie Lake, O Lago dos Zumbis, El Lago de los Muertos Vivientes; El Lago de los Zombies; I Limni Ton Zontanon Nekron; Zombik Tava; Zombies Lake; Sumpf der Lebenden Toten*
1981 / Eurociné, JE Films (Julián Esteban Films)
90 Mins (Original version), 71 Mins (Censored German version), 88 Mins (Spanish version), 83 Mins (UK version), Colour, 35mm, Original Ratio: 1:66:1
Director: Jean Rollin (as J.A. Laser) **Screenplay:** Julián Esteban, Jesus Franco **Producers:** Marius Lesoeur, Daniel White, Sean Warner **Associate Producer:** Daniel Lesoeur **Director of Photography:** Max Monteillet **Editors:** Claude Gros, María Luisa Soriano **Music:** Daniel White **Makeup:** Christiane Sauvage **Special**

Effects: Michael Nizza **Cast:** Howard Vernon (Mayor), Pierre-Marie Escourrou — credited as Pierre Escourrou (German Soldier), Anouchka (Helena), Antonio Mayans — credited as Robert Foster (Morane), Lynn Monteil — credited as Nadine Pascal (Helena's Mother), Youri Radionow — credited as Youri Rad (Chanac), Gilda Arancio (Blonde Swimmer), Marcia Sharif (Katya), Jean Rollin (Stiltz), Pascal Vital (First Girl at Lake), Bertrand Altmann — credited as Burt Altman, Yvonne Dany, Jean Rene Bleu, Edmond Besnard, René Douglas, Julián Esteban, Alain Petit, Jean Roville, Claude Sendron

Le Lac des Morts Vivants (more commonly known in the UK and US as *Zombie Lake*) is something of a trash epic, and, despite directing pseudonymously, it would tarnish Rollin's reputation forever. For the uninitiated, the plot is as follows: during World War II, a troop of German soldiers pass through an isolated rural village and are murdered by the locals. The bodies are disposed in a lake. Years later, the cursed 'Lake of Ghosts' sees the decomposed Nazis in wait beneath the surface, drowning swimmers and feasting on the locals. The village is soon gripped with fear and the bodies start piling up. One of the zombies turns against his own kind when he remembers a love affair he shared with one of the village girls. The zombie then meets his adult daughter for the first time. Eventually, the remaining villagers lure the Nazi zombies to a deserted house and burn them to second-death in the ruins.

Le Lac des Morts Vivants is undeniably an awful slice of horror cinema and easily Rollin's worst feature. There is very little value in this shockingly inept production. In Rollin's defence, he wasn't originally lined up to direct it; it was to have be been directed by the notorious Jess Franco. The film was conceived by the Parisian production company Eurociné, who were purveyors of such bottom-barrel 'Eurotrash' as *The Devil Hunter* (1980), *Oasis of the Zombies* (1981) and *Cannibal Terror* (1981).

Franco backed out of the project at the last minute and Eurociné drafted Jean Rollin as a last minute substitute. Apparently, Rollin was preparing to go on holiday when he received the offer. With no time to see a script, he accepted on the spot. His first glance of the screenplay was on his way to the shoot.

Detractors of Rollin's work often cite *Le Lac des Morts Vivants* as their key argument when attacking his abilities as a filmmaker

and artist, failing to appreciate the circumstances of this dreadful production. What's even more unfortunate is that *Le Lac des Morts Vivants* was the first 'Rollin film' made available on home video. Its wide availability certainly did him no favours. In truth, there is very little (if anything) of Rollin's thematic, visual or stylistic trademarks at work here. The film simply fails to work on any level. The plot is ridiculous but has potential to be great entertainment as a 'bad movie' experience. It begins promisingly enough, with a beautiful

Nazi zombies rise from the depths to wreak clumsy havoc. *Le Lac des Morts Vivants.*

woman skinny dipping in the lake, who is subsequently drowned by a Nazi zombie. This is easily the best scene in the entire film thanks to the colourful photography, lush scenery and nudity. But the moment when a zombie's hand breaks the surface of the water like a poor-man's *Jaws* and then disappears again generates laughter rather than suspense. Boredom then quickly takes precedence. The characterization and dialogue are awful, made worse by the laughable dubbing that leaves the actors' mouths silently flapping. The acting ranges from poor to jaw-droppingly awful. The only purpose of Katia's character is to lengthen the running time. She simply appears to extract a story from the mayor, told in flashback, which lasts for fifteen minutes! This sequence looks like the most expensive part of the film, featuring several soldiers in German uniforms with machine guns and several army jeeps. The film stock for this

Carry On Zombie Lake? No. Pascal Vital ignores the warning signs and takes a dip (top left). Jess Franco regular Howard Vernon realises he is in *Le Lac des Morts Vivants* (top right). Hand of death (left). *Le Lac des Morts Vivants*.

footage, depicting heavy artillery and troops trudging through the countryside, looks mismatched and is likely to have been culled from another source — a common practice in cheap European exploitation films (*The Beast in Heat*, 1977, instantly springs to mind).

The gunfights and explosive action sequences are poorly staged and several sound effects of gunfire are missing when soldiers fire their weapons. Even a snow sequence appears out of place, and was most likely an opportunistic inclusion. The locations are kept to a minimum; other than the local pub (which looks like a living room) and the mayor's office, the majority of the photography is exterior. The underwater photography is another missed opportunity, having clearly been filmed in a swimming pool with a little pondweed thrown in. Several shots feature underwater pool lights, tiles and creased tarpaulin (probably used to hide the steps!). Even the score is recycled from several Jess Franco films, including Daniel White's beautiful theme from *The Female Vampire* (1973), commonly dredged for use on Eurociné features.

Zombie fans will be greatly disappointed by the amateur effects. The zombies are merely smeared with green grease paint and terrible patches of patently fake flaky skin (during the second murder you can clearly see the zombie makeup falling away). There is none of the requisite gut-munching for a zombie film, but instead the Nazi zombies simply run their lips along their victims' necks

The Celluloid Dreams of Jean Rollin

as though giving them a love-bite, while blood inexplicably pours from the victims' mouths. No expense is spared to display naked female flesh, however; the film delivers more sex and nudity than horror and gore. A sex scene in a barn is interminable. There is even a scene where a woman hitches up her skirt to fix her stockings while walking along a pathway, revealing her thighs.

The film could have been worse. There are several beautiful photographic compositions, particularly the aforementioned opening sequence, the countryside locales, and a scene in which the mayor stands at his balcony in order to observe the mist-enshrouded lake. But these moments are too brief and few and far between.

Le Lac des Morts Vivants has frequently been mistaken for a Franco film, with its incessant use of zooms, recycled musical passages by regular Franco composer Daniel White, and the inclusion of actor Howard Vernon as the mayor. Further confusion has been generated by the fact Eurociné employed Rollin to shoot some extra zombie footage that could be inserted into another film at a later date, to create a 'new' product from something old. This footage appeared in Eurociné's early nineties re-release of Franco's *A Virgin Amongst the Living Dead* (originally 1971).

Although directorial credits go to the nom de plume J.A. Laser (billed as J.A. Lazer in some prints), Rollin is credited under his real name for a small acting role.

The UK DVD release from Arrow is the uncut version and presented in widescreen (1:85:1 ratio) with an English audio track. Judging by the variety of countries mixed up in this co-production, no matter which dubbed version you see the dialogue is not likely to be synchronized throughout. The UK pre-certification video from Modern Films was also a complete version (one of the least expensive videos for original pre-cert collectors). For fans of the film (if there are any?), the uncut US DVD by Elite Entertainment (part of the 'Euroshock' release) features an English and French audio track with optional subtitles and some interesting extras. The nude scenes were also shot in clothed variants for distribution in territories with stricter censorship regulations. These alternate scenes can be viewed as an extra feature on Elite's DVD. They include a clothed version of the opening skinny dipping scene, an alternative take of the nude volleyball game (with the players in their underwear), and a clothed version of the topless girl in the pub.

Ne Prends Pas les Poulets pour des Pigeons

AKA: *A Chicken Amongst The Pigeons*
1985 / Les Films ABC, Les Films de l'Eau Vive
80 Mins, Colour, 35mm, Original Ratio: 1:66:1
Director: Jean Rollin (as Michel Gentil) **Screenplay:** Jean-Claude Benhamou **Producer:** Jean-Claude Benhamou **Director of Photography:** Quinto Albicocco **Editors:** Janette Kronegger
Music: Jean-Claude Benhamou, Alex Perdigon **Cast:** Jean-Claude Benhamou (Inspector Cellier), Jean-Marie Vauclin (Inspector Lesourd), Popeck (Paul the Pirate), Michel Galabru (Commissioner Dufresne), Gérard Landry (Blanchard), René Tramoni (Bricot), Brigitte Borghese, Christian Forges, Claudia Silver, Cécile Laligan, Yvette Arnaud

This is the most obscure feature length title in Rollin's filmography. Credited as Michel Gentil, the film was made to repay a favour for a friend, Jean-Claude Benhamou, who previously appeared in Rollin's *Les Trottoirs de Bangkok*. The original idea for *Ne Prends Pas les Poulets pour des Pigeons* belonged to Benhamou, who intended to use the film as a vehicle for a career in acting. He also produced and scored the film, which is a comedy police thriller. Rollin became involved in the project when he was preparing *Les Trottoirs de Bangkok* in 1984. Rollin needed to raise some money quickly to fund his film and Benhamou offered him cash, but with two conditions. First of all, Benhamou requested an acting role in *Les Trottoirs de Bangkok*, and the second condition was that Rollin would direct *Ne Prends Pas les Poulets pour des Pigeon* for him. Rollin, of course agreed. Over the years, there has been some confusion surrounding whose film this is, but Rollin did indeed direct the picture based

*Ne Prends Pas les
Poulets pour des Pigeons*

purely on Benhamou's concept and script. The credits also feature several Rollin regulars, including editor Janette Kronegger, sound technician Jean-Claude Reboul, Lionel Wallmann and of course, Natalie Perrey — Rollin's long serving assistant.

The plot concerns two cops sent to the Côte d'Azur to smash a drug trafficking network. The dealers use a factory specializing in the production of carnival masks as a cover for their illegal operations.

Ne Prends Pas les Poulets pour des Pigeons is incredibly difficult to track down. It received a brief theatrical run and was released on VHS in France in the late eighties, now out of print. There is no official DVD release for the movie at the time of writing.

Emmanuelle 6

AKA: *Emmanuelle — Paraíso Selvagem; Emmanuella No 6; Bonitas E Despidas; Emmanuelle: Amazone des Dschungels*
1988 / 90 Mins, Colour, 35mm, Original Ratio: 1:66:1
Directors: Bruno Zincone, Jean Rollin (Uncredited) **Screenplay:** Jean Rollin **Producer:** Alain Siritzky **Executive Producer:** Roger Corman

Associate Producer: George Korda **Director of Photography:** Serge Godet, Max Monteillet **Editors:** Michel Crivellaro **Music:** Daniel Margules **Makeup:** Isbelia Coro, Luisa Palacios, Eric Pierre
Cast: Natalie Uher (Emmanuelle), Jean-René Gossart (Dr. Simon), Thomas Obermuller (Benton), Gustavo Rodríguez (Tony Harrison), François Guerrar (Carlos), Luis Carlos Mendes (Morales), Tamira (Uma), Dagmar Berger, Edda Kopke, Rania Raja, Ilena d'Arcy, Melissa, Virginie Constantin, Christele Merault, Edmund Soockermany, Tony Manzano, Alfredo Sandoval, Hans Schaffer, Ruben Malave, Alexis Mosquera, Sosimo Hernandez , Hamish Cranfield, Clive Bland, Santiago Pérez, Andy Garcia, Catherine Wassmitt, Simy Benzoquen, Amami Mertinez, Adriana Leon, Doris Medina, Sammy Garcia, Yvette Dominguez, Luby Lefol, Rhazmylle, Ximena Negrin, Mario Olave, P.J. Diaz, Samy Harronch, Manuel Boffil, Alvaro Romero, Augusto Cuatro, Jorge Piaggo, Antonio Rodriguez, Brigitte Belmondo

The most surprising pseudonymous venture in Rollin's career as a director is this, the fifth sequel to Just Jaeckin's original softcore sex hit. Rollin is not credited on any release prints or even referenced on VHS or DVD packaging.

Like *Ne Prends Pas les Poulets pour des Pigeons*, there is contradictory information as to who actually directed the film. The producer of *Emmanuelle 6*, Alain Siritzky, was looking for a writer to pen a screenplay for the latest instalment in the *Emmanuelle* franchise. A friend of Rollin's, who was a movie agent at the time, suggested to Siritzky that Rollin would be the right man for the job. Rollin wrote the script, and then worked alongside Siritzky to cast the film along with the proposed director, Bruno Zincone. The iconic Sylvia Krystal was substituted in the lead role by the much younger Natalie Uher.

The original script featured a group of fashion models travelling to South America for a photoshoot, where they model expensive diamonds against the backdrop of tropical rainforests. During their inescapable erotic escapades, the models and crew unwittingly become mixed up with a group of villains, who attempt to steal the diamonds. With its sleazier elements and danger thrown into the mix, *Emmanuelle 6* is more comparable to Aristide Massaccesi's *Black Emanuelle* films than the previous instalments of Just Jaeckin's series. Shooting began in South America but after a few weeks

The Celluloid Dreams of Jean Rollin 209

La primera co-producción Franco-Venezolana para ser vista por 350 millones de espectadores en todo el mundo. Continuando la serie de mayor éxito mundial.

con: GUSTAVO RODRIGUEZ
LUIS CARLOS MENDEZ
TOMAS OBERMULLER
NATALIE UHER

Emmanuelle 6

NATALIE UHER JEAN-RENE GOSSART

Zincone had to leave the film for another project. The the film was far from complete and Zincone's departure jeopardized the production.

Zincone left the project with approximately four hours of rushes, but only around forty-five minutes' worth of usable footage. A huge

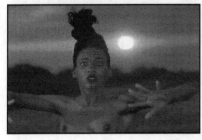

Natalie Uher (top left; top right). Exotica, erotica
and memory loss in *Emmanuelle 6*.

portion of Rollin's original script had not yet been filmed and the
darker elements of the plot remained absent.

With funds and production time rapidly depleting, Rollin's talent
for improvisation prevented a disaster for the financiers. He worked
out what scenes could be saved from the existing rushes and then
quickly prepared another script that could serve as a framing de-
vice and restore the film to feature length. In Rollin's new version,
Emmanuelle is suffering from amnesia after a traumatic experience
on a modelling shoot in South America. She spends her time wan-
dering her spacious château, watching her servants have sex and
recalling flashbacks of her tropical escapade. Gradually she begins
to remember her erotic adventure and her identity. After mastur-
bating in the vast countryside that surrounds her home, it floods
back to her.

Rollin worked out he needed only one week's worth of shooting,
which could all be achieved in Paris, and in the end succeeded in
bringing in a feature length film of eighty minutes. He is responsi-
ble for directing all the wraparound narrative footage and Parisian
scenes, which he shot with the aid of his regular cinematographer
Max Monteillet (*Le Lac des Morts Vivants*, *La Morte Vivante*, *Killing*

The Celluloid Dreams of Jean Rollin 211

Car, Perdues dans New York). The final cut of *Emmanuelle 6* should be viewed as a combined effort. So, to set the record straight, the South American footage is Zincone's and the Parisian images are Rollin's, all framed within his own heavily redrafted script. Rollin's recurrent themes of memory and amnesia are the core of the narrative.

Emmanuelle 6 is an average softcore sex flick, shot and edited like a glossy music video, with flashy, eye candy imagery. The acting and audio dubbing are average, but the film does feature pleasant location footage of South America, while the clichéd waterfall sequence is memorable, depicting Natalie Uher frolicking in the cascading water. Nevertheless, Rollin's budget footage shot in Paris is more visually arresting than Zincone's rainforest sequences. Zincone doesn't make use of the beautiful locations as much as one would expect. Considering the problems that faced its production, the final film is coherent and competent, if on the whole not particularly good.

American independent movie mogul Roger Corman was one of the executive producers on the picture. *Emmanuelle 6* was released on video in the UK with two seconds of cuts in the early nineties. The film is available uncut on DVD from the USA in an unrated, full screen transfer from Corman's New Horizon's Home Video imprint. The extras are minimal, consisting of a theatrical trailer and a cast biography.

SEXUAL VIBRATIONS

The Hardcore Years

ROLLIN'S HARDCORE SEX pictures, *Phantasmes* aside, were shot purely as commercial sex films with little artistic intention. To critically review each film would be a pointless exercise; Rollin himself regarded them as uninteresting and simply a series of sex scenes with virtually no plot. His intention was to create commercial sex films and nothing more.

Films from the golden period of hardcore sex cinema — the seventies and early eighties — can often be difficult to obtain and most of those listed here are currently unavailable on any format. The original video distributors no longer exist, although *Vibrations Sexuelles* (1976) and *Gamines en Chaleur* (1979) were reissued on VHS and DVD in Italy, largely because of the participation of the iconic cult French porn star (and also writer) Brigitte Lahaie, as well as the growing cult reputation of Jean Rollin. The packaging of the recent Italian release of *Vibrations Sexuelles* gives directorial credit to Jean Rollin rather than Michel Gentil (the name that actually appears on the print).

Rollin frequently dabbled in the world of hardcore pornography, directing around twenty XXX features, only one of which is credited to his real name. The remainder of these efforts were made under the pseudonyms Michel Gentil, Robert Xavier and Michael Gand.

With softcore sex a staple ingredient of sixties cinema, filmmakers pushed representations of sexual imagery as far as legally possible within their political climates. In America, low-budget black and white roughies like *The Touch of Her Flesh* (1967) and *The Defilers* (1965) were extremely successful independent exploitation ventures. As the market continued to grow, the advent of hardcore was inevitable. Hardcore sex films first appeared on the European continent in Denmark and the Netherlands before exploding in the American mainstream with *Deep Throat* (1972).

At this time, in France, hardcore was still illegal. It was during this period Rollin lensed his two softcore features, or 'Sexie films' as they were then known, *Jeunes Filles Impudiques* (*Schoolgirl Hitchhikers*) and *Tout le Monde il en a Deux* (*Fly Me The French Way*). Both

were extremely successful and returned more profits for the financial investors than Rollin's previous films. *Tout le Monde il en a Deux* in particular pushed the softcore element to the absolute limit, depicting explicit sex acts short of actually showing penetration. This also helped the possibility of splicing hardcore inserts into such scenes for less conservative markets and audiences.

The floodgates opened for a torrent of hardcore sex films in 1974, when President Valéry Giscard d'Estaing abolished censorship in France. Sex films were segregated from mainstream films with the creation of specialist porn cinemas, which breathed new life into the Pigalle district of Paris — the home of Moulin Rouge and an area that would later become synonymous with crime and prostitution. The movement was so successful that in the mid-seventies over half of France's cinematic output was hardcore pornography. Filmmakers who had trouble earning a profit from independent and commercial filmmaking had a chance to invest small amounts of money and receive high profits in return as the sex films were quick and cheap to lens. Profit was guaranteed and the industry boomed.

French hardcore from this golden period was often beautifully shot on 35mm by professional filmmakers, and the female performers always stunning and natural. Little wonder that these classy offerings now have a huge cult following. Among the hardcore starlets to emerge from French XXX were Brigitte Lahaie and Marilyn

Jess. Notable directors of the period were Michele Ricaud, Frédéric Lansac, José Bénazéraf, Jean Desvilles and of course, Jean Rollin.

As successful as it was, the arrival of hardcore in France met with much protest from film critics and political parties, who regarded it as the death of French cinema and 'the decimation of the French audience base'[*]. One critic in particular accused Rollin of being chiefly responsible for 'killing what was left of indigenous French cinema[†]' with his hardcore productions. Soon the wave of sex films overpopulated the French market, so much so that two thirds of all French productions in this period were hardcore sex films. Any filmmaker dabbling in such material was instantly disregarded or blacklisted as an artist or filmmaker. His reputation already tainted since the scandal of *Le Viol du Vampire* in 1968, Rollin had little to lose.

Rollin's first foray into the world of hardcore pornography came after the commercial failure of his deeply personal vampire movie *Lèvres de Sang*. The producer suggested shooting some hardcore sex scenes to insert into the existing film. Initially hesitant, Rollin caved and shot a handful of extra scenes using some of the performers from *Lèvres de Sang*. The new version was titled *Suce Moi*

[*] Temple and Witt, *The French Cinema Book*, 258.
[†] Tohill and Tombs, 155.

Vampire (*Suck Me Vampire*) and was a commercial hit in sex cinemas. Rollin took this as an insult and was deeply hurt. He became disheartened with filmmaking for a short period.

Lèvres de Sang was not the only personal film of Rollin's to be released in a hardcore variant. *Les Démoniaques* and *La Nuit des Traquées* were also released with XXX inserts by opportunist distributors. Rollin claims he had nothing to do with shooting the hardcore elements for the latter two films.

In time, Rollin saw potential possibilities in narrative driven *fantastique* hardcore. He attempted to do something new and push the boundaries of the sex film with *Phantasmes* (1975), which combined explicit sex with a narrative and heavy doses of gothic atmosphere. Shot on location in a huge castle, the film featured Jean-Pierre Bouyxou and the blonde twins Catherine Castel and Marie-Pierre Castel. The plot concerns an evil count who lures beautiful women to his castle for his own sexual amusement.

Rollin was so enamoured of the fact that something truly interesting could be done with the genre, he even put his real name to *Phantasmes*. Unfortunately the film was a commercial failure; the viewers didn't care for the narrative and wanted wall-to-wall sex. *Phantasmes* was later cut, re-edited and re-titled as *The Seduction*

of *Amy*, set to appeal to different markets and conform to overseas censorship regulations. It received a UK release in 1978 as *Once Upon a Virgin* — albeit in a heavily censored, softcore variant with a reduced running time of less than one hour. Since then, the film has drifted into complete obscurity. At one point, Redemption owned the distribution rights to the softcore and hardcore versions of

both *Phantasmes* and *La Comtesse Ixe* (1976), but neither has appeared on home video yet.

Rollin's challenging and uneven attempt to mix horror and hardcore sex pre-dates Aristide Massaccesi's *Emmanuelle in America* (1977), *Erotic Nights of the Living Dead* (1980) and *Porno Holocaust* (1981). Even Tinto Brass' much-criticized *Caligula* (1979) didn't hit the big screen until several years later. All of these films are a fusion of different genre types, hardcore sex included, meeting with varying degrees of success.*

Initially, Rollin had not wanted to make sex pictures and he even had problems shooting the softcore sex comedy *Tout le Monde il en a Deux*. After briefing the actors and preparing the set, Rollin would leave the crew to shoot the sex scenes while he went to the local café. He finally overcame his shyness for shooting such material when his close friend and director of photography Claude Bécogné played a prank on him. After preparing an obligatory orgy scene Rollin was preparing to leave the set when all of a sudden the actors stripped him naked and forced him onto the bed. Rollin laughed so much he was cured. He found it difficult to shoot fake sex scenes and found them laughably unreal. When it came to directing hardcore, it was a different story altogether: if the action onscreen was genuine and natural, it was easier for him to shoot.

After the failure of *Phantasmes*, Rollin made no further effort to do anything unique with the genre. He gave the audience exactly what it wanted ... sex. The films were undemanding and fun to shoot and Rollin regarded his seventies hardcore years as a wonderful experience. The actors and crew worked very closely together and the attitude to filmmaking was very professional but also light-hearted. There was nothing perverse about what they were doing, everybody was having a great time and the films were so easy to shoot and finance. The crew and regular actors became like a family, living and working together. After a shoot, they would settle down to eat dinner together. Despite the wonderful friendships and atmosphere of this period, Rollin regarded the films themselves as dull

* A more successful approach to dark, narrative hardcore is the Swedish independent revenge shocker, *Thriller: A Cruel Picture* (1974), directed by Bo Arne Vibenius, which uses hardcore inserts in a much more concise way, never allowing the sex to become titillating. The XXX elements here are an important part of the story and help plunge the viewer into a horrific world were nothing is hidden or obscured.

and uninteresting.

Living and working with the same people and shooting films without artistic merit soon wore Rollin down and he ceased directing hardcore productions for a time, returning to his personal films with *Les Raisins de la Mort*. However, after the mournful, gore-soaked *La Morte Vivante* in 1982, Rollin's cinematic output began to slow and he made fewer personal films. He ventured back to hardcore porn. In 1994, France's number one hardcore film director Michele Ricaud died. Everybody involved in the X-rated film market wanted to take his place. Producer/distributor Marc Dorcel approached Rollin and offered him a chance to write and direct another hardcore film that would have a story rather than just wall-to-wall sex — ironic considering that Rollin had tried to this two decades previously, with the commercial failure *Phantasmes*. Rollin accepted the challenge and the film became *La Parfum de Mathilde*. It depicts a rich aristocrat called Sir Remy who is haunted by the

FASCINATION

death of his beautiful wife Mathilde. He believes he can still smell the scent of her perfume lingering in his lavish castle homestead. The themes of mourning, memory and nostalgia are pure Rollin, and even the references to scent and perfume recall *Lèvres de Sang*. But the final film looks like most French porn from the early nineties, and is visually and emotionally far removed from Rollin's personal work. Despite the story and the tone, the prevalence of the hardcore footage detracts from the narrative. The result is an average porn flick with an emphasis on anal sex.

Rollin found the world of hardcore pornography had changed. Everything was business and there was no friendship between the crewmembers, technicians and actors. There was no atmosphere on the set, either. The element of fun was gone, replaced by a drive for commerce. The change in attitude is evident to anyone comparing seventies and early eighties hardcore films with the mass-produced sex films that populate the adult market now. Modern adult films often appear cold, humourless and loveless next to earlier efforts. *La Parfum de Mathilde* was Rollin's last hardcore sex film.

The following filmography represents all of Rollin's hardcore titles. Due to the pseudonymous nature of these films and their rarity on the home video market, some key production and casting roles remain unknown and uncredited. In some cases, running times were also difficult to confirm.

Suce Moi Vampire

AKA: *Suck Me Vampire*
1975 / 71 Mins, Colour, 35mm, 1:66:1
Nordia Films (Distributed theatrically by Alpha France)
Director: Jean Rollin **Screenplay:** Jean Rollin (Adaptation: Jean-Loup Philippe, Jean Rollin) **Production Representative:** Jean-Marc Ghanassia **Director Of Photography:** Jean-François Robin
Editor: Olivier Grégoire **Music:** Didier William Lepauw **Sets:** Alain Pitrel **Makeup:** Eric Pierre **Sound:** Gerard Tilly **Cast:** Jean-Loup Philippe, Annie Briand (Annie Belle), Natalie Perrey, Willy Braque, Paul Bisciglia, Martine Grimaud, Cathy Castel, Pony Castel, Hélène Maguin, Anita Berglund, Serge Rollin, Jean Rollin, Sylvia Bourdon, Claudine Beccarie, Julien Etchevery, Béatrice Harnois, Mireille d'Argent.

Phantasmes

AKA: *Once Upon a Virgin; Phantasme Pornographique; Phantasmes d'Isabelle; The Seduction of Amy; Phantoms*
1975 / 88 Mins (uncut version), Colour, 35mm, 1:66:1
Impex Films, Les Films ABC
Director: Jean Rollin **Screenplay:** Jean Rollin **Producer:** André Samarq, Jean-Paul **Director Of Photography:** Charlot Recors (as Allinh. E) **Music:** Didier William Lepauw **Makeup:** Catherine Castel **Cast:** Mylene d'Antes, Jean-Louis Vattier, Marlène Myller, Manuella Marino, Marie-Pierre Castel, Catherine Castel, Monica Swinn, Jean-Pierre Bouyxou, Jean Rollin, Évelyne Thomas, Corinne Lemoine, Claudia Zante, Greg Masters, Cyril Val, Alban Ceray, Sarah Toga.

Douces Pénétrations

AKA: *La Romanciére Lubrique; Introductions; Gode Story*
1975 / 75 Mins, Colour, 35mm, 1:66:1
Director: Michel Gentil (Jean Rollin) **Screenplay:** Michel Gentil (Jean Rollin) **Director Of Photography:** Oscar Lapin **Music:** Didier William Lepauw **Asst Director:** Jean-Pierre Bouyxou **Makeup:** Catherine Castel **Cast:** Tanya Bussellier, Martine Grimaud, Eva Khris, Eva Kwang, Catherine and Marie-Pierre Castel, Jocelyne Ciairis, Charlie Schreiner, John Oury, François Gharsi, Victor Samama.

Hard Penetration

1976 / 80 Mins, Colour, 35mm, 1:66:1
Director: Michel Gentil (Jean Rollin) **Screenplay:** Michel Gentil (Jean Rollin) **Director Of Photography:** Georgy Fromentin, Bernard Dechet **Editor:** Bernard Honnore **Music:** Michel Roy **Cast:** Catherine Castel, Alban Ceray, Alain Richard, Jacques Marboeuf, Gilbert Servien, Sweet Virginie, Myriam Watteau, Elisabeth Bure, Jean-Marie Metthey.

La Comtesse Ixe

AKA: *Sueurs Chaudes*
1976 / 84 Mins, Colour, 35mm, 1:66:1
Director: Michel Gentil (Jean Rollin) **Screenplay:** Michel Gentil (Jean

Masked onanism. *La Comtesse Ixe*.

Rollin) **Music:** Didier William Lepauw **Asst Director:** Jean-Pierre Bouyxou **Makeup:** Cathy Tricot (Catherine Castel) **Cast:** Rachel Mhas, Jackie Dartois, Alban Ceray, Cyril Val, Catherine Castel, Karin (Karine Gambler), Sandrine Pernelle, Patrice Maranzzano, Antonia, Guy Royer, Chris Martin, Jean-Pierre Bouyxou.

Apothéose Porno

1976 / 70 Mins, Colour, 35mm, 1:66:1
Les Films ABC
Director: Michel Gand (Jean-Marie Ghanassia and Jean Rollin — uncredited) **Director Of Photography:** Raffael Josse **Editor:** Clarisse Dearing **Asst. Director:** Jean-Pierre Bouyxou **Cast:** Christine Martin, Véronique Aubert, Catherine Castel, Virginie Swyt, Jean-Louis Vattier, Cyril Val, Jacques Marboeuf.

Amours Collectives

AKA: *Histoire d'X*
1976 / 75 Mins, Colour, 35mm, 1:66:1
Scorpion V
Director: Michel Gand (Jean-Pierre Bouyxou and Jean Rollin — Uncredited) **Cast:** Jean-Pierre Bouyxou, Catherine Castel, Rachel Mhas, Jean-Louis Vattier, Alban Ceray, Jacques Marbeuf, Cathy Cat, Willy Braque, Caroline, Jackie d'Artois, Jean Rollin (as Mike Genttle, the vampire).

Vibrations Sexuelles

AKA: *Vibrations Sensuelles*
1976 / 75 Mins, Colour, 35mm, 1:66:1
Director: Michel Gentil (Jean Rollin) **Screenplay:** Michel Gentil
(Jean Rollin) **Cast:** Brigitte Lahaie, Alban Ceray, Maude Carolle (Aude
Lecoq), Elisabeth Blin, Catherine Castel, Rachel Mhas.

Saute Moi Dessus

1977 / Running Time Unknown, Colour, 35mm, 1:66:1
Les Films ABC
Director: Michel Gentil (Jean Rollin) **Screenplay:** Michel Gentil (Jean
Rollin) **Director Of Photography:** Michel Gentil (Jean Rollin) **Editor:**
Michel Gentil (Jean Rollin) **Music:** Paul Piot, Michael Roy **Cast:**
Miriam Watteau, Patrick Lyonnet, Marilyn Chanaud, Jean-Paul Bride,
Mika Barthel (Therese Barthel), Therese Barthel.

Lèvres Entrouvertes

AKA: *Open Lips; Monique: Lèvres Entrouvertes pour Sexes Chauds*
(censored version)
1977 / Running Time Unknown, Colour, 35mm, 1:66:1
Director: Michel Gentil (Jean Rollin) **Music:** Gary Sondeur **Cast:**
Samantha (Genevieve Hue), Charlie Schreiner, Cyril Val, Miriam
Watteau, Marilyne, Mica, Gerard Delair, Guida Hernandez, Patrick
Bechard.

Discosex

1977 / 90 Mins, Colour, 35mm, 1:66:1
Impex Films
Director: Robert Xavier (Jean Rollin) **Screenplay:** Michel Gentil (Jean
Rollin and Jean-Pierre Bouyxou) **Producer:** André Samarcq **Director
Of Photography:** Gérard Loubeau **Title Designer:** Jean-Pierre
Bouyxou **Cast:** Jean-Pierre Bouyxou, Cathy Stewart, Agnès Lemercier,
Diane Dubois, Marie-Claude Viollet, Thierry de Brem, Jack Gatteau,
Dominique Irissou, Frédérique Prétot, Jean Rollin, Rosalina.

Brigitte Lahaie gets it on with French XXX legend, Alban Ceray.
Vibrations Sexuelles.

Positions Danoises

AKA: *Danish Positions*
1977 / Running Time Unknown, Colour, 35mm, 1:66:1
Les Films ABC
Director: Michel Gentil (Jean Rollin) **Screenplay:** Michel Gentil (Jean
Rollin) **Music:** Jean-Pierre Pouret, Dany Darras **Cast:** Willy Braque,
Lisa Stophenberg, Jean-Claude Bertin, Marilyne, Charlie Schreiner,
Maude Carolle, Gerard de Laire, Mika.

Remplissez-Moi ... Les Trois Trous

AKA: *Jeannette & Catherine*; *L'Epouse en Manque*
1978 / 66 Mins, Colour, 35mm, 1:66:1
Director: Robert Xavier [Jean Rollin and Jean-Pierre
Bouyxou) **Director Of Photography:** Georges Julien **Cast:** Cathy
Stewart, Jenny Feeling, Véronique Smith, Diane Dubois, Elsa Pime, Cyril
Val, Divan Ledoux, Michel Gentil (Jean Rollin), Jean-Pierre Bouyxou.

Petites Pensionnaires Impudiques

1978 / Running Time Unknown, Colour, 35mm, 1:66:1
Director: Michel Gentil (Jean Rollin) **Screenplay:** Michel Gentil (Jean
Rollin) **Cast:** Agnès Coeur, Muriel Trahl

Hyperpénétrations

AKA: *Par Devant Par Derriére*
1978 / Running Time Unknown, Colour, 35mm, 1:66:1
Director: Robert Xavier (Jean Rollin) **Cast:** Alban Ceray, Diane Dubois,
Edwige Faillel, Jacques Marbeuf, Valérie Martins, Barbara Moose, Joh
Oury, Jean Rollin, Guy Royer, Cyril Val, Marie-Claude Viollet.

Gamines en Chaleur

AKA: *Si Jeune et Deja Cochonne*
1979 / 73 Mins, Colour, 35mm, 1:66:1
Director: Robert Xavier (Jean Rollin) **Producer:** Joe De
Palmer **Music:** Michel Grone **Production Management:** Lionel
Wallmann **Title Design:** Jean-Pierre Bouyxou **Cast:** Richard Allan,
Dominique Aveline, Diane Dubois, Dominique Irissou, Marilyn Jess, Agnès
Lemercier, Barbara Moose, André Pastis, Jean-Jacques Renon, Eric Roy,
Cathy Stewart, Cyril Val, Anna Winn.

Bouches Lascives et Pornos

1979 / Running Time Unknown, Colour, 35mm, 1:66:1
Director: Robert Xavier (Jean Rollin) **Cast:** Patricia Arent, Dominique
Aveline, Christine Lodes, Cathy Stewart, Cyril Val.

Pénétrations Vicieuses

AKA: *Vicious Penetrations*
1979 / 75 Mins, Colour, 35mm, 1:66:1
Director: Michel Gentil (Jean Rollin) **Director Of Photography:**
Pierre Fattori **Music:** Sonorinte **Cast:** Henri Lamotte, Orson Rosebud,
Cyril Val, Cathy Stewart, Ingrid, Paulette Durond.

Rêves de Sexes

AKA: *Quand le Chat*
1982 / Running Time Unknown, Colour, 35mm, 1:66:1
Director: Robert Xavier (Jean Rollin) **Cast:** Jean-Pierre Armand, Jean-
Paul Bride, Christine Chavert, Gérard Grégory.

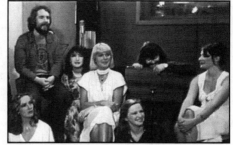

Title cards (left), and the cast of *Discosex*
(above) before disrobing for an orgy.

Sodomanie

AKA: *Apprendiste Viziose*
1983 / 77 Mins, Colour, 35mm, 1:66:1
Director: Robert Xavier (Jean Rollin and Michel
Berkowitch) **Screenplay:** Robert Xavier (Jean Rollin and Michel
Berkowitch) **Director Of Photography:** Pierre Fattori, Guy
María **Editors:** Gilbert Kikoïne, Pierre B. Reinhard (as Reinhard
Brulle) **Cast:** Jean-Pierre Armand, Jean-Paul Bride, Marie-Christine
Chireix, Christoph Clark, Jérôme Proust.

Folies Anales

1983 / Running Time Unknown, Colour, 35mm, 1:66:1
Director: Robert Xavier (Jean Rollin) **Cast:** Agnès Ardant, Jean-Pierre
Armand, Marianne Aubert, Jean-Paul Bride, Pauline Magenta, Béatrice
Vidal.

Le Parfum de Mathilde

AKA: *The Scent of Mathilde*
1994 / 90 Mins, Colour, 1:66:1
Directors: Marc Dorcel, Jean Rollin (uncredited) **Screenplay:** Jean
Rollin **Producer:** Marc Dorcel **Director Of Photography:** Serge de
Beaurivage **Editors:** Marc Dorcel, Norma Poulipoulos **Music:** Marc
Dorcel **Cast:** Draghixa, Lydia Chanel, Christoph Clark, Erica Bella, Élodie
Chérie, Marc Dorcel, Richard Langin, Maeva, Manon, David Perry, Thomas
Santini, Elisabeth Stone, Simona Valli, Eric Weiss.

Short Films and Unfinished Projects

JEAN ROLLIN DIRECTED over fifty films. Only half of these were personal films. His pseudonymous work in the hardcore sex genre also represents a large portion of his output. But on top of these, there are many obscure titles in Rollin's filmography that have intrigued European cult cinema fanatics. Various reports and scraps of information, printed here and there, delve into Rollin's ambiguous early shorts and unfinished projects. This chapter will hopefully shed a little more light on these obscure titles. Many are well worth checking out, if you can find them that is! It's a shame that short films in general receive such little respect compared with full-lenth features. Considering Rollin's keen eye for unusual and interesting images, it surprises me that he was never approached to shoot surrealist music videos for goth rock bands, bands that often revel in Rollin-esque imagery. We may be thankful for small mercies.

Les Amours Jaunes

> **AKA:** *The Yellow Lovers*
> 1958 / 12 Mins, B&W, 35mm, 1:33:1
> **Director:** Jean Rollin **Screenplay:** Jean Rollin **Producer:** Jean Rollin **Writer:** Claude Mann **Director of Photography:** Jean Rollin
> **Cast:** Jean Denisse, Guy Huiban, Dominique Vidal

Inspired by a Tristan Corbière poem, *Les Amours Jaunes* is a twelve-minute short photographed entirely on the beach at Dieppe. Images of the waves lapping at the shoreline are lovingly captured as Corbière's words are delivered as voice-over narration. The location would later become a key ingredient in Rollin's personal films.

Rollin borrowed a 35mm Maurigraphe camera from a work colleague and shot the film over a single weekend. The complicated camera was extremely heavy and difficult to use. Rollin charged the camera batteries at the public toilets at the beach.

Les Amours Jaunes can be found as an extra feature on the Region 1 NTSC Image Entertainment DVD of *Perdues dans New York* (now deleted). It also appears as an extra feature courtesy of Encore Entertainment's region 2 DVD of *Lèvres de Sang*.

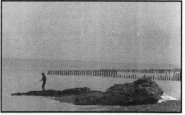

The beach at Dieppe,
Les Amours Jaunes.

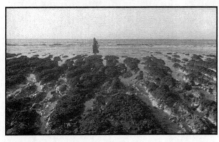

Ciel de Cuivre

AKA: *Sky of Copper*
1961 / 20 Mins, B&W, 16mm, 1:33:1
Director: Jean Rollin **Screenplay:** Jean Rollin **Producer:** Jean Rollin

A sentimental and surrealist short, approximately twenty minutes long, which was never completed for financial reasons, as well as Rollin's lack of confidence in the project. *Ciel de Cuivre* can be found as an extra feature on the out-of-print Region 1 NTSC DVD of *Perdues dans New York* (from Image Entertainment).

L'Itinéraire Marin

1963 / 60 Mins (unfinished), B&W, 35mm, 1:66:1
Director: Jean Rollin **Screenplay:** Jean Rollin, with dialogue by Marguerite Duras and Gérard Jarlot **Director of Photography:** Guy Leblond **Cast:** René-Jean Chauffard, Pascal Fardoulis, Michel Lagrange, Gaston Modot, Silvia Monfort, Bernard Papineau, Jean-Loup Philippe, Anne Tonietti

Originally intended as Rollin's debut feature, this was the first film to be produced with his own company, Les Films ABC. Rollin per-

sonally funded it, along with contributions from close friends. Due to the death of the lead actor and financial complications, the film was never completed and only one-hour of footage was completed. Once again, Rollin incorporated the beach at Dieppe. Despite being listed as an existing film in French cinema archives, *L'Itinéraire Marin* has never been made available anywhere and has yet to surface as an extra feature on DVD or Blu-ray. Some still images of the film and production shots are shown in *La Nuit des Horloges*.

Vivre en Espagne

AKA: *Life in Spain*
1964 / 30 Mins, B&W, 35mm, 1:33:1
Director: Jean Rollin **Cast:** Francisco Franco (Himself)

Rollin's first and only foray into documentary filmmaking. Running approximately thirty minutes, *Vivre en Espagne* explores fascism in Spain under the control of General Franco. The film took around ten days to shoot on location in Spain. Rollin and his crew left the country with the Spanish police hot on their tails. Luckily, they completed the film and made it back over the French border unscathed.

The finished film was shown during political discussions and meetings but has never surfaced on any other format and has been declared lost. Rollin himself has declared this one impossible to find, so good luck to all you completists out there!

Les Pays Loin

AKA: *The Far Country*
1965 / Les Films ABC
17 Mins, B&W, 35mm, 1:66:1
Director: Jean Rollin **Screenplay:** Jean Rollin **Producer:** Jean Rollin **Director of Photography:** Gerard de Battista **Assistants:** Jean Denis Bonan, Olivier le Gentil **Cast:** Pascal Fardoulis, Nadine Ninio, Julie, Bernard Papineau, Ben Zimet

Les Pays Loins was originally conceived as a novel, to have been published by Eric Losfeld's (*Saga of Xam* and *Barbarella*) Terrain Vague imprint. Although the book was ultimately never published,

Les Pays Loin

Rollin decided to use the title for this short film (there is no other connection to the content of the book). The film shares many similarities to *La Rose de Fer* and is a beautiful, dark and surreal journey.

It was never screened in theatres and Rollin himself had apparently not seen the film for almost forty years, before Encore Entertainment included it as an extra feature in their special edition DVD release of *Les Démoniaques*.

Les Pays Loins depicts a young man who has lost his way in a derelict city of ruined buildings and dark, rainy streets. He desperately tries to escape the bleak world that entombs him. On his travels, he meets a young woman who suffers the same predicament. They try to escape together, but in the end appear to fall in love and conform to the world that surrounds them. Beautifully photographed on 35mm in crisp black and white by Gerard de Battista and accompanied by a jazz-influenced soundtrack, the film is a must-see for admirers of surrealist cinema and Rollin's work. *Les Pays Loins* is available as an extra feature on Encore Filmed Entertainment's limited edition DVD of *Les Démoniaques* (Region 0, PAL, French Language with optional English subtitles), where it is accompanied by an insightful commentary track by Rollin.

La Griffe d'Horus

AKA: *The Claw of Horus*
1990 / Colour (Shot On Video)
Directed by: Jean Rollin **Written by:** Jean Rollin, Gérard Dôle (based on characters by Jean Ray) **Editor:** Dominique Saint-Cyr **Cast:** Jean-Michel Nicollet, Philippe Mellot, François Ducos, Christine Louveau de la Guigneray, Pierre-Henri Pichot, Maurice Hubert

Supersleuth Harry
Dickson has a big eye.
La Griffe d'Horus.

For many years, *La Griffe d'Horus* was impossible to see. It is a short teaser or demo, if you will, of improvised clips based on the fictional supersleuth Harry Dickson, who, along with his trusty assistant, Tom Wills, Dickson solves mysteries that involve vampires, mad scientists and demons. Belgian writer Jean Ray penned many of the Harry Dickson novels and they were extremely popular in Germany, Holland, Belgium and France. He appeared in hundreds of pulp magazines between 1929 and 1938.

Based on a treatment written by Gérard Dôle and Marie Paule Vadunthin, Rollin and Dôle (also a writer, musician and journalist) planned to create a TV series consisting of several twenty-five-minute episodes. Not one TV studio or film company was interested and the project was developed no further.

Typical of Rollin's filmmaking technique, he decided to shoot the demo footage in an improvised manner, using friends, non-professional crewmembers and amateur actors. In some cases, members of the public appear as extras. French illustrator Jean-Michel Nicollet played Harry Dickson.

The improvised material was shot around Paris on video over the course of one day. It only took a further day to edit the footage. The existing footage delivers some Dickson dialogue and a pursuit of a monster, whereupon the short finishes hastily. Apparently a twenty-two-minute cut was originally made but the only version available appears to be this three-minute demo, which appears as an extra feature at the end of the German VHS release of *Perdues dans New York* from Lucertola Media.

Blood and erotica. *A Virgin Amongst the Living Dead.*

A la Poursuite de Barbara

AKA: *Chasing Barbara*
1991 / 20 Mins, Colour, 35mm, 1:66:1
Director: Jean Rollin **Producer:** Kevin Collins **Executive Producer:**
Tommy Chase **Director Of Photography:** Jean Rollin **Cast:** Domiziano
Arcangeli, Françoise Blanchard, Jean Rollin, Ida Galli, Claude Boisson,
Olivier Mathot, Muriel Montossé, Sara Ashton, Pietro Martellanza

Rollin photographed and directed this short film at Eurociné's re-
quest while in Madrid, shooting in the luscious garden of his hotel.
He shot twenty minutes of 35mm footage in a single day.

Eurociné specified they wanted living dead footage and they lat-
er spliced the material into Jess Franco's *A Virgin Amongst the Liv-
ing Dead* for its re-release in the early nineties. Rollin had no idea
where his footage would end up when Eurociné purchased it from
him, and he never saw *A Virgin Amongst the Living Dead.* Rollin's
footage has never actually been made available in its original form.

Interview with Jean Rollin

THIS INTERVIEW WAS conducted on October 1, 2005, at Jean Rollin's apartment in Paris.

DH: Could you tell me about your upbringing, your childhood ... I understand your father was a theatre actor?
JR: Actor and director.

DH: What kind of theatre did your father work in?
JR: At the beginning it was classics ... Baudelaire ... all the classics ... and after he began to be an actor and director of avant-garde ...

DH: Did this influence you to become a filmmaker?
JR: No ... not at all. What he was thinking ... I think differently, completely. I have great admiration for his work but it's not my way.

DH: What age did you know you wanted to make films ... when did you start writing?
JR: I have always wrote things. Beginning at school. I worked in the movie business, I was first assistant director on the film *Un Cheval pour Deux* [a comedy by Jean-Marc Thibault]. I shot my first two short films ... So I had a choice, take another job or try and do my first film. I chose to do my first film, of course, *Rape of the Vampire*. I had no knowledge of the directing business. First it was a short film and I found an American in Paris, Sam Selsky, and he put some money in. I had a proposition from a friend who was a distributor who had an American film *The Vampire, Evil Creature*. The film was 1 hr 10 mins, in the United States, it was a second [supporting] film. In France that doesn't exist. He told me if you do thirty minutes of film, vampire or whatever, I can give you four cinemas to show it in. So I wrote *Rape of the Vampire*, and we shot it to be thirty minutes. At the end, the film was forty-five minutes, so Sam Selsky said to me 'we have forty-five minutes of vampire film for practically nothing'. So for another forty-five minutes for practically nothing we have ninety minutes of film — a real film. So we forgot *The Vampire, Evil Creature* and we try to make our own film. But the difficulty was at the end of the [first] film all the characters die, so I had to make someone alive from the first film to be in the sequel. After *Rape of*

FASCINATION

the Vampire we began to shoot *Queen of the Vampire*, the sequel. So we said make it like the old serials ... first part ... second part ... It was two short films put together. We shot about two months after *Rape of the Vampire* [*Queen of the Vampire*] and we edit all the thing. So we had *Viol du Vampire*.

DH: The film was shot in two parts. How much do you feel this affected the film?
JR: The film is very bizarre ... surreal. I knew practically nothing of directing or how to make a film and the second one, the sequel, two months later I had the experience from the first one ... so it's better [laughs].

DH: You mentioned the serials earlier. Were those the American serials from your childhood?
JR: Yes. When I was young, seventeen, eighteen, even before, I go to the Cineaque. The Cineaque was a cinema in a railroad station. Only for people who have twenty minutes to pass between trains and so on. It was a little cinema and people entered and went out at each second and when we were sitting in the cinema we could hear all of the announcements for the rail road, '*so and so train will be leaving in ten minutes*' and so on, but I go there. It was fantastic for me, such an ambience. And to see all those parts of serials, there was three or four episodes and three or four different serials, and the next week I try to go and see the next part and sometimes I miss some parts. It's a great souvenir. It's my greatest souvenir of cinema.

DH: Did the ambience and image of the railway station influence your films? It recurs frequently.
JR: Probably ... it's possible. I saw *Fu Manchu*, I saw *Zorro*. And now I have these films on VHS. When I was in New York I found a place that we can buy all those serials. I have original *Zorro*, *Fu Manchu*, all that.

DH: Your films are very hard to find in Paris.
JR: In Paris you have to go to a specialist near Saint Michael. There is a little shop where you can find every DVD possible. Next month I have a signing there — October 22. There are three or four shops.

The Celluloid Dreams of Jean Rollin 235

DH: Have you got a cult following in France and Paris?
JR: Yes, I think so. Many fanzines make special issues about my films.

DH: You worked as an editor in the army. You made a film called Mechanographie. *Was this released in cinemas or made only for the army?*
JR: Only for the army.

DH: Are all your early films available, prior to Le Viol du Vampire, *on DVD as extras?*
JR: Now for the first time some people want to make complete editions of my films. Twelve DVDs of all my films. They make a coffin box for Halloween.
 In Amsterdam there is a producer who buys the rights to make definitive editions of my films.

DH: Could you tell me about the comic book you worked on, Saga de Xam?
JR: I was friends with the publisher Eric Losfeld. I wrote the story and made the pallet, the organization of the drawings, and I had a friend who I asked to draw.

DH: Is Saga of Xam *available to buy now in a reprint edition?*
JR: You can find it in certain places, but it is very expensive.

DH: How many issues did you make?
JR: Only one. There was a second edition without colour. The original was colour.

DH: You have also written books. Could you tell me about them?
JR: I made only one film in spirit of the book I write … *Two Orphan Vampires*. I was very sick for a period. My kidneys don't work. Dialysis. I stayed for eight years in dialysis, every two days. Four hours a day in hospital without doing anything, I began to write books. In this period of eight years I shot two films. When I think about it now, I ask how I would do that — every two days I have to go four hours in hospital. My assistant had to find me a hospital … incredible … I remember one day I shot at night, all the night, and when they came back here [Rollin's house] at seven o'clock in the morn-

ing after all night shooting, the ambulance was there waiting for me to take me back to the hospital. I made two films like this, the *Two Orphan Vampires* and *Fiancée de Dracula*.

For the *Two Orphans* I remember, I was so terribly sick I directed one day lying on a stretcher with two persons waiting in case anything went wrong. So I wrote during those eight years ...

DH: Do the books explore similar themes to your films? Were they of same genre? Horror or fairytale?
JR: The same as the films, vampires or like that. A friend critic wrote somewhere in a magazine 'when we read a book of Jean Rollin it's exactly like when we see one of his films'.

DH: Have the books been printed in English as well as French?
JR: In English, there is only the little book by Redemption, *Two Orphan Vampires*, only the first part ... It's a big book.

DH: Do you prefer writing to directing?
JR: It's exactly the same for me, but now I'm an old man. I'm a sick man. It's much easy for me to write a book than shoot a film. If only I had more money, more time. Now I'm too old to do what I was doing. It was very difficult to make *Fiancée de Dracula*. We had ten different locations everywhere in France ... If I'd had the good idea to write a script in only one place in a château and nothing else [laughs], it would be easy [laughs] but it was like that.

DH: Do you feel that you fit into French cinema and French culture or would you consider yourself an outsider?
JR: It does not belong to me to say that, but yes probably. There is a part of my work that came from the surrealists, the Dadaists and so on. Another part of my work is directly from the serials and those kind of things. The third part of my films is under the influence of people like Georges Franju and Luis Buñuel. I was a fanatic of Buñuel.

DH: When Le Viol du Vampire *was released, it received harsh criticism?*
JR: Scandal! We can compare it to the scandal of *Un Chien Andalou*, *L'Age d'Or* and so on ... incredible ... people broke the seats and

The Celluloid Dreams of Jean Rollin

threw things at the screen ... Brawling, howling in the cinema, running after me in the streets to punch me. It was terrible, terrible. I never understand why that made such a scandal.

DH: When La Vampire Nue *was released shortly after, did this provoke a similar response?*
JR: No. Many people said the film was nothing, stupid and so on. Too violent. *Rape of the Vampire* was violence ... In one of the cinemas where we played *Rape of the Vampire* we had to phone the police ... the Scarletta. I don't know why that film made such a scandal. Probably people say I was making a joke of the audience. I don't know really.

DH: Is the film still despised in France today? How do people perceive it now?
JR: We tried an experience with the Cinémathèque Française, a kind of mainstream screen. By miracle we found a print, practically new, of *Rape of the Vampire*. So we had a print to project. We made at the Cinemateque a screening of *Viol du Vampire*. The place was full. The film, for the first time in this life [laughs] was screened in complete silence. When the film was onscreen in 1968 everybody whistled and shouted, we couldn't hear the film.

At the end [of the re-release] I came on the stage to make a little talk with the audience and one old man said, 'I saw the film when it was first released in 1968 — I understood nothing. But I like it, and today I see the film again — I still understand nothing and I like it very much again!' I think the reason it made such a scandal is because nobody understands it. Me, I find the story perfectly clear but I am the only one to say that [laughs].

I show it one time, maybe ten years ago, in a cinema in London, it was good. A good screening. But it was in French and people understood nothing [laughs]. They don't think they understood it because it was strange, they think they didn't understand it because there were no subtitles [laughs] ...

DH: The style of your films ... are they comparable to any other directors before or after you? Whether intentional or not?
JR: I don't think so. I don't think any films have been influenced by one of mine.

DH: Your films are unique.
JR: In a bad or good sense ... I don't know [laughs].

DH: Most of your films seem very personal, such as La Rose de Fer. *Did you intend to portray any social or political themes within the symbolism of your films?*
JR: Probably. One is deliberate — *La Nuit du Traquées.*

DH: The issue with the German prison system at the time?
JR: Yes. That was intentional. The railway station, the doctor, the chimney where they burn the bodies. I was very concerned at this period.

DH: Did you always intend to make unique films rather than commercial films?
JR: At the beginning my films were supposed to be commercial [laughs] and I assume that I give the producer what they wanted ... the naked girl [laughs]. But there are many things that I put in my films that are my signature. So it is a mix of them both.

DH: As a filmmaker and a writer is there any particular individual that has influenced your work ... such as Tristan Corbière?
JR: Not very much. I use it as a model for my first short film because it's a poem I like ... but I don't think he has influenced me.

DH: What about Gaston Leroux?
JR: Gaston Leroux! Certainly! Many of my films contain elements or situations of Leroux. Particularly *Fiancée de Dracula.*

DH: Do you like German Expressionism? Did you intend any references or influence from Nosferatu?
JR: Yes, of course.

DH: In Nosferatu *the vampire is very predatory like yours.*
JR: Maybe. But the difference is in most of my films the vampires are all women.

DH: Did the Hammer films influence Le Viol du Vampire *and* La Vampire Nue?

The Celluloid Dreams of Jean Rollin

JR: It was the same period in France. Everything to do with vampires at that time came from Hammer. Maybe the reason for the scandal of *Viol du Vampire* was because every person who went to the film wanted to see Hammer.

DH: Are you a fan of the Hammer films?
JR: Not a fan. It was my period when I was thirty. It was the period of Hammer film and we had practically nothing else to see. But I prefer the period of 1930s to 1940s, Universal, the black and white ones.

DH: Did you have an audience in mind when you made your sixties and seventies' films?
JR: Of course. If I don't have an audience I make no *more* film. So I put in the film what the audience need. This is the reason for the erotic. I play on two places. I have the audience of the horror films and the audience of the naked girls. And this was exactly the proposal of the cinema Midi-Minuit — and in fact I was wrong. None of those kind liked my films! [laughs] The people who went to see the girls, they said 'what is this stupid vampire story?' ... The horror people didn't want the naked girls! [laughs] But they came. Not a great success but [shrugs] ... Later those cinemas disappeared. The Midi-Minuit does not exist anymore. The Scarletta doesn't exist anymore.

DH: Do your producers have much of an influence on the final film?
JR: No. Before they did. The script stage, particularly Sam Selsky, they discuss the script. I have to fight line by line [laughs]. Sam Selsky said 'you can't put a girl inside a coffin at midnight'. I say to Sam, 'okay, let me put my girl in the clock, but for you she will be naked' [laughs]. Everything was discussed like that! [laughs] And we wrote a combination.

DH: Do you think working like that benefited the films?
JR: Yes, sure. Because I think when I shot in a graveyard at night I put a girl lying naked on a grave, it is not on record for Sam, it's because the image became bizarre. There is something brought by the naked body which is not the same if she was dressed. Nudity had great importance for me. The audience know what it is [expecting a sex picture] and they come to see that — they like that — a girl and

FASCINATION

a man in a bed, okay great ... but it's a girl naked somewhere which is not in a bed, she is in a strange place. It's become like a painting ... kind of collage.

DH: How about your budget in the sixties and seventies? Did you finance the films yourself?
JR: Yes. Sometimes. When I had money [laughs]. I always put myself [money] in the film, or a little part, because I didn't want the other producers or the people who put money in to cut the film, they can't change the editing and so on. So I have a little part so I have the right to say no. I never had much money. In all the films of my career I have never been paid. I always put money in but ... [laughs].

DH: Do you prefer smaller budgets as a director ... you obviously have to use your imagination and skill as an artist to do the very best with less?
JR: Yes. I remember Buñuel say something like that ... he said 'I prefer low-budget because it stimulates me to find ideas'.

DH: Did you intend your films to be so dreamlike?
JR: It's generally something that happened. But if I can do it, I do it of course ... but generally it is coincidence [laughs].

DH: Which of your films are your personal favourites?
JR: Which one? [laughs] Some days this one, some days that one. Generally the film I prefer is probably *Requiem pour un Vampire*. It is a naïve film. I wrote the script in one day ... [laughs].
When I was camping as a child this guy could invent a story in the moment ... when I wrote *Requiem* I remembered that. I had to work quick when my producer said we can make a film but we have to do it now and start shooting in fifteen days. So I take the white paper and have no idea at all what I have to write. I began with a car and two clowns. I wrote free flow, and at the end, practically at the end ... I realized I had put no dialogue in it [laughs]. There is nothing because I/they, had nothing to say. They began to speak after about one hour of film. There is music and noise but no dialogue. I like that very much [laughs]. When I finished the script, it was the beginning of the day, it was getting light. So I say, okay, now the challenge is to shoot the film exactly like I wrote it, and I shot the film

exactly like my script. The reason why I like this film is because it is completely naïve like the two girls who play in the film.

DH: Any others?
JR: Yes, personally, my best work is *Fiancée de Dracula*. My best work as a director. I produced it all myself by selling three of my old films to television ... *Le Frisson des Vampires*, I don't remember which other ones [laughs]. Canal+ wrote to me because of Jean-Pierre Jeunet likes my films. With the money from those three films I produced *Fiancée de Dracula*. If I produced myself, I have no censorship on my back. I have hospital on my back [laughs] but I forgive the hospital and write what I like [laughs]. The ending of *Fiancée de Dracula* is the same ending as *Un Chien Andalou*. The same ending. The two characters walking on the beach. In the spring, everything has changed! [laughs].

DH: Which other filmmakers do you like, both when you were young and now?
JR: Now, it is difficult [laughs] ... Jim Jarmusch ...

DH: Clowns are a recurring image?
JR: We find the same clown in *La Rose de Fer*, *Les Démoniaques* the same girl. The first one was *Requiem pour un Vampire* but the image followed me for the films after.

DH: I like the image of the clown in La Rose de Fer, *in a place of mourning with a smiling face ... very poignant ...*
JR: In *La Rose de Fer* the clown maybe puts the flowers on the grave of the other clown [laughs]. I could only have one of the two actresses from that previous film.

DH: The beach at Dieppe, why is this location so special to you?
JR: That has meaning. It's a remembrance of when I was a child. I go on holiday with my mother and we discover that beach and I was very fascinated by the beach because it was different than now. Everything was white like chalk, and white rocks. After they bring rocks to cover up the white because it was dangerous to boats. But when I first saw that place with all the white I said if only one day I can make a film, I would like to make a film here. Every time I have

the possibility I film there [laughs]. There is a cave in the rocks and I wrote a book, where inside the cave there is a corridor and that brings you to the cemetery of strange creatures.

DH: *The moment in* La Fiancée De Dracula *where the night creatures emerge from a cave at dusk a reference to that?*
JR: Yes. I put it in *Fiancée de Dracula* but I had written it many, many years before and I could never shoot it. It is the scene with the girl tied to the pole with the sea coming up higher around her. It was difficult to shoot that, particularly at that place. I thought maybe it's my last film … maybe it is? So I wanted to put that scene in, and we put it in.

DH: *You are often regarded as a horror film director, would you consider your films as horror films?*
JR: No. I don't think I put horrible things [in my films], there are exceptions, such as *Grapes of Death*. At the beginning we were supposed to be making a horror film, so I put in some sequences. I don't like horrible scenes. If I do some horrible scene it's with a background of poetry or something else.

DH: *The eerie or 'horror' moments in your films often comes directly from beauty?*
JR: Yes, of course. It's the reason why my vampires are girls and not boys. Because I have to insist on the side of seduction of the vampire. A girl is more easily seductive than a man. When we see Brigitte in *Fascination*, she is not a vampire of course, but assimilated to a vampire … When she is in black with the scythe … something happens! If it is a man — nothing! It is not similar … it's not the same thing.

DH: *You did thrillers such as* Sidewalks of Bangkok.
JR: *Sidewalks of Bangkok* is not a good film. It's not even a film. It was funny for me to direct it because I directed exactly like if I was nineteen-years-old. A critic, I don't remember which one, he said 'Jean Rollin has made two good films, *Rape of the Vampire* and *Sidewalks of Bangkok*'. It is the same thing — completely improvised. Completely shot without any money and with friends passing by in the street.

The Celluloid Dreams of Jean Rollin 243

DH: Are you fond of Sidewalks of Bangkok*?*
JR: It's a good remembrance, a good experience. The serials we were talking about earlier, I think the first serials were maybe shot or done that way. Completely improvised ... people pass by [in the street], 'here you do that, you do that' ... it's the kind of cinema I like ... free. I like that film because I like the way I shot it ... more than the story, which is not important.

DH: The story is actually quite complicated and new information is revealed in every scene ... did you have a script to shoot with or was it entirely improvised?
JR: I had two pages [laughs].

DH: Is that your voice on the narration of the film?
JR: I don't remember [laughs].

DH: The colour schemes are very vivid and vibrant in your films, particularly Nue, Frisson, Requiem *...?*
JR: I was working in this period with Jacques Renon who was a great director of photography. He never shot anything for more important films because he drank too much. He died of that. Renon had a problem. At the beginning he would have liked to be a painter and he had a choice to make — he could be a director of photography in film and get paid, or be a painter and have no money [laughs], so he choose to be a director of photography and he always regretted it. Working with me, it was great for him because at this period I was so mad. He was completely mad too [laughs], so we experienced many things. *Frisson* was the film in which we gained most experience. Each room had a different dominant colour, we made the castle bleed ... it was very funny. We put together in the graveyard a young girl in white because she is just married and another girl in black for she is a widow ... many things connect.

DH: Your films have a strong fairytale ambience to them, particularly La Fiancée de Dracula. *Time seems unimportant. Is this something you intended?*
JR: I think it's possible.

DH: Everything about your films is beautiful — characters, land-

FASCINATION

scapes, mise en scène ...

JR: It is very important to me. Many times I chose the place to shoot before I wrote the script. I don't say that the locations are more important than the script or actors, but it's the location for me that conditions the rest. Even when I write a book I say we are in an old dungeon and so on, and after I begin the story. But during writing the story somewhere in my mind that old dungeon remains. It is the same for the films. *Requiem pour un Vampire* — I write like that ... but it's not totally the truth. I started at my table. I had something in my mind, not a story, but one image — it was a friend of mine who played in *Les Démoniaques*, Louise Dhour, she was a singer. When I began to write *Requiem* I had that image in my mind. So I say I must put Louise Dhour somewhere at a piano in a cemetery at night. I wrote all the script and in the middle she is playing piano in moonlight. I can tell you, it's true, that sequence was the most expensive in all the film! [laughs] To bring a big piano from Paris to there, to put in the middle of the cemetery it cost much money [laughs].

DH: Did Sam Selsky approve this cost happily?

JR: He say 'why not, maybe'. Sam Selsky was a strange person, without him I probably never would have shot a film. He was like a father for me. He was very rational like an American ... of course he doesn't understand many things I do but he was intelligent enough to consider that my way of filming could be a good way. He said 'okay, put the piano in the graveyard ... I never saw that in my lifetime ... But do it ... it's your idea, do it'. For me it was fantastic to find somebody like that. Okay, he probably won't like that so I put two naked women somewhere and he say 'yes we can do that!' [laughs].

DH: What's the average timescale from writing to finished film?

JR: Depends on the film. Each film is of a special kind.

DH: Do you make many rewrites?

JR: No. I write just once. Then I take notes and make changes. One day, it was on *Grapes of Death*, everything was different than I had written — the continuity — and my mind was different. When we write something precisely, it is a certain day and when you shoot what you have written it is two months later and in those couple of months you have changed. So I shot the beginning of *Grapes of*

Death with the script and after about one week I completely improvised and I didn't use the script anymore. For that film, I never made a technical script! For *Living Dead Girl* I had a real script with some indication about the place of the camera and so on.

DH: Tell me about the lighting in Requiem pour un Vampire.
JR: I wanted to put some light on the graves ... I remember in that sequence of *Requiem*, a big house exists for the cemetery keeper, and that big house I didn't like, so I lit all the rest but not the house and it disappeared!

DH: How many crewmembers do you employ per shoot?
JR: On *Sidewalks of Bangkok* I had four technicians. A cameraman, makeup, not even a script! [laughs] One assistant for me, lighting. But for *Grapes of Death* we had twenty.

DH: Do you prefer working with larger crews?
JR: The ideal would be between the four technicians and the twenty ... the middle [laughs].

DH: Do you record sound live or do you postdub?
JR: In the beginning I made dubbing because that meant two technicians less and we save time on the shooting. But now it's impossible for me to shoot without sound because many times I have beginners and they are better direct than dubbing.

DH: How do you approach directing actors?
JR: For the *Two Orphans*, for the first and last time in my life, I took time to make repetition with the two girls before filming here [Rollin's house] and repetition with the actors before shooting. I took time to work with the players. But the other films I didn't have any time for that. When we ate, we had a discussion to say how they had to play. I regret I didn't have enough time to work with the actors ... Before each take I can say 'you know you have to do that, and do it like that', and so on in two minutes ... quickly.

During the preparation we can have one, two or three meetings with the leading cast to explain. I wanted to discuss more with the actors but when you're ready saying 'roll', it's impossible to take more time [laughs].

FASCINATION

DH: Do you cast the films yourself or does the producer have a strong say in who appears in the film?
JR: Yes. I do it.

DH: Do you produce storyboards prior to shooting?
JR: Never … If I make a storyboard then anybody can direct the film. My pleasure is to have nothing prepared for the directing and improvise all the technical directing when I get to the set. When I get to the set for the first time I absolutely don't know what I have to shoot, or how to shoot what I have to shoot and the miracle is at the moment I put my feet on the set for the first time I can immediately say the camera is here and so on. There's something magical that happens; you can call that inspiration or whatever …

DH: Do you always use 35mm film?
JR: Yes. But I used Super 16mm for the last two [*Les Deux Orphelines Vampires* and *La Fiancée de Dracula*]

DH: What about Killing Car*?*
JR: I'm not sure. Now you ask I'm not sure. Maybe it was 16mm.

DH: You never shoot in CinemaScope?
JR: I shot one time in CinemaScope but it was not one of my films. I always shoot in 1:66:1. None of my films require CinemaScope or anything like that.

DH: Do you plan the shoots or does the producer help with that?
JR: Myself.

DH: Do you edit the films yourself?
JR: Yes. *Requiem* … at the beginning I close myself in the editing room and I make the first rough cut … and when I am sure I have ninety minutes … [laughs].

DH: How do you prepare scores for your films?
JR: I am not a musician so it is very difficult for me to discuss with the musician, but with the last one with Philippe d'Aram, who I have worked with for many years, I take discs and I made him learn what I want.

The Celluloid Dreams of Jean Rollin 247

I have jazz music for *Rape of the Vampire*. It was by a guy named François Tusques. We see him in the film at the wedding sequence — one shot of a guy who is hitting the piano, this is Françoise.

DH: How long does it take from script to completed film on average?
JR: I'd say maybe one month preparation, three or four weeks shooting. Two to three months in total. *La Morte Vivante* was four weeks.

DH: The women in your films are often more powerful than the men ...
JR: I like to film female characters and I don't like very much to film male characters. The part of the girls are, of course, more important in my films than the rest. For me it's more pleasing to film a girl than a man and I write more easily the parts for the girl than the man.

DH: Moving onto the X films that you made, you used an alternative name, apart from Phantasmes *...*
JR: Generally at the time the director who shot X films had to hide themselves behind a pseudonym. So I say okay, I do one, on my name, *Phantasmes*.

DH: You tried to do something unique and new with Phantasmes *with hardcore being a new genre ... it was not received very well I understand?*
JR: No success at all. People came to see that kind of film, sex film. They were not interested at all. So I was wrong when I said maybe we can do a *fantastique* film in X version. People were not interested.

DH: What was it like to shoot those X films at that time in France ... was it a comfortable environment?
JR: Oh it's easy. The first one I shot it was not easy for me. It was absolutely not the kind of film I wanted to do ... In the first one, before the X film we made what we call a sexy film [*Bacchanales Sexuelles*]. A film based on a sexy story with many sex scenes in it, but not hardcore. I remember one moment shooting a sex sequence I said you do that there, camera you shoot that, and I go to the café. One day my director of photography made a plot with the actors — 'that's enough for Jean Rollin, he has to be open for these things' ... so they make a little plot. At the end of those films there is always

a sex scene with everybody on the bed at once. It was the moment to shoot the last sequence. I said 'everybody on the bed and you shoot' [laughs] and I prepared myself to go to the café [laughs]. The director of photography made a scene and all the actors jumped on me and take off my clothes and put me on the bed with the rest of the people. I was laughing so much that I was cured. And they shot the sequence with all the people and me in the middle. I was okay for the rest of my life [laughs].

DH: Did you like the X films that you shot? Why did you stop making them?
JR: It is curious to explain. I like the sex films. I liked to shoot the X films because all the characters who played in the films became friends. It was a very funny atmosphere and we laughed so much. But the films themselves are without any interest. The mood of the film, with all those people being so kind, the mood was absolutely not perverse. It was very funny. It was a great moment for me for those two or three years when I shot those films. They were so easy to shoot and after a shoot everybody would make dinner and so on. It was very friendly and professional. After two years of that I had to stop because I was losing myself. It was so easy to do that I make about twenty films but I had no time to make my other films. Always, we worked day and night with the same people ... a gang. Always between us, to speak, to eat. I had to see other people and see other things to come back to my old kind of films.

DH: Did you have much involvement with La Parfum de Mathilde*?*
JR: The X director Michel Ricaud died. And everybody in X films wanted to take his place. One day Marc Dorcel spoke to me and said why don't you make a film for me. I made *Le Parfum de Mathilde.* But it was not the same kind of film than in the beginning. When I made my X films it was the beginning [of French hardcore] and everything was new.

I had passed twenty years hiding what you can't see because of censorship, and then we had to show what we had to hide all those years before [laughs]. So that was a challenge, but the last period, the period of *La Parfum de Mathilde*, it was not the same friendship between the actors, the technicians and so on. It was not so funny to shoot. It was you do that, you do this ...

The Celluloid Dreams of Jean Rollin 249

DH: More serious?
JR: Yes.

DH: Are the X films available to buy now or have they disappeared altogether?
JR: I think probably they have disappeared. But sometimes for one reason or another, the producer decides to take those films back. I made a film with Brigitte Lahaie, an X film [*Vibrations Sexuelles*]. This one is showing again. When I was in Italy recently, I saw the film was signed [credited] to me. They put my name on it, on the advertisement. Tomorrow, another film will be back if one of the girls is well known or something like that, or just because the audience wants to see the old film for fun ... I don't know.

DH: Le Lac des Morts Vivants? [laughs].
JR: Oh not again! [laughs].

DH: The film looks like it was fun to do. Was it entirely improvised?
JR: There was a script but I never read it. The producer had one print of the script and he was the only one to have it [laughs] and he'd say to me 'now you film the mayor getting out of his house' ... and things like that ... 'and now we film that girl and she is afraid because she sees the living dead and we'll shoot the living dead another day' ... and so on. So I film practically without knowing the story.

DH: How did Ne Prends Pas les Poulets pour des Pigeons come about?
JR: Benhamou wanted to be an actor ... he is not! [laughs]. He is selling furniture! [laughs] And he had the story of the film. I was preparing *Sidewalks of Bangkok* and some money was missing. Jean-Claude Benhamou said, 'listen, I give you the money you need for finishing *Sidewalks of Bangkok* but you have to take me in it as an actor and afterwards you direct *Ne Prends Pas les Poulets pour des Pigeons* for me'. He played in *Sidewalks of Bangkok* and after I directed his film.

DH: Did anything ever come of La Griffe d'Horus?
JR: *La Griffe d'Horus* is a film that does not exist, there was only five minutes of shooting with the actor who was supposed to be Harry

Dixon. The film never got shot.

DH: *How did you become involved with* Emmanuelle 6*?*
JR: The producer was looking for a writer. One of my friends was an agent and he said to him why don't you have Jean Rollin write this as he is a good writer and so on. So I met with Sam Selsky and he was okay to work with me and he proposed me to write the script for *Emmanuelle 6*. I write the script and Sam Selsky, myself and director Bruno Zincone cast the film ... and things are what they are. When they came back from Venezuela there was many, many, many rushes ... three or four hours' worth. Bruno Zincone said 'I have other things to do, I can't shoot no more'. Selsky asked me to arrange the rushes and make a film out of it. Many, many things had not been shot! So I wrote another film ... then some other parts were added to make a full film. And they are all arranged and we needed only one more week shooting in Paris. I shot that bit. So there is a little part of that which is mine — shooting around Paris, and the rest is from Bruno Zincone.

DH: *Do you have any more films pending?*
JR: Yes. It will contain parts of all my films.

DH: *Do you have a script yet?*
JR: Yes, of course. It will probably be my last film.

DH: *Do you have a shooting title?*
JR: Yes. From now on it will be called *La Nuit Transfigurée*.

Interview with Lionel Wallmann

I WROTE TO Lionel Wallmann on several occasions during the early stages of writing this book. At that time, Wallmann was residing in Florida, USA. He was extremely convivial and helped me source some of Rollin's more obscure films. Wallmann passed away on October 13, 2011, in France. The following brief interview was conducted in writing in November 2005.

DH: How did you first meet Jean and how did you become his producer?
LW: I met Jean Rollin through a friend, Sam Selsky, an American living in Paris.

DH: Was Nordia Films your own production company?
LW: Yes.

DH: Are you a fan of the films you made with Jean or was your involvement purely financial?
LW: I absolutely didn't know Jean Rollin before, it was an opportunity to work in the movie business.

DH: Do you have any personal favourites amongst the films you shot with Jean?
LW: Of course, those I produced myself like *Les Démoniaques*.

DH: Did you have a strong influence on the films through each stage of production, writing, shooting and editing?
LW: Absolutely not. On the stage, Jean is the boss.

DH: When on set during production, did you get involved with other technical roles?
LW: In each and just for fun, I always have a little part, usually driving a car.

DH: Did you write Bacchanales Sexuelles*?*
LW: I gave the idea to Jean but he always wrote his script.

DH: How would you describe Jean's shooting style? I understand he prefers improvisational shooting?

LW: I can say that it is organized improvisational shooting. When you have little money it is absolutely necessary to have a perfect pre-production ...

DH: Personally, I don't regard Jean's films as horror films or erotic films, I feel they belong to a unique genre of their own. Would you agree?

LW: I absolutely agree.

DH: How was your working relationship with Jean? Did you enjoy working with him?

LW: Of course, if not, I would not have made more than ten movies with him.

DH: Are you involved with Rollin's current project, La Nuit Transfigurée, still in pre-production?

LW: Absolutely, and to find the money for the preparation I put an advertisement on the net to find some money. I got about $2,000 and we made the preparation in the city of Limoges. The film is still in preparation.

DH: How would you describe the atmosphere on set when shooting Jean's films? Does the production team work well together?

LW: Very friendly and convivial. The team is practically the same for years and it is like a family.

DH: Other than producing Jean's films, have you worked on any other films, in America for example?

LW: Yes, with my friend Norbert Moutier (aka Norbert Mount, to look like an American). We shoot in Las Vegas with the help of another friend living there, Charles Nizet — Operation Las Vegas and in New York also with Norbert The Brooklyn Cop. Always with a very little budget, around $100,000. Then with a Canadian friend, Jacques Descent, a low-budget thriller with Jacqueline Stallone (Sylvester Stallone's mother), who was a friend of his. And also in Fort Lauderdale with the same team, it was my first stay in Fort Lauderdale where I meet the people of the Fort Lauderdale Film Festival.

They invited me to come work for the film festival of 1990/1991. It is where I met my wife Pamela who was already working for the festival.

I work also with Gilles Katz in a film named *Les Lettres De Stalingrad*, and also with him in another film shoot in Tunisia — *La Femme Adultere de Marcel Camus*, a pilot for TV.

With Pierre Unia in Paris, a sexy comedy, *Les Maitresses De Vacances.*

Finally I produce a film with my company Nordia Films with Évelyne Dassas directed by Richard Balducci *Les Demoiselles A Peage*, another sex comedy which must have been a very good business. Unfortunately, the film was the victim of the French censor which classify all the films after their titles ... of course all mine were X and it was the end of Nordia Films.

DH: Was it yourself or Sam Selsky who produced Requiem pour un Vampire? *Or was this a co-production? The French language print describes you both as being involved as producers.*
LW: It was the beginning of our relationship. Sam Selsky brought me to the film which was in production but short of money. I didn't have much money myself but I agree to pay the salary if the team accept some draft or checks at three months ... Everybody agree and we finish the film and that was the beginning of a nice adventure for the next forty years ...

DH: Could you recommend any production companies or producers who would be interested in reading any low-budget horror/thriller screenplays?
LW: Very good question! I try myself to find money here for an old project we have named *Miami Vampire*.

Jean Rollin Bibliography

Les Pays Loins
 1964 / (Unpublished)
Saga de Xam
 1967 / Le Terrain Vague
Aujourd'hui, Gaston Leroux
 Midi-Minuit Fantastique, volumes 23 and 24
 1970 / Le Terrain Vague
Une Petite Fille Magique
 1988 / Éditions Du Schibboleth
Les Demoiselles de l'Étrange
 1990 / Filipacchi
Le temps d'un visage
 1990 / Saint-Germain de Prés
Enfer privé
 1991 / Belles letters (1st edition)
 1998 / Nouvelle edition, Éditions Sortilèges, Collection *Les Anges Du Bizarre* (2nd edition)
Les Deux Orphelines Vampires (Two Orphan Vampires)
 Serial Novellas featuring: *Les deux orphelines vampires, Anissa, Les Voyageuses, Les Pillardes, Les Incendiares*
 1993 / Fleuve Noir (1st edition)
 2001 / Films ABC (2nd edition)
 Redemption Books (English translated edition as *Little Orphan Vampires*)
Bestialité
 1995 / Éditions Fleuve Noir, Collection *Frayeur* n.28 (1st edition)
 2006 / Éditions Nuits d'Avril (2nd edition)
Le Gouffre/Suivi De/Un Visage Oublié
 1995 / Nouvelles in Zoo n.0
Ombres vives
 1996 / Saint-Germain-des-Prés
La cabriole a disparu. Prix De La Premiere œuvre Pour La Jeunesse En 1999
 1997 / Illustrated by Michel Solliec
 Collection *Letavia Jeunesse* — Liv'Éditions
La statue de chair

1998 / Éditions Sortilèges, Collection *Les Anges Du Bizarre*
Belles letters

Monseigneur Rat roman
1998 / Éditions Sortilèges, Belles letters

Cauchemar d'anniversaire
1998 / Nouvelle, Raphaël de Surtis

Les dialogues sans fin précédés de quelques souvenirs sur George Bataille, Maurice Blanchot et Michel Fardoulis-Lagrange
1998 / Nouvelles, Éditions Mirandolle — Tirages Limités

La promeneuse romans
1999 / Belles letters/Éditions Sortilèges

Vies et aventures de Jean-Pierre Bouyxou
2001 / Films ABC

Gargouillis glauques
2001 / Raphaël de Surtis

La petite Ogresse: er Prix Littéraire de l'Automnale du Livre de Sury-Le Comtal
2001 / Éditions Raphaël de Surtis/Éditinter

Tùathà
2002 / Belles letters

La petite fille au cerceau
2002 / Films ABC/Raphaël de Surtis

Estelle et Edwige, les demoiselles de l'étrange
2003 / Films ABC

Les Voleuses De Fondre/Suivi De/Tùathà
2004 / Éditions Films ABC

Jean-Pierre Bouyxou contre la femme au masque rouge
2004 / Films ABC

Rien n'estvrai
2004 / Les Films ABC Editions

Les voleuses de foudre
2004 / Les Films ABC Editions

Déraison
2005 / Films ABC

Trois Petites Filles Sorcières
2005 / Raphaël De Surtis

Alice et Aladin détectives de l'impossible

2006 / Films ABC

MoteurCoupez!: Mémoires d'un cinéaste singulier
 2008 / Films ABC

Bille de clown
 2009 / Films ABC

Jean Rollin: Écrits complets Volume 1
 2010 / E/dite

Jean Rollin: Écrits complets Volume 2
 2011 / E/dite

Jean Rollin Filmography
Index of Film Titles

As director

1958 Les Amours Jaunes (*short* p.228)

1961 Ciel de Cuivre (*short* p.229)

1963 L'Itinéraire Marin (*short* p.229)

1964 Vivre en Espagne (*documentary short* p.230)

1965 Les Pays Loin (*short* p.230)

1967 Le Viol du Vampire/The Rape Of The Vampire (p.57)

1969 La Vampire Nue/The Nude Vampire (p.68)

1970 Le Frisson des Vampires/Shiver Of The Vampires (p.76)

1971 Requiem pour un Vampire/Requiem For A Vampire (p.85)

1973 La Rose de Fer/The Iron Rose (p.92)

1973 Jeunes Filles Impudiques/Schoolgirl Hitchhikers (*for hire/ pseudonymous* p.194)

1973 Les Démoniaques/The Demoniacs (p.100)

1974 Tout le Monde il en a Deux/Fly Me the French Way (*for hire/ pseudonymous* p.196)

1975 Lèvres de Sang/Lips Of Blood (p.109)

1975 Suce Moi Vampire/Suck Me Vampire (*adult* p.116)

1975 Phantasmes (*adult* p.222)

1975 Douces Pénétrations/Gode Story (*adult* p.222)

1976 Hard Penetration (*adult* p.222)

1976 La Comtesse Ixe/The Countess X (*adult* p.222)

1976 Amours Collectives (*adult* p.223)

1976 Apothéose Porno (*adult* p.223)

1976 Vibrations Sexuelles/Sexual Vibrations (*adult* p.224)

1977 Saute Moi Dessus (*adult* p.224)

1977 Lèvres Entrouvertes/Open Lips (*adult* p.224)

1977 Discosex (*adult* p.224)

1977 Positions Danoises/Danish Positions (*adult* p.225)

1978 Remplissez-Moi ... Les Trois Trous (*adult* p.225)

1978 Petites Pensionnaires Impudiques (*adult* p.225)

1978 Hyperpénétrations (*adult* p.226)

1978 Les Raisins de la Mort/The Grapes Of Death (p.118)

1979 Fascination (p.125)

1979 Gamines en Chaleur (*adult* p.226)

1979 Bouches Lascives et Pornos (*adult* p.226)

1979 Penetrations Vicieuses/Vicious Penetrations (*adult* p.226)

1980 La Nuit des Traquées/Night Of The Hunted (p.125)

1981 Le Lac des Morts Vivants/Zombie Lake (*for hire/ pseudonymous* p.201)

1981 Les Échappées/The Escapees (p.135)

1982 La Morte Vivante/Living Dead Girl (p.140)

1982 Rêves de Sexes (*adult* p.226)

1983 Sodomanie (*adult* p.226)

1983 Folies Anales (*adult* p.226)

1984 Les Trottoirs de Bangkok/The Sidewalks Of Bangkok (p.147)

1985 Ne Prends Pas les Poulets pour des Pigeons (*for hire/ pseudonymous* p.207)

1988 Emmanuelle 6 (*for hire/uncredited* p.208)

1989 Perdues Dans New York/Lost In New York (p.152)

1990 La Griffe d'Horus/The Claw Of Horus (*short* p.231)

1991 A la Poursuite de Barbara (*short* p.233)

1993 Killing Car (p.157)

1994 Le Parfum de Mathilde/The Scent Of Mathilde (*adult* p.227)

1997 Les Deux Orphelines Vampires/Two Orphan Vampires (p.162)

2000 La Fiancée de Dracula/The Fiancée Of Dracula (p.171)

2007 La Nuit des Horloges/The Night Of Clocks (p.181)

2010 Le Masque de la Méduse/The Mask Of Medusa (p.186)

FASCINATION

Sources

Bibliography

Gelder, K., *The Horror Reader* (London: Routledge, 2000)

Marriott, J., *Horror Movies* (London: Virgin Books, 2004)

Punter, D., *The Literature of Terror: A History of Gothic Fictions from 1765 to the Present Day* (New York: Longman, 1980)

Rollin, J., *Little Orphan Vampires* (London: Redemption Books, 1995)

Temple, M. and Witt, M., *The French Cinema Book* (Suffolk: BFI, 2004)

Thompson, N., *DVD Delirium: Volume 1* (2nd edition, UK: FAB Press, 2003)

Tohill, C. and Tombs, P., *Immoral Tales: European Sex & Horror Movies, 1956–1984* (New York: St. Martin's Griffin, 1995)

DVD

Two Media Blasters DVDs (both 2002) contain worthwhile Jean Rollin interviews conducted by Lucas Balbo: *Two Orphan Vampires* and *Fiancée of Dracula.*

Websites

The official Jean Rollin website
www.shockingimages.com/rollin/intro.html

Journals

The Dark Side, edited by Allan Bryce. Issue 62: French Horror Special.

Acknowledgements

I WOULD LIKE to thank all of the kind individuals who have provided support during the writing of this project. Without their help this book would not have been possible. The book was written during two separate time periods. The initial period began in 2005 and I would like to thank Gemma Goadby and Kevin Pottage for their kind support during these early development stages.

The final draft was completed throughout 2014 and I would like to thank my wife Laura for her patience and invaluable assistance with the final draft.

I thank Jamie Richardson and my father, Philip, for their support throughout the life of this project.

I would also like to thank David Kerekes for supporting its development and for the opportunity to write such a book. Both he and Lucas Balbo helped to arrange the interview with Jean Rollin that appears at the end of this book.

Finally, a posthumous thankyou to Jean Rollin and Lionel Wallmann. They were extremely generous and supportive during the initial development of this project and their input was both vital and fascinating.

'It is the dead who dream of the living. Not the other way round. Maybe there is a dead person dreaming of me. Who has dreams of me even though he is long gone. Even though he is buried somewhere else. He is everywhere, here, there ... and every day and night, he is dreaming of me. He has nothing else to do. Who could he be? I do not know. Maybe Michel Jean ...'

Ovidie, *La Nuit des Horloges*

A HEADPRESS BOOK

First published by Headpress in 2016

[email] headoffice@headpress.com
[web] www.worldheadpress.com

FASCINATION
The Celluloid Dreams Of Jean Rollin

Text copyright © David Hinds
This volume copyright © Headpress 2016
Cover design & book layout: Ganymede Foley
Main cover image: *A Virgin Amongst the Living Dead*
Thanks: Alex Jaworzyn, Thomas McGrath, Caleb, David, Giuseppe

A CIP catalogue record for this book is available from the British Library

978-1-909394-23-0 ISBN PAPERBACK
978-1-909394-24-7 ISBN EBOOK
NO-ISBN HARDBACK

1 H E A D P R E S S Est 1991

WWW.WORLDHEADPRESS.COM
the gospel according to unpopular culture
Special editions of this and other books are available exclusively from Headpress